1655	1667	1667	1669	1676	
Alessandro VII	Chigi	Clemente IX	Rospigliosi	Clemente X	Altieri

Alessandro VII Chigi

Clemente IX Rospigliosi

Clemente X Altieri

Innocenzo XI Odescalchi

Alessandro VIII Ottoboni

Innocenzo XII Pignatelli

1676 1689

1689 1691

1691 1700

D0800759

VATICAN SPLENDOUR

MASTERPIECES OF BAROQUE ART

VATICAN SPLENDOUR

MASTERPIECES OF BAROQUE ART

CATHERINE JOHNSTON · GYDE VANIER SHEPHERD · MARC WORSDALE

NATIONAL GALLERY OF CANADA,
OTTAWA, 1986

© National Gallery of Canada
for the Corporation of the National
Museums of Canada, Ottawa, 1986

*Rights to photographic materials used
for reproduction:*

FIGURES: photographs have been
supplied by the owners or custodians
of the works reproduced, except for
the following: figs. 12, 14, 15, 17,
19, 21, 22 provided by the author;
fig. 23 Robert Derome, Montreal;
figs. 24, 26 National Gallery of Canada;
figs. 27, 29 Musée du Quèbec; fig. 28
Ministère des Affaires culturelles;
Fonds Gerard Morisset, nég. 8343-F-6

CATALOGUE: all colour provided by
the Vatican Museums and Biblioteca
Apostolica Vaticana, except for
the following: Cat. nos. 2, 3, 8, 10, 14
National Gallery of Canada;
Cat. no. 13 Art Gallery of Ontario

PHOTO CREDITS:
fig. 25 Guy Perrault, Ste-Foy, Quebec;
figs. 27, 29 Patrick Altman, Quebec City;
Cat. nos. 1, 4, 43, 44, 46-49
P. Zigrossi; Cat. nos. 11, 16, 20,
25, 38, 40, 45 M. Sarri, Scala/Art
Resource, New York; Cat. no. 13
Carlo Catenazzi, Toronto; Cat.
no. 14 Eberhard Otto, Toronto; Cat.
nos. 15, 17, 18, 19, 21, 22 Scala/
Art Resource, New York.

Every reasonable attempt has been
made to contact holders of
reproduction rights. Errors or
omissions will be corrected
in reprint.

Canadian Cataloguing in Publication Data

Vatican splendour.

Issued also in French under title:
Splendeurs du Vatican.
Bibliography: p.
Contents: The role of papal patronage in Italian
baroque art / Catherine Johnston —
Eloquent silence and silent eloquence in the work of
Bernini and his contemporaries / Marc
Worsdale – The art of revelation / Gyde
Vanier Shepherd.

ISBN 0-88884-533-2: $29.95

1. Art, Baroque—Vatican City. 2. Art, Baroque—
Italy. 3. Art, Baroque—Quebec (Province)
4. Vatican Palace (Vatican City) 5. Bernini,
Gian Lorenzo, 1598-1680.

I. Johnston, Catherine. The role of papal
patronage in Italian baroque art. II. Shepherd,
Gyde Vanier, 1936- . The art of revelation.
III. Worsdale, Marc, 1954- . Eloquent silence
and silent eloquence in the work of Bernini
and his contemporaries. IV. National
Gallery of Canada.

N6415 B3 V33 1986 709'.03'2 CIP 86-099507-0

DESIGN: Frank Newfeld
PRINTED IN CANADA

ITINERARY OF THE EXHIBITION

The National Gallery of Canada, Ottawa,
6 March–11 May 1986

The Vancouver Art Gallery,
14 June–1 September 1986

The Art Gallery of Ontario,
3 October–30 November 1986

The Montreal Museum of Fine Arts,
19 December 1986–15 February 1987

This exhibition has been made
possible by generous grants from
Northern Telecom Limited and Alitalia.

DESIGN AND INSTALLATION OF
THE EXHIBITION: George Nitefor

Insurance for the exhibition has been
provided by the Government of Canada
through the Insurance Programme for
Travelling Exhibitions.

COVER
Detail of CAT. NO. 4
Domenichino
The Last Communion of St Jerome 1614
Pinacoteca Vaticana

Contents

Lenders

Monumenti, Musei e Gallerie Pontificie
 Pinacoteca Vaticana

Biblioteca Apostolica Vaticana
 Museo Sacro
 Medagliere
 Archivio Chigi

Archivio Segreto Vaticano

Reverenda Fabbrica di San Pietro

Sagrestia Pontificia, Cappella Sistina

Basilica di Santa Maria Maggiore, Sagrestia

Basilica di San Giovanni in Laterano, Museo

Joey and Toby Tanenbaum, Toronto,
 on loan to the Art Gallery of Ontario

National Gallery of Canada

A Word from Northern Telecom

At Northern Telecom we believe cultural support is a vital force that contributes to the development of a richer, more civilized society. We sponsor programs that transcend geographical boundaries and touch people through the international language of the arts.

The splendid collection of rare religious objects represented in *Vatican Splendour* speaks of the universality of the human condition and of the striving of the human spirit to attain the beauty to which it is drawn. The exhibition's national tour will enable Canadians to share in this celebration of the vivid and compelling vision of 17th-century Baroque art.

The *Vatican Splendour* tour will afford Canada a unique opportunity to view many works of art never before seen in North America. Northern Telecom is proud to be part of making the exhibition a reality, together with our friends at the National Gallery of Canada, the Art Gallery of Ontario, the Vancouver Art Gallery and the Montreal Museum of Fine Arts.

DAVID VICE

President
Northern Telecom Limited

A Word from Alitalia

A very large number of the art treasures we enjoy today are in existence thanks to judicious decisions made by the great art patrons down the centuries.

Alitalia's more direct involvement with culture dates back to 1960, when paintings of contemporary Italian painters were first exhibited on board the company's DC-8 aircraft. In more recent years events sponsored by Alitalia include the Spoleto Festival of Two Worlds, the Biennale of Cinema in Venice, and exhibitions such as the *Florence of the Medicis in the 16th Century,* the *Genius of Venice* in London, and the recent *Caravaggio* in New York, to cite only a few.

Alitalia's experience, professionalism, and advanced technology have also served art: company technicians performed an endoscopy on the statue of Marcus Aurelius, which greatly contributed to the restoration of this magnificent equestrian monument, the centrepiece of the square conceived by Michelangelo on the Capitoline Hill. Similar examinations were also carried out on the Mazzocchi horse in Naples, and more recently on the Riace bronze warriors.

Technology and art are then expressions of the same complex reality which constitutes man as a whole.

ALITALIA

Foreword

The exhibition *Vatican Splendour: Masterpieces of Baroque Art* is the outcome of an initial disappointment and an unfulfilled dream. I was given the task, in the fall of 1981, of asking the Vatican authorities to have the major exhibition of Vatican masterpieces – or at least those works that had ties with some of the works in our own collection – detour to Ottawa on its 1983 showing at three American museums. I was not really expecting a miracle, but I felt sure that my request would lay the groundwork for a future exhibition even if my main purpose was not achieved. Knowing the courtesy of the Vatican Museums authorities and their interest in the outside world, I intended to suggest, if my original request was refused, that some of the works in the American tour and certain others be loaned to us for an exhibition which would include some of the best Baroque works of our own collection, such as those by Bernini, Rubens, and Poussin. The theme of the exhibition would be the important rôle of the popes and their court in 17th-century Italian art. The idea was greeted enthusiastically by Professor Carlo Pietrangeli, Director General of the Vatican Museums, who had no choice under the circumstances but to refuse my first proposal. Since the American tour was a major undertaking, the Vatican authorities asked me to re-submit the proposal at a later date to give them time to evaluate the impact of their first international exhibition. From the time of my first contacts with the officials in Rome, a vital rôle was played by Mr Yvon Beaulne, Canada's ambassador to the Vatican, who guided me through the complexity of the Vatican administration with the help of his dedicated staff at the embassy and the appropriate channels at External Affairs. Mr Beaulne wrote the first official letter of request to Cardinal Agostino Casaroli, Secretary of State. The response to that letter was extremely cordial and positive.

We then had to refine our proposal, place it in context, and develop the content as much as possible. This task was given to Myron Laskin, Catherine Johnston, and Michael Pantazzi, our Curators of European Art. Throughout our discussions with the Vatican authorities, Mr Beaulne and the ambassador who succeeded him – Mr Pierre Dumas – took all the necessary steps and used their diplomatic contacts to promote our project and help ensure its success. We are sincerely grateful for their assistance.

To respond to a wish expressed from the beginning by the Vatican authorities, the National Gallery of Canada undertook to include other Canadian galleries in the tour, on the basis of geographic distribution and the various potential publics. The first to become enthusiastically involved was William Withrow, Director of the Art Gallery of Ontario, Toronto, who has participated in every phase of the project and was very effective in obtaining the necessary financial assistance to make the undertaking a success. The Vancouver Art Gallery will incorporate this first-class international exhibition in its Expo 86 celebrations, and the last stop on the Canadian tour will be the Montreal Museum of Fine Arts.

The exhibition is being organized by Catherine Johnston, the National Gallery's Cu-

rator of European Art. She has defined the scope of the exhibition and ensured that the content is excellent and significant. Responsibility for the catalogue has been shared with Marc Worsdale, an art historian who is an expert on Bernini and lives in Rome, and with Gyde Shepherd, the National Gallery's Assistant Director of Public Programmes, who looked at Canadian religious art, particularly that of New France, from a historian's perspective, and identified various Baroque influences. We are especially grateful to the Musée des Augustines de l'Hôtel-Dieu in Quebec City for the loan of the *Reliquary of Father Jean de Brébeuf*, which illustrates the European Baroque heritage and complements the *Reliquary Bust of St Bibiana* on loan from Sta Maria Maggiore.

Owing to the diversity of the Vatican institutions that participated with the Vatican Museums in preparing this exhibition, a great many contacts had to be made to resolve various questions and reach agreement on all aspects of the project. We are indebted to all those who generously supported and facilitated our efforts. We would reiterate our respect and deep gratitude to Cardinal Agostino Casaroli, Secretary of State, who accorded our project his gracious patronage, and to the other Cardinals in charge of the various Vatican institutions: Cardinal Sebastiano Baggio, Cardinal Alfons Stickler, Cardinal Aurelio Sabattani, Cardinal Carlo Confalonieri, Cardinal Ugo Poletti, and Cardinal Pietro Palazzini.

In particular, we would like to acknowledge the co-operation of Father Leonard Boyle, Prefect of the Vatican Library, who provided us with invaluable material. Moreover, we cannot overemphasize the keen interest shown throughout the project by Dr Walter Persegati, Secretary General of the Vatican Museums, and the contribution of Mrs Patricia Bonicatti of the Vatican Secretariat, who efficiently resolved the many logistical problems involved in arranging the exhibition. Marquis Giulio Sacchetti, the senior lay Vatican official, used his authority to conclude a contract between the partners, among whom a strong climate of trust developed during the negotiations.

Willard Holmes, head of Exhibition Services for the National Gallery, worked diligently, until his departure for Vancouver, to ensure the success of the negotiations between the Vatican authorities, the curators of the other museums, and ourselves.

An undertaking on the scale of *Vatican Splendour: Masterpieces of Baroque Art* requires adequate financial resources to cover all the expenses of organizing the exhibition and moving it from one gallery to another. Thanks to the dedication and skill of the AGO Director William Withrow and his staff, we obtained a grant from Northern Telecom Limited. This funding is divided evenly among the museums where the exhibition is to be held. We are grateful to David G. Vice, President of Northern Telecom Limited, and John Strimas, Chairman of the Company's Corporate Contributions Committee, who believe in creativity and communication and support our efforts in that area.

We wish to thank Alitalia for generously transporting free of charge the works of art from Rome to Ottawa and from Montreal back to Rome, and for carrying the dignitaries and those escorting the works.

There is no doubt that Pope John Paul II's triumphant tour of Canada in 1984 was the prelude to this exhibition of Baroque masterpieces from the Vatican Museums and from our National Gallery. The Holy Father's travels and his interest in the world paved the way for our ambitious project, which provides Canadians, whatever their religious background, with the unique experience of admiring these Vatican masterpieces along with works from the National Gallery's European art collection.

JOSEPH MARTIN

Director
National Gallery of Canada

Preface and Acknowledgements

Few if any of the works in this exhibition are unpublished though they may not be familiar to the viewer, a great portion of them never having travelled beyond the Vatican. Many of them have recently been cleaned and restored. The works in the catalogue are ordered by medium according to the following general sequence: paintings, sculpture, medals, vestments, and tapestries. Within each grouping, a chronological sequence is attempted. In instances where it is impossible to be precise about the attribution, the question of authorship is discussed in the text. Similarly, dates are quoted with the title only where securely documented. In the case of multiple authorship, precedence is given to the 'inventor' of the design, followed by its 'interpreters' such as engravers and founders. As for embroiderers, at present there is not sufficient information to determine their identity or the author of the design from which they worked. The inventory numbers pertain to the collections from which the works were borrowed; where no inventory number is cited, none was provided by the lender. In dimensions, height precedes width, precedes depth.

Specific references are made within the individual entries of the catalogue, but no attempt has been made at a complete bibliography. As well, highlights in the provenance of a work may be cited, but in the interest of a popular, readable catalogue, no further definition has been sought. A select bibliography is given for the reader interested in pursuing the subject. This does not include the immense literature that has appeared in recent years in scholarly journals but may well lead to it. The field of painting and sculpture in 17th-century Rome is well known, but the study of the minor arts still tends to be restricted to the specialist. It is hoped that the inclusion of liturgical objects, papal medals, vestments, and tapestries in this exhibition, as well as the illustrated material in the Introduction, will give the viewer an indication of the breadth of the subject.

For assistance given in relation to this project the authors wish to thank, first of all, Professor Carlo Pietrangeli, Director General of the Vatican Museums, and Father Leonard Boyle, Prefect of the Vatican Library, for their extreme kindness and patience in facilitating access to the works in their care, and to Dr Fabrizio Mancinelli, Curator of Byzantine, Medieval and Modern Art of the Vatican Museums, and Dr Giovanni Morello, Curator of the Museo Sacro, for the time they have spent similarly and in furnishing information related to the catalogue. Thanks are also due to Dr Giancarlo Alteri of the Medagliere of the Vatican Library, to Archbishop Lino Zanini, Delegato of the Reverenda Fabbrica di S. Pietro, and Architetto Pier Luigi Silvan, to Father Josef Metzler, Prefect, and Monsignor Charles Burns of the Archivio Segreto, to Monsignor Pietro Canisio Van Lierde for loan of the altar frontals from the Sistine Chapel, Monsignor Dilwyn J.D. Lewis and Monsignor Gioacchino Sormanti at S. Maria Maggiore, and Monsignor Mario Di Sora at S. Giovanni in Laterano. Attention should also

be drawn to the excellent work of Biagio Cascone and Maurizio Parodi of the Vatican Restoration Laboratory in cleaning and restoring most of the paintings in the exhibition. To Jennifer Montagu, Catherine Johnston wishes to express her warmest appreciation for having discussed many of the problems related to the cataloguing of the exhibition, for photocopies of pages of the *Aedes Barberinae*, and for her generous sharing of Algardi information over a number of years. Her thanks also go to Suzanne Boorsch of the Metropolitan Museum in New York, Stefania Massari, Evelina Borea, and Simonetta Prosperi Valenti Rodinò of the Istituto Nazionale per la Grafica, Elisabeth Kieven of the Bibliotheca Hertziana, Rome, and Borjë Magnusson of the Nationalmuseum, Stockholm; to John Beldon Scott for readily responding to queries regarding the iconography of the Barberini tapestries on which he is working, and to Monsignor Dante Pasquinelli of the Embassy of the Holy See in Ottawa for iconographical details pertaining to the same tapestries. Serena Hortian was also extremely patient in trying to trace silk with the insignia of Alexander VII produced by Scalamandré Silks early in this century. The generous hospitality in Rome of Giulia Cornaggia Medici and Claudia Sanfelice cannot go unacknowledged nor their enthusiasm in pursuing relevant material in local churches and palaces, not least of which the Borghese Sacristy in Sta Maria Maggiore. In the National Gallery Library, Silvia Giroux has been very helpful and Maija Vilcins in her usual selfless fashion has pursued many iconographical problems far beyond the confines of the Library. The Curators of Prints & Drawings in the Art Gallery of Ontario and National Gallery of Canada, Katherine Lochnan and Mimi Cazort, have been helpful in supplying photographs of drawings reproduced in the Introduction. Of the National Gallery Publications staff, Lynda Muir has been an exemplary editor with the difficult task of coordinating a manuscript coming from several sources and Esther Beaudry has done commendable work on the French edition.

Marc Worsdale specifically wishes to thank Jennifer Montagu for bringing to his attention the drawing of the golden rose with the Chigi arms, figure 16, and for allowing him to publish the photograph with which she kindly provided him; Henry Lee Bimm for the photograph of the design for vestments, figure 21; and Meinolf Trudzinski for that of Clement IX, figure 11; Ron Lacy of Bryn Mawr for having pointed out as oak the leaves in the drawing of the golden rose by Bernini, figure 16; Brian Rose of Columbia University for helping to type the manuscript; William Worsdale for his contribution to the French translation of the introductory essay, and Derrick Worsdale for his collaboration on the French version of the catalogue entries, as well as Sheherazade Barthel-Hoyer for stylistic embellishments to the Introduction. Last but not least, he would like to thank the staff of the National Gallery of Canada, especially those with whom he has worked in indirect contact and not been able to thank in person, reiterating appreciation and gratitude to the editors, and to the Photograph Editor, Colleen Evans, and extending thanks to Catherine Johnston for her friendly collaboration, to Gyde Shepherd, Willard Holmes, Craig Laberge, Irene Lillico, and Catherine Sage.

CATHERINE JOHNSTON
MARC WORSDALE

Pope John Paul II arrived in Quebec City on 9 September 1984 to begin an historic pilgrimage to Canada on the 450th anniversary of Jacques Cartier's exploration of the Gulf of St Lawrence. The Musée du Québec celebrated this event with the spectacular exhibition *Le Grand Héritage: L'Eglise catholique et les arts au Québec,* which the Pope opened the following day. Organized by Jean Trudel and his many colleagues, this exhibition and its brilliantly illustrated catalogue are landmarks of Canadian art history. The catalogue, together with its companion volume *L'Église catholique et la Société du Québec,* included a most up-to-date bibliography of exhibitions and related books published in both French and English. Several publications are available in Canada's two official languages, in particular Harper's centennial *Painting in Canada: A History* (1966) and Mellen's *Landmarks of Canadian Art* (1978). The next important publication to come on Quebec sculpture, in 1986, will be John R. Porter's *La sculpture au Québec, trois siècles d'art religieux et profane,* Editions de l'Homme, Montreal.

As an antiphon to *Vatican Splendour,* "The Art of Revelation" is intended to commemorate the art and art history of Quebec's foundation. Although any errors of generalization, attribution or dating are the author's, this essay is entirely indebted and dedicated to Marius Barbeau, Jean Sutherland Boggs, Marie-Aimée Cliche, François-Marc Gagnon, Alan Gowans, Russell Harper, Charles Hill, Robert Hubbard, Yves Lacasse, Laurier Lacroix, G.-E. Marquis, Peter Mellen, Jacques Monet, s.j., Peter Moogk, Gérard Morisset, Michael Pantazzi, John R. Porter, Dennis Reid, Pierre-Georges Roy, Ramsay Traquair, Jean Trudel, and Doreen Walker. Acknowledgement is also made of the scholarship of Anthony Blunt in *Art and Architecture in France, 1500 to 1700* (1953 and later editions), William Crelly in *The Painting of Simon Vouet* (1962) and of Cecil Gould in *Bernini in France, An Episode in Seventeenth-Century History* (1981).

Finally, in my capacity as Acting Head of Exhibitions and Assistant Director of Public Programmes, I would like to take this opportunity to thank all those members of the National Gallery of Canada staff who have risen to the occasion and contributed to the success of this endeavour. Thanks to Peter Smith, Chief of Publications, the editors, Esther Beaudry and Lynda Muir, the Photograph Editor, Colleen Evans, Production Officer, Arnold Witty, Editorial Co-ordinator, Irene Lillico, and Word Processing Operator, Sylvie Lefebvre. MacGregor Grant and Anne Maheux of the Restoration and Conservation Laboratory have helped to secure the safe condition of all loans to the exhibition, as have André Fortin, Head of Technical Services, Kathleen Harleman, Registrar, Jacques Desjardins, Head of Security Services; and Emile Mongrain, Head of Fleet Services of the National Museums of Canada. Dayne Darling, Financial Advisor, and Bernard Pelletier, Materiel Management Officer, have, with Philip Palmer and David Walden of the Canadian Department of Communications, contributed their expertise; JoAnne Doull provided her varied administrative skills; Alison Cherniuk and Catherine Sage of Exhibitions Programme have assisted in the general organization of the exhibition and its tour; Monique Baker-Wishart has designed the Education Programme for the exhibition in Ottawa; and Janine Smiter and her staff are to be thanked for the capable promotion of the exhibition. It has been my personal pleasure to work with them all to produce this major exhibition of important Baroque works.

GYDE VANIER SHEPHERD

1
View of St Peter's and
the Vatican Palace, c.1600
anonymous drawing,
Wolfenbüttel: Herzog August
Bibliothek: Cod. Guelf. 136 Extrav.

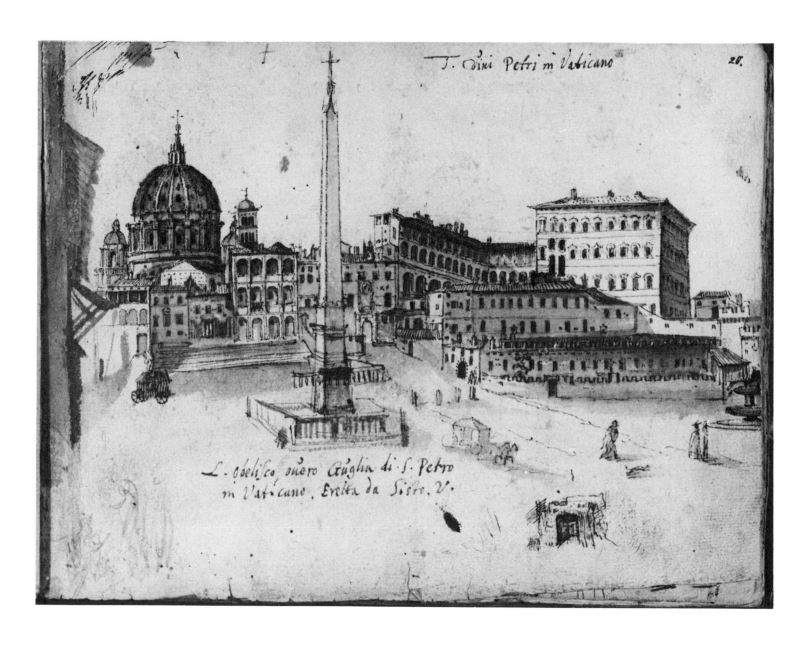

CATHERINE JOHNSTON

The Rôle of Papal Patronage in Italian Baroque Art

Rome was unquestionably the theatre for the development of Baroque art, and essential to this development was the patronage of the Papal Court. The Pope, his nephews, the cardinal princes, and other dignitaries attached to the Court provided commissions on an unprecedented scale. Painters, sculptors, architects, and artisans of all kinds had always been drawn to Rome, but now in response to the recommendations of the Council of Trent to reform and reinvigorate the Catholic Church using art as a vehicle, a whole new range of possibilities opened up. Churches dedicated to the early Christian martyrs, such as Saints Bibiana, Cecilia, Martina, and Susanna, were rebuilt and decorated, and three churches devoted to St Charles Borromeo, canonized in 1610, were constructed. New Orders were founded, among them the Oratorians and Theatines, while others such as the Capuchins or the Barefoot Carmelites were reformed. These Orders required buildings to house them, and churches complete with altarpieces and sculpture, as well as liturgical objects and vestments for the celebration of Mass. The *Quarant'ore*, or forty-hour vigils of the Jesuits, and catafalques of deceased popes and cardinals required designers of ephemeral sets and floats, as did religious processions through the streets of Rome.

St Peter's – the very centre of Christian worship – had been undergoing remodelling for over a century (see FIG. 1). Since the mid-fifteenth century the old Constantinian basilica had been deemed in poor repair and too small to accomodate the large numbers of pilgrims who flocked to the Eternal City. Now, to Bramante's design for a centrally-planned church, architect Carlo Maderno was to add a nave of huge proportions, transforming the shape of the ground plan into that of a Latin cross. The decoration of St Peter's interior and the alterations to its immediate surroundings would employ Bernini and a host of artists for the rest of the century. It was at this time that the Pontiff gave up living in the palace adjacent to St John Lateran, and accordingly enlarged the papal apartments in the Vatican Palace, but these were found unsuitable in the summer months, the low-lying situation making them vulnerable to outbreaks of malaria. Thus Gregory XIII's villa on the Quirinal Hill, noted for its fresh breezes and gardens, was expanded and embellished by a succession of popes. The papal nephews, the *cardinali nipoti*, established residences in the vicinity, where they lived and entertained in splendour. In their entourage were men of erudition who helped them to form libraries and collections of paintings and antique sculpture. In the decoration of their garden villas with frescoes of mythological subjects they often employed the most noted painters of the epoch.

Since the monumental decorations of Raphael and Michelangelo in the first half of the sixteenth century, the quality of painting

in Rome had fallen off into a pale imitation of art in which form dominated but conviction was lacking. By about 1580, three painters from northern Italy – their works characterized by adherence to naturalism – breathed new life into the depleted artistic scene. To Annibale Carracci and Caravaggio – but also to Federico Barocci a generation earlier – is owed the beginning of a style known as Baroque. Their works were novel in their close observation of the natural world and in the freshness of their artistic vision. Throughout the seventeenth century, with successive stages known as High and Late Baroque, *di sotto in sù* ceiling frescoes were to become the norm, and the undulating façades and illusionistic architectural devices of Borromini and Bernini were to transform the outward appearance of Rome. Only toward mid-century were other Italian cities, specifically Naples, Genoa, Florence, and Bologna, to develop their own individual manifestations of this style.

The various pontificates, and the artistic personalities which the pope and his cardinal nephews gathered about them, can to an extent be characterized. Pope Clement VIII Aldobrandini (reigned 1592–1605) is perhaps better remembered for his temporal achievements: his efforts to bring back France and Poland to the bosom of the Church, his espousal of the Congregation of Missions in the Orient, Africa, and the New World, and for the annexation of Ferrara to the Papal states; yet he was a devout and humble man, not adverse to walking barefoot in processions and pilgrimages. He favoured the Oratorians, befriending the founder St Philip Neri – a drawing in the National Gallery of Canada (FIG. 2) shows the Saint visiting the Pope during one of his painful attacks of gout. His confessor, Cardinal Baronius, was a scholar

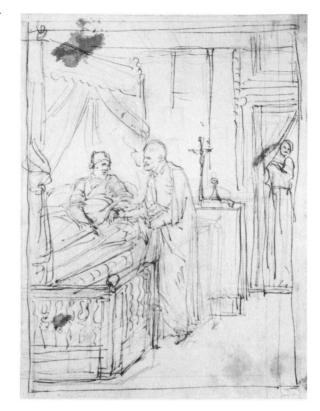

2
Guido Reni
St Philip Neri Healing Pope Clement VIII
drawing,
National Gallery of Canada
(Acc. no. 28150)

and author of a twelve-volume history of the Church, the *Annales ecclesiastici*.

Artistically, Clement VIII's reign was a period of transition. To St Peter's he added the bronze orb and cross that crown the lantern above Michelangelo's cupola, and he commissioned Cavalier d'Arpino to design the mosaics on its interior surface. Altarpieces commissioned for the Basilica were based on a programme devised by Baronius and devoted to St Peter; these were given to the not very innovative artists of the time, such as Roncalli, Vanni, and Passignano.[1] Yet it was during this very period that Caravaggio revolutionized painting with his dramatic and realistic scenes of the *Calling and Martyrdom of St Matthew* (1599–1601, in Cardinal Matthieu

Cointrel's Chapel, S. Luigi dei Francesi) and the *Conversion of St Paul* and *Crucifixion of St Peter* (1600–02, chapel of Tiberio Cerasi, papal treasurer, Sta Maria del Popolo). His *Entombment of Christ* was similarly commissioned to adorn the chapel of a member of the papal court in the Chiesa Nuova (see CAT. NO. 3). Caravaggio went on to receive the commission for an altarpiece in St Peter's, the *Madonna with the Serpent*, painted for the Chapel of the Palafrenieri, or the papal grooms. Delivered in 1606, the year after Clement's death, it hung only briefly in the Basilica before finding its way into Cardinal Scipione Borghese's collection. For his family chapel in Sta Maria sopra Minerva, the Pope commissioned a painting of *The Last Supper* by Barocci, but this too was to arrive only after his death. In the large audience chamber in the Vatican Palace, the Sala Clementina, he employed Giovanni and Cherubino Alberti to paint frescoes on the ceiling using fictive architectural perspective.[2] Though the illusionism was impressive, the vocabulary was distinctly Mannerist and could not compete with the extremely complex fresco decoration that Annibale Carracci painted in the Farnese Gallery. Clearly harking back to Michelangelo's ceiling in the Sistine Chapel in its use of *quadri riportati* and *ignudi*, the figure style in Carracci's work was based on a close observation of nature in combination with a renewed classical spirit. With the help of assistants, Annibale painted the landscape frescoes in the chapel of the Aldobrandini Palace; these formed the basis for the development of landscape painting as a separate genre in the seventeenth century.

If the Pope's personal taste was not avant-garde, his nephew Cardinal Pietro Aldobrandini displayed a very enlightened interest in art. For the Abbey of Tre Fontane, of which

Aldobrandini was protector, Guido Reni produced a Caravaggesque rendering of the *Martyrdom of St Peter*, which is today in the Pinacoteca Vaticana (but being painted on panel, was not available for loan to this exhibition). For the Cardinal's titular church, the cathedral in Ravenna, Reni was later to paint frescoes in the cupola of the Cappella del SS. Sacramento. Also for Cardinal Aldobrandini, Domenichino painted the *Assumption of the Virgin* in the richly coffered ceiling of Sta Maria in Trastevere and executed the beautiful landscape frescoes (now National Gallery, London) with the story of Apollo in the Villa Aldobrandini at Frascati. It is to be remembered, too, that Domenichino's oil painting of the *Bath of Diana* was originally commissioned by Cardinal Aldobrandini. Two other cardinals in the Aldobrandini era had notable collections. Cardinal Francesco del Monte (d. 1626) is best remembered as Caravaggio's early patron in Rome, and his collection boasted many works by this master. Cardinal Paolo Emilio Sfondrati, nephew of Gregory XIV, was responsible for the restoration of the Church of Sta Cecilia in Trastevere on the recovery of the Saint's body in 1599, commissioning from Reni works dedicated to St Cecilia, as well as Stefano Maderno's remarkable marble statue of her prostrate form, which is incorporated into the main altar.[3] It should not be overlooked that following Clement VIII's sojourn in Ferrara during six months of 1598, much of the Este collection migrated to Rome. Giovanni Bellini's *Feast of the Gods* and Titian's *Bacchanals* from the famous Camerino d'Alabastro in the Ducal Palace in Ferrara were to have considerable importance in the development of Baroque painting.

With Paul V Borghese's (1605–21) accession to the papal throne, the completion of St Pe-

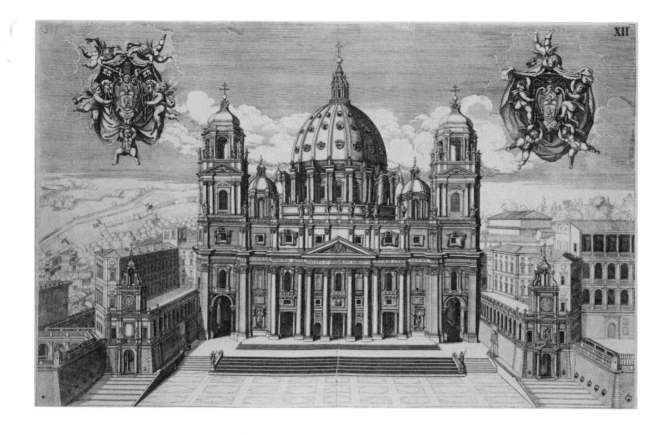

3
Martino Ferrabosco
Façade of St Peter's
with the Borghese Arms
engraving, c.1620,
published 1684,
Metropolitan Museum of Art
(Inv. no. 52.519.172[12])

ter's was a very clear priority. To this end, hundreds of workmen laboured literally day and night to remove the old structure and to build Carlo Maderno's nave, which was completed by 1615 (see FIG. 3). The new Pontiff also built his family chapel in Sta Maria Maggiore. On the lateral walls he had placed funerary monuments of himself and his predecessor, Clement VIII.[4] The frescoes in the pendentives and lunettes above, painted by Cavalier d'Arpino and Guido Reni, were based on an iconographic programme devised by the Oratorians, glorifying the Virgin and depicting the heroes of the Eastern and Western Church. Reni was also responsible for the decoration in the Cappella dell'Annunciata in the Quirinal Palace, where Tassi, Gentileschi,

and Lanfranco collaborated on the painting of audience chambers. In the Vatican Palace, Reni also painted frescoes in the apartments of the papal nephew Scipione Caffarelli, and he executed his most famous work, the *Aurora* ceiling, in the casino of his palace opposite the Quirinal Palace. Soon after, Cardinal Scipione, who adopted the name Borghese, also constructed a villa nearby in which to house his vast collections of antiquities and his paintings by Renaissance masters and contemporary Roman artists. A voracious collector, he took possession of Raphael's *Entombment*, which had come from the Baglioni Chapel in Perugia, works by Dosso from the Este collection in Ferrara, Domenichino's *Bath of Diana*, and apparently did not hesitate

to take Caravaggio's *Madonna dei Palafrenieri* from St Peter's. Bernini has left a very lively portrait (FIG. 4) of this patron of his early sculptural groups such as the *Apollo and Daphne*.

Aside from these more worldly endeavours, Paul V cared for the spiritual and physical welfare of the citizens of Rome. He repaired the ancient aqueducts, building new fountains, and cleared streets through the medieval city, as had Sixtus V a quarter of a century earlier. His arms – a dragon surmounted by an eagle – are everywhere apparent in Rome. Late in his reign Paul V planned the elaborate ceiling decoration of the Benediction Loggia over the entrance to St Peter's, with scenes from the life of the titular Saint. This he entrusted to a young Carracci pupil from Parma, Giovanni Lanfranco, whose plans are known to us through the engravings his son caused to be made of his father's drawings.[5] However, with the death of the Pontiff these were not to be realized.

Gregory XV Ludovisi (1621–23) was born in Bologna and had recently been its Cardinal Archibishop. On his accession he summoned to Rome artists from his native city. Aside from Guercino, who painted the gigantic *St Petronilla* altarpiece for St Peter's[6] and frescoes in the Casino Ludovisi, Reni and Domenichino were recalled. Both painted portraits of the Pontiff and ultimately received major commissions for altarpieces in the city. Cardinal Ludovico Ludovisi ordered for the Jubilee year of 1625 Reni's great *Trinity* altarpiece for SS. Trinità dei Pellegrini, and Domenichino painted for St Peter's a large oil mural *The Martyrdom of St Sebastian* (removed in 1736, and replaced by a mosaic copy). Appointed papal architect during Gregory XV's pontificate, Domenichino is known to have made designs for the interior of the Casino

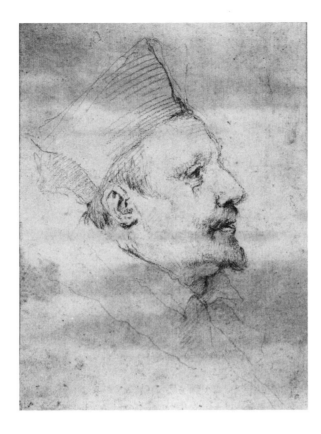

4
Gian Lorenzo Bernini
*Portrait of
Cardinal Scipione Borghese*
drawing,
Pierpont Morgan Library
(No. IV, 176)

Ludovisi and the façade of the Theatine church S. Andrea della Valle,[7] where he executed his masterpiece, the fresco decorations of the story of St Andrew. Here too his rival Lanfranco painted the frescoes in the cupola which decisively influenced the treatment of cupola decoration for the remainder of the century.

Bernini's portrait of Gregory XV (CAT. NO. 13) is a sensitive portrayal of this reflective personality, who was trained as a Jesuit. Despite the brevity of his reign, he succeeded in giving official recognition to the Congregation of Missions under the name of the *Propaganda Fide*, and in the canonization in 1622 of four Spanish Saints – Ignatius Loyola, founder of the Jesuits; Teresa of Jesus, who

reformed the Carmelites; Francis Xavier, who led the mission to the Far East; and Isidore Agricola – in addition to St Philip Neri, founder of the Oratorians. Their activities provided new subjects for many altarpieces. Already in 1626 Cardinal Ludovisi laid the cornerstone for a church devoted to S. Ignazio, which Algardi decorated with a frieze of festoons, putti, and the Ludovisi arms. It was also at this time that Monsignor Giovanni Battista Agucchi, formerly secretary to Cardinal Aldobrandini and now that of the Pope himself, wrote his treatise on painting supporting classicist ideology.

At the accession of Pope Urban VIII Barberini (1623–44), the new Pontiff is said to have uttered these words: "It is a piece of luck for you, Cavaliere, to see Maffeo Barberini Pope, but far greater is our good fortune that the lifetime of Cavaliere Bernini should fall within our pontificate." Indeed he immediately placed the sculptor in charge of the papal foundry and commissioned the great bronze *Baldacchino,* brazenly decorated with emblems of the Barberini family, to cover the main altar of St Peter's directly over the tomb of the Saint (FIG. 5). On the death of Carlo Maderno in 1629, Gian Lorenzo Bernini was to assume the rôle of Court and State architect and architect of the Reverenda Fabbrica di S. Pietro, the office responsible for the construction and decoration of the Basilica. Bernini was virtual dictator of Roman artistic production until his death in 1680, with only a brief eclipse during the Pamphilj pontificate. Fortunately his genius and organizational abilities were worthy of such a rôle.

Maffeo Barberini had a reputation for literary erudition. One of his first acts was to visit the Vatican Library, which he put in charge of Cardinal Francesco, and later of his brother Cardinal Antonio Barberini, both of

5
Bernini's *Baldacchino*, anonymous 17th-century engraving, Metropolitan Museum of Art (Inv. no. 45.82.2[39])

them raised to the purple soon after his accession. He ordered an inventory to be made of the precious manuscripts the Library contained, and subsequently had the Archives placed under a separate administration. His own considerable library was put in the charge of the German scholar Lucas Holstenius and was made accessible to other scholars. Urban also took an active interest in the University, attracting eminent professors and constructing buildings to house it.

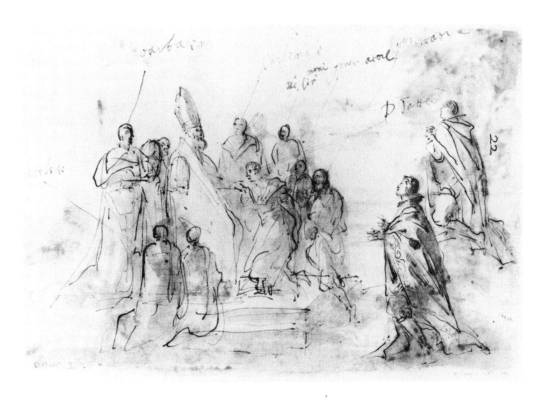

6
Agostino Tassi
*Pope Urban VIII Bestowing
the Prefecture of Rome upon
His Nephew Taddeo Barberini*
drawing, Art Gallery of Ontario,
Toronto (Inv. no. 69/34)

In November 1626 the Pontiff solemnly consecrated St Peter's Basilica (see CAT. NO. 48). He turned his attention to the decoration of the interior of St Peter's, commissioning altarpieces in which we find active the predilection of Urban VIII and Cardinal Francesco for French artists such as Vouet, Valentin, and Poussin (see CAT. NOS. 7, 8 and 9) working in Rome at the time. There was a conscious turning away from the Bolognese artists preferred by Paul V and Gregory XV, and support for a new generation of Italian artists, among them Pietro da Cortona and Andrea Sacchi. Cortona had already distinguished himself with frescoes on the life of St Bibiana in the church dedicated to her, recently restored by Bernini (see CAT. NO. 16). In St Peter's he painted the large *Trinity* altarpiece for the Chapel of the Blessed Sacrament, and provided cartoons for mosaics on

the ceiling. Sacchi contributed his early masterpiece *The Miracle of the Corporal* (CAT. NO. 6), and later paintings for the outside of the piers of the crossing, where there were altars dedicated to the most important relics in the church: the veil of St Veronica, the lance of St Longinus, the head of St Andrew, and part of the True Cross recovered in Jerusalem by St Helen, mother of the Emperor Constantine, founder of the Old St Peter's. For the niches on the inside of these piers, Bernini organized the execution of four large marble statues of the Saints, himself executing the Longinus. The balconies above these niches, where the relics were exhibited on special occasions, were also designed by Bernini.[8] Other works the sculptor was to execute in St Peter's which owe their origin to Urban VIII include the Pontiff's tomb (FIG. 13 and CAT. NO. 17) and that of Countess Matilda of Tuscany, whose remains were translated to the Basilica in 1634.

The splendour of life in Palazzo Barberini is recorded in the publication by Girolamo Teti, *Aedes Barberinae ad Quirinalem* (1642). Here resided Urban's nephews Cardinal Antonio Barberini and his brother, the prefect of Rome, Taddeo Barberini (see FIG. 6). Begun by Carlo Maderno and completed by Bernini with the assistance of Borromini,[9] its interior was decorated with frescoes by Pietro da Cortona and Andrea Sacchi. The iconography of these is based on a programme devised by Francesco Bracciolini representing *Divine Providence* and *Divine Wisdom,* but in which emblems of the Barberini family – the sun, bees, and laurel – play a prominent rôle as they had in the ornamental decoration of Bernini's *Baldacchino.* Although in his design for the vast expanse of the ceiling of the Gran Salone (see FIG. 7), Cortona used fictive architecture to extend the space of the room into

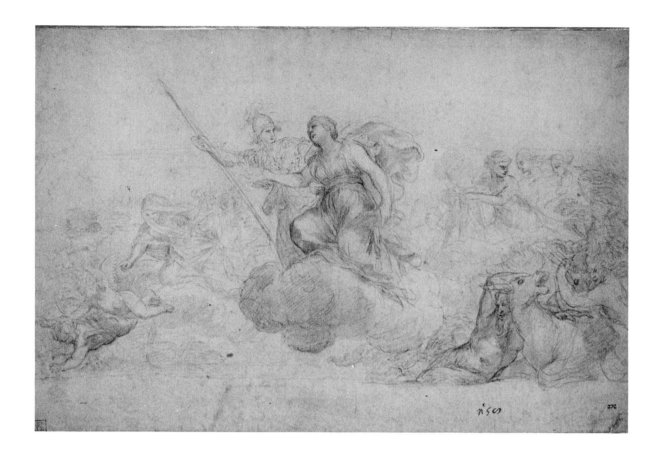

7
Pietro da Cortona
*Sketch for Part of
the Ceiling Decoration of
the Palazzo Barberini*
National Gallery of Canada
(Acc. no. 6134)

the simulated sky above, for the first time in the history of Baroque ceiling decoration he represented a coherent space through which the myriad figures move. The space continuum, in fact, was meant to begin with wall frescoes representing scenes from the life of Urban VIII (see FIG. 8 and CAT. NOS. 46–49 for tapestry series on this subject), before ascending to the ceiling where the Barberini arms are thrice crowned with the papal tiara, the poet's laurel, and the crown of immortality in the form of stars.[10] Although family emblems had previously been incorporated into decorative schemes, nothing quite so blatantly worldly as this apotheosis of the Barberini family had yet been seen.

In the Palazzo Barberini the tone of High Baroque art was set. Distinguished writers and scholars were received there, among them the English poet John Milton, and operas were performed in its theatre during Carnival. Though the atmosphere in Rome at this time may be said to have been worldly, it was also enlightened. Academies – literary, scientific, and artistic – flourished. Although Galileo was made to recant at his trial in Rome in 1633, there were those who openly sympathized with him. There was also a renewed interest in antiquity. Cassiano dal Pozzo, Cardinal Francesco Barberini's secretary, commissioned drawings recording antique relics in Rome; and it was also for him

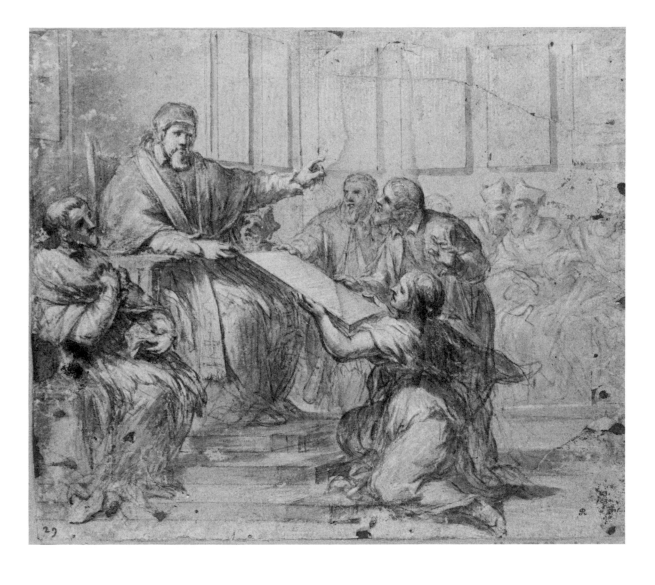

that Poussin painted the series of *Seven Sacraments*. Their grave and reserved tone is in marked contrast to the more rhetorical art of the period. There was also a host of northern artists living in Rome at the time, with a lively interest in landscape, and who were not adverse to inserting Roman monuments into their paintings. While they did not aspire to the major commissions of church or palace decoration, their smaller cabinet pictures were avidly sought by the cardinal princes, among them the Sacchetti brothers, and Guido Bentivoglio.

With the election of the Pamphilj Pope Innocent X (1644–55; FIG. 19) following the death of Urban VIII, allegiances changed again in favour of Spain. The Barberini were accused of extravagance in their way of life and of unprecedented nepotism. They retreated in exile to France, and those who had

frequented their entourage were out of favour. Innocent X chose Camillo, son of his brother Pamphilo and Olimpia Maidalchini-Pamphilj, for the rôle of Cardinal nephew – but when the latter put aside the purple to marry the Aldobrandini heiress, he too was obliged to withdraw from Rome until the birth of their son put the couple back in good graces. For Camillo, the Bolognese sculptor Alessandro Algardi oversaw the construction of the Villa Belrespiro on the Janiculum, decorating its interior with beautiful stucco reliefs on the story of Hercules. With Bernini momentarily out of favour, Algardi's talents became apparent in the numerous commissions connected with the Pope. Primary among these was the more than life-size bronze statue of the Pontiff in the Palazzo dei Conservatori. Algardi also made portrait busts of the Pontiff and his family; that of Olimpia Maidalchini is truly a formidable portrayal. It was at this time that Algardi realized two commissions for St Peter's: the large marble relief for the altar of St Leo the Great and the tomb of Pope Leo XI, who had reigned for one month in 1605.

To the palace in Piazza Navona that Innocent X had occupied as cardinal, Borromini added a long gallery, and here Pietro da Cortona painted the ceiling with scenes from the *Aeneid* linking the Pamphilj family to the founder of Rome. The Church of S. Agnese in Agone, adjacent to the palace (see FIG. 18 and CAT. NO. 27), was remodelled and eventually contained the Pontiff's tomb. For the Piazza Navona, situated over the Roman stadium of Domitian, Bernini brilliantly conceived the fountain of *Four Rivers* (see CAT. NO. 26) to relieve its long narrow shape.

Innocent X entrusted Borromini with the remodelling of St John Lateran, to be completed for Holy Year in 1650. Thus the façade and nave took on a thoroughly contemporary appearance, with the inventive decoration typical of Borromini's interiors. To the years of the Pamphilj pontificate belong two further church decorations of importance, one of them sculptural, the other painted in fresco, but each involving a degree of illusionism and anticipating the emotional response of the viewer. These were, first of all, Bernini's extremely theatrical treatment of the chapel of Cardinal Cornaro in the Carmelite church of Sta Maria della Vittoria, where he placed over the altar a large marble group representing the ecstacy of the recently canonized St Teresa. While the focus is on the sculpture, which is illuminated from a hidden light source, Bernini extends the setting to the walls, where relief busts of members of the Cornaro family look on, as if from boxes of a theatre. Ceiling frescoes and inlaid marble floor decoration complete the spatial illusion. Cortona's frescoes in the Chiesa Nuova show a similar spatial progression from the *Assumption of the Virgin* portrayed in the apse to the celestial sphere of the *Trinity* represented in the cupola.

The outstanding event at the beginning of the reign of Pope Alexander VII Chigi (1655–67; see FIG. 9) was the reception in Rome of Queen Christina of Sweden, following her abdication in 1654 and her conversion to the Catholic faith. She established a permanent residence in Palazzo Riario from 1659, installing her library and important Renaissance pictures collected by Rudolph II. There she gathered about her the best-known artists and intellectuals of the period. The pontificate of Alexander VII marked the reinstatement of Bernini and saw a number of important commissions connected with St Peter's.[11] In 1656 was begun construction of the enormous colonnade that embraces the piazza in front of

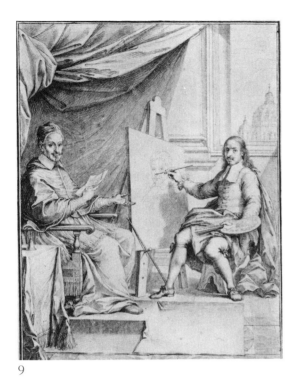

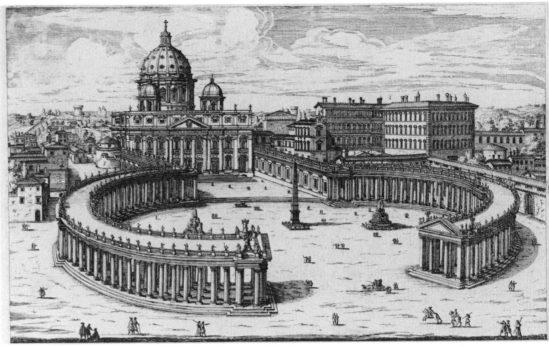

9

10

9

Agostino Masucci
*Pier Francesco Mola Painting
the Portrait of Alexander VII*
drawing,
Nationalmuseum, Stockholm
(NMH 554/1863)

10

G.B. Falda
St Peter's and the Colonnade
engraving, 1667–69,
Metropolitan Museum of Art
(Inv. no. 31.67.4[53])

the Basilica (see FIG. 10 and CAT. NO. 37). Over several years evolved his design for the throne of St Peter in the Choir, known as the *Cathedra Petri* (see CAT. NO. 29). At this time Bernini designed crucifixes and candlesticks, bearing the Chigi arms, to ornament the altars in St Peter's (see CAT. NOS. 24 and 25). Alexander VII persuaded Bernini to adapt his designs for a statue of Constantine, commissioned by Innocent X for the interior of the Basilica, to the foot of the recently completed Scala Regia (see CAT. NO. 30). This he did by placing an enormous piece of fictive drapery behind the equestrian group. He also executed the tomb of Alexander VII, with allegorical figures of Charity and Truth set against rich pink marble drapery held aloft by a gilded bronze skeleton.

To the Chigi Chapel in Sta Maria del Popolo, Bernini contributed the marble statues of *Daniel* (1655–57) and *Habakkuk* (1655–61; see CAT. NOS. 21 and 22), and for their chapel in the cathedral of Siena he made those of the *Magdalene* and *St Jerome* (1661–63). Alexander VII's keen interest in the Roman University, the Sapienza, to which he contributed the Biblioteca Alessandrina, was crowned by the consecration in 1660 of Borromini's church, Sant'Ivo, begun by Urban VIII, but which clearly bears the Chigi *monti* and stars as decoration.[12] At this time Bernini designed three churches in Rome, Ariccia, and Castelgandolfo, which were experiments with a central plan. In the realm of painting, Alexander VII's most important commission was the frescoed decoration (1656–57) of the gallery in the Quirinal Palace. There Pietro da Cortona directed a number of artists, among them Ciro Ferri, Mola, Lazzaro Baldi, Grimaldi, Gaspard Dughet,

and the two Cortese, in scenes from the Old Testament.[13] Alexander VII also decorated the summer palace at Castelgandolfo. His nephew, Cardinal Flavio Chigi, purchased a palace in Piazza SS. Apostoli, for which Bernini designed the façade using a colossal order of pilasters, and in the casino in his gardens at the Quattro Fontane, he kept his collection of Bernini *bozzetti* (see CAT. NOS. 17, 21 and 22).

Giulio Rospigliosi, who took the name Clement IX (1667–69; see FIG. 11 and CAT. NO. 12), had had a brilliant career, making his début in the Barberini entourage when his dramas were set to music and performed in their palace. In 1644 he was made nuncio to Spain, remaining there nine years, and under Alexander VII he had served as Secretary of State. Aside from his literary prowess, he was interested in art and visited Queen Christina's collection in 1668. He charged Bernini with the responsibility of designing angels for the Ponte Sant'Angelo, mostly executed by his pupils, a small image of which occurs on a medal in this exhibition (CAT. NO. 32). The Rospigliosi vestments exhibited here (CAT. NOS. 41 and 42) display a delicate form of decorative motif which was characteristic of this period. In painting there was a similar lightening of the palette and delicacy of form, and a corresponding change in sculpture such as can be seen in the work of Melchiore Caffà, for instance in his relief of St Catherine in the Church of Sta Caterina da Siena a Magnanapoli, Rome. Among the cardinals whom Clement IX elevated was the Florentine Leopoldo de' Medici, one of the foremost collectors of the century, assiduously corresponding with his agents to acquire quantities of gems, coins, and drawings in addition to the more traditional areas of painting and sculpture. He was responsible for the restoration of the Roman church of SS. Domenico e

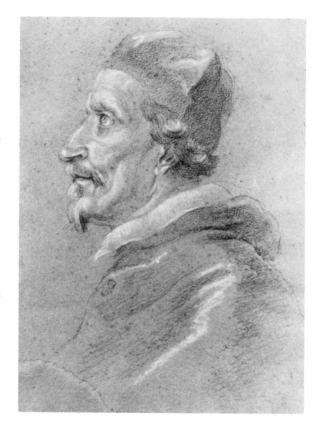

11
Gian Lorenzo Bernini
Portrait of Clement IX
drawing,
Niedersächsisches Landesmuseum,
Hanover (Inv. no. 243)

Sisto, engaging the Bolognese specialists in *quadratura* painting, Domenico Maria Canuti and Enrico Hoffner, to execute the fresco *The Apotheosis of St Dominic* (1674–75) on the ceiling.

Emilio Altieri (1670–76; see CAT. NOS. 33 and 34) was elected pope when he was eighty years of age, taking the name of Clement X in honour of his predecessor. He adopted for the rôle of papal nephew a man related to him by marriage, Cardinal Paluzzi degli Albertoni, who assumed the name of Altieri. Cardinal Altieri greatly enlarged the family palace near the Gesù, commissioning frescoes celebrating ancient and Christian Rome from Canuti and Maratta. Maratta's ceiling with the *Triumph of Clemency*, a play on the Pontiff's name, is only part of a much larger decoration that he plan-

ned for the main hall, based on a programme devised by the biographer G. P. Bellori.[14] Giovanni Battista Gaulli's contemporaneous decorations of the Gesù were a sumptuous combination of painted fresco with stucco clouds and angels and gilded coffering. The scene in the vault, the *Adoration of the Name of Jesus*, is a triumph of aerial perspective using areas of brilliant light in contrast to deep shadow. In the manner of Bernini's *Cathedra*, stucco angels and clouds spill over the frame, and a simulated shadow on the coffering increases the illusionistic effect. The whole complex of Gaulli's frescoes in the church were in preparation of the Holy Year 1675, when records show that Rome received 280,496 pilgrims. Bernini's tabernacle to adorn the Chapel of the Blessed Sacrament in St Peter's was also commissioned for these celebrations. Another notable Bernini commission of the time is the altar of the Blessed Ludovica Albertoni (1671–74),[15] the Pontiff having recently approved the cult devoted to this member of his adopted nephew's family.

Innocent XI Odescalchi's reign (1676–89; see CAT. NO. 35) was marked by the advance of the Turks on Vienna and his efforts to form a Christian alliance to repulse them. In this he was frustrated by the uncompromising absolutism of Louis XIV. He was restrained in his spending, shunned nepotism, and called for a reform of public conduct. His artistic patronage was essentially limited to the completion of projects already underway. His Secretary of State, Cardinal Alderano Cybo, however, constructed his family chapel in Sta Maria del Popolo. Designed by Carlo Fontana, it was richly ornamented with marble. From Carlo Maratta, Cybo commissioned the renowned altarpiece of the *Virgin Immaculate with SS. Gregory, John Chrysostom,* *John the Evangelist, and Augustine.*[16] Fontana and Maratta were also the artists preferred by Innocent XII Pignatelli (1691–1700), collaborating, for example, in the execution of the Baptistry in St Peter's. These years also witnessed the culmination of one of the most elaborate church decorations of the century, that by Fra Andrea Pozzo for S. Ignazio. There he painted in the vault of the nave the *Glory of St Ignatius*, set in a sharply receding architectural perspective, in which figure the protagonists of the Jesuit mission. It was a summation of the triumphant Late Baroque style which was exported all over Catholic Europe and eventually to the New World.

Thus came to an end the century which had witnessed the development and successive stages of Baroque art, intimately linked with the expression of resurgent religious fervour. Notable contributions had been made to the disciplines of architecture, sculpture, painting, and the decorative arts. Not only did the artists of the Baroque era change the outward appearance of Rome, but they created new modes in church design, such as the oval ground plan. They brought to the embellishment of the interior a more monumental form of *baldacchino* and decorated the altar with free-standing sculpture or marble relief altarpiece. The new iconography of painted altarpieces invited the emotional response of the viewer, and the illusionistic frescoes extended the temporal space of the congregation to a celestial one above. They designed vestments and liturgical objects to be an integral part of church ritual. Above all, it was the sense of unity achieved through combining all of these elements, and the conscious movement from one to another, that resulted in a total expression which was uniquely Baroque.

Notes

1. Miles L. Chappell and Chandler W. Kirwin, "A Petrine Triumph: The Decoration of the Navi Piccole in San Pietro under Clement VIII," *Storia dell'Arte,* Vol. 21, 1974, pp. 119–170.

2. K. Herrman-Fiore, "Giovanni Alberti, Kunst und Wissenschaft der Quadratur *Eine Allegorie* in der Sala Clementina der Vatikan," in *Mitteilungen des Kunsthistorischen Institutes in Florenz,* XXII, 1978, pp. 61–84; Fabrizio Mancinelli, "Mostra dei Restauri in Vaticano," *Bollettino dei Musei e Gallerie Pontificie,* IV, 1983, pp. 229–234.

3. A. Nava Cellini, "Stefano Maderno, Francesco Vanni e Guido Reni a Santa Cecilia in Trastevere," *Paragone,* no. 227, 1969, pp. 18–41.

4. M.C. Dorati, "Gli scultori della Cappella Paolina in Sta Maria Maggiore," *Commentari,* XVIII, 1967, pp. 231–260; S. Pressouyre, "Sur la sculpture à Rome autour de 1600," *Revue de l'Art,* Vol. 28, 1975, pp. 62–77; A. Herz "The Sistine and Pauline Tombs. Documents of the Counter Reformation," *Storia dell'Arte,* Vol. 47, 1981, pp. 241–261.

5. E. Schleier, "Les projets de Lanfranc pour le décor de la Sala Regia au Quirinal et pour la loge des Bénédictions à Saint Pierre," *Revue de l'Art,* Vols. 7–10, 1969–71, pp. 40–67.

6. Leo Steinberg, "Guercino's Saint Petronilla," *Studies in Italian Art and Architecture 15th through 18th centuries,* Cambridge, Mass. 1980, pp. 207–234.

7. Richard Spear, *Domenichino,* New Haven 1982, I, p. 98, repr. II, fig. 412; John Pope-Hennessy, *The Drawings of Domenichino in the Collection of His Majesty the King at Windsor Castle,* Phaidon, London 1948, p. 121, nos. 1735–1739; repr. Spear, *loc. cit.,* II, figs. 405–407.

8. Irving Lavin, *Bernini and the Crossing of Saint Peter's,* New York 1968.

9. Anthony Blunt, "The Palazzo Barberini: the Contributions of Maderno, Bernini and Pietro da Cortona," *Journal of the Warburg and Courtauld Institutes,* XXI, 1958, pp. 256–287.

10. Walter Vitzthum, "A Comment on the Iconography of Pietro da Cortona's Barberini Ceiling," *The Burlington Magazine,* CIII, 1961, pp. 427–433.

11. Giovanni Morello, "Bernini e i lavori a S. Pietro nel 'diario' di Alessandro VII," *Bernini in Vaticano,* Rome 1981, pp. 321–340.

12. John Beldon Scott, "S. Ivo alla Sapienza and Borromini's Symbolic Language," *Journal of the Society of Architectural Historians,* XLI, 1982, pp. 294–317.

13. Norbert Wibiral, "Contributi alle ricerche sul Cortonismo in Roma: I pittori della Galleria di Alessandro VII nel Palazzo del Quirinale," *Bollettino d'Arte,* XLV, 1960, pp. 123–165; and S. Jacob, "Pierre de Cortone et la décoration de la galerie d'Alexandre VII au Quirinal," *Revue de l'Art,* II, 1971, pp. 42–54.

14. Jennifer Montagu, "Bellori, Maratti and the Palazzo Altieri," *Journal of the Warburg and Courtauld Institutes,* Vol. 41, 1978, pp. 334–340.

15. Christopher M.S. Johns, "Some Observations on Collaboration and Patronage in the Altieri Chapel, San Francesco a Ripa: Bernini and Gaulli," *Storia dell'Arte,* Vol. 50, 1984, p. 43–47.

16. H. Hager, "La Cappella del Cardinale Alderano Cybo in S. Maria del Popolo," *Commentari,* XXV, 1974, pp. 47–61.

MARC WORSDALE

Eloquent Silence and Silent Eloquence in the Work of Bernini and His Contemporaries

In preparing himself for his work he would think about one thing at a time, and would give this as a precept to his pupils, that is about invention first, and then would he reflect on the ordering of parts, and finally on giving them perfection of grace and tenderness. He would adduce as an example for this the Orator, who first invents, then orders, clothes, and adorns, because he would say, each of these operations took the whole man, and giving the whole of oneself to several things at the same time was not possible.

F Baldinucci,
Vita del cavaliere Gio. Lorenzo Bernini,
Florence 1682, p. 71.

…on the vault of the Chapel… are painted eleven stars, to which Astronomers give the name of Virgo… and among them I placed the moon alluding to the Most Blessed Virgin… and whoever might not recognise in those stars the symbol of the Virgin, will be able to recognise the allusion from a cipher…which is well-known to anyone with be it even the very slightest tinge of mathematics, but should both the constellation as well as the cipher be unrecognisable, the moon and gilded stars against a field of azure, cannot fail to give pleasure to the eye.

Virgilio Spada on his intentions for the family chapel at S. Girolamo della Carità – *cf.* N.12.

Artists of the period illustrated by this exhibition could expect of their audience a certain familiarity with traditional themes, of which their works might represent new interpretations and original variations. The present introduction is intended to investigate the intimate connection between a somewhat disparate assembly of objects, each of which, however, is in fact representative of a consistent mode of thought. By thus preparing one's palate for the heady wine of ideas on which the artists and patrons thrived, one can share in their understanding – just as connoisseurs of wine can communicate sensations of taste, and reach mutual definitions through comparative language. Since the language of art expresses ideas by speaking to the eyes, the last word is with the works themselves, which it is our good fortune to be able to see before us.

A typical example of a frequent paradoxical conceit, re-echoed from Horace, is the assertion that paper is more permanent than bronze. This conceit could be expressed in literary form, as in the two sonnets that preface a book by Bonanni on papal medals illustrating the building-history of St Peter's in Rome.[1] The idea that even these metallic records of the deeds of popes are subject to the all-destructive voracity of Time, and that paper will better preserve their memory, is elsewhere paraphrased in prose.[2] A cleverly elliptic visual expression of the same idea is given in Bonanni's frontispiece-engraving. It shows Fame proclaiming, by the very fact of being printed on the page (and therefore more effectively than the medals or even the building itself), that "great will be the glory of this house on the last day."[3]

Reference to the Horatian dictum is made in Bernini's engraving (FIG. 12) illustrating the medal cast in honour of Alexander VII with the scene of Androcles and the lion (CAT. NO. 28), also designed by Bernini. The engraving comprises several levels of perspective illusion that give striking relief to its very nature as paper, which not only supports but even outlasts the more physically durable metal.[4]

The associations that paper could convey made it a frequent feature in the decoration of seventeenth-century sepulchral monuments. Bernini's tomb of Urban VIII (FIG. 13, *cf.* CAT.

12

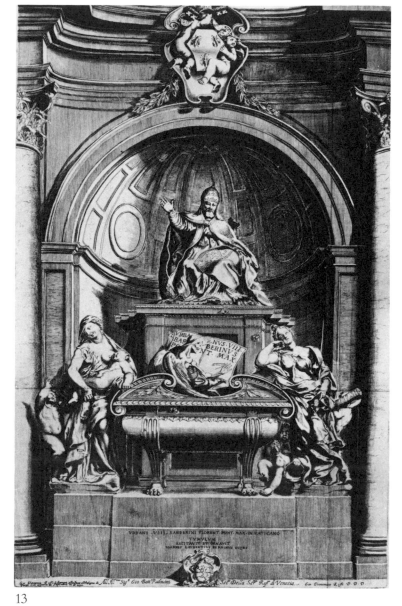

13

NO. 17) in St Peter's represents a complex fusion of conceits. The Pope's name is written in golden letters on the black pages of a book, made of so-called touchstone, proving the incorruptible purity of Urban's reputation. The fact that the pages of the book are black, where one would expect them to be white, takes the viewer beyond appearances to recognise that darkness is bright, since the death of Christ gave rise to the Resurrection.

The book and pen are held by a skeleton of dark bronze graced with gilded wings. These are no hideous bat's-wings, but rather the angelic wings of the soul with which, at the end of time, the bones of the dead will be recomposed to take flight to heaven and dwell with God for all eternity. Wings are associated with Time – that flies. Their combination with death has transformed their significance, just as elsewhere in Bernini's work the skeleton has disarmed Time of his hour-glass and scythe, thus turning weapons of destruction into instruments of harvest.[5] For whatever comes into contact with death must die and, therefore, when death comes for Time, then time will have come for death – to die, and for the dead to live.

The scenario enacted by the *dramatis personae* scripted and directed by Bernini in the tomb of Urban VIII anticipates the fulfilment of that expectation. The event is situated in a dimension of time equivalent to a continuous future-perfect, re-echoing the sequence of tenses from the passage of the gospel read at the funeral of popes and at the commemoration of All Souls:

> …the hour cometh, and now is, when the dead shall hear the voice of the Son of God: and they that hear shall live.
>
> Wonder not at this: for the hour cometh wherein all that are in the graves shall hear the voice of the Son of God.

And they that have done good things shall come forth unto the resurrection of life…[6]

Until time has ended, the virtues accompanying Urban mourn; Justice, below on his left, still awaits the bestowal of the fullness of her reward, while Charity, on his right, is bereft of her support. But in spite of her widowhood Charity can still smile valiantly to comfort her orphaned children.

It is literally by virtue of his death that the Pope's name is written in the book of life. For it was considered the crowning achievement of a lifetime's pursuit of lasting laurels, especially those of poetry.[7] Since in virtue he lived, now he lives in memory, and in glory will live.[8] His fame is better ensured by the inscription of his name on paper than by his commemoration in an effigy of bronze.

The contrast in materials between Justice and Charity in marble and the statue of the Pope in bronze achieves a conceit within a conceit, showing the papal effigy as a sculpture within the sculpture. Bernini thus set up an internal logic whereby the skeleton assumes a paradoxical significance in full accord with the tenets of faith. For if the virtues mourn, it is because the Pope is dead, and that being so, the skeleton's ultimate rôle cannot be to take life away. Thus the first impression of the deathliness of the skeleton in contrast with the vivid presence of Urban's likeness as he was in life is completely reversed. This life is made to seem no life at all compared to that bestowed by death in the world beyond, to which the virtues long to return to be reunited with their heroic champion.[9]

Urban VIII is commemorated as having benignly fulfilled with Charity and Justice the majestic office of supreme pontiff. He is adorned in the sacred vestments that symbolically expressed and materially clothed

that dignity with suitable splendour. Just as the decorative details of these vestments form an integral part of the monument, so did the monument form part of a greater whole, which is the grandeur of St Peter's. The Basilica undoubtedly represents a balanced and finely interwoven ensemble, in which every element, from the largest to the smallest, contributes to create the earthly embodiment of an ideal image of the heavenly world. That image was most completely manifested when the Mass, for which St Peter's was intended to provide a magnificent setting, was being celebrated by the pontiff. The solemn train of attendants that the event entailed involved a representative proportion of the entire city (see FIG. 14).[10]

The range of scales of the works of art that ensured the continuity of quality throughout every level of that heavenly image is displayed in telescoped form by the medal illustrating the canonization of St Francis de Sales (CAT. NO. 31). The detail of the altar frontal exemplifies how major artists gave equal attention at every level of production. Indeed, the extent of so-called "minor" works in their total output corresponds to the breadth of vision that one associates with great artists. As much originality of thought and refinement of design can equally well be displayed in so minute a work as a golden rose of Paul V (FIG. 15) and another designed by Bernini (FIG. 16); for further discussion of both of these works, see CAT. NO. 45.

A similar altar frontal appears in another medal, for which Bernini provided the drawing, representing his design for the *Cathedra Petri* (CAT. NO. 29). The altar frontal from St John Lateran with the arms of Alexander VII (CAT. NO. 45) manifests the same bold massiveness in the volutes, reflecting that quality which Bernini characterised as the "splendour of a

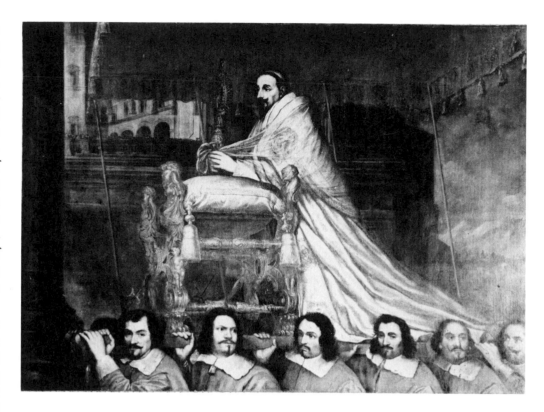

distinct, clear, and noble idea."[11] The essential simplicity of the design, conveying a sense of heightened vitality, eloquently expresses the symbolic significance of the altar that the frontal adorns.

In some instances documents support the attribution to such artists as Bernini and Borromini of responsibility for the design of certain decorative elements, for example pilaster drapes[12] (FIG. 17). These transformed the architectural quality of the churches they enhanced by animating the cool solidity of the immobile structure with a counterbalancing softness and warmth of texture and colour. Other designs by Algardi, Bernini, Borromini, Pietro da Cortona, and Romanelli, mentioned in documents or recorded by drawings, have either not survived or not yet

14
Procession of Corpus Christi with Pope Alexander VII Being Borne on a Litter
here attributed to
Giovanni Maria Morandi
Musée des Beaux-arts, Nancy
(Inv. no. 37)

15
Golden Rose of Paul V
Schatzkammer,
Kunsthistorisches Museum,
Vienna

16
Gian Lorenzo Bernini
Drawing for a Golden Rose
École des Beaux-arts, Paris
(Masson Coll. no. 36)

17
Pilaster Drapes
on designs here attributed
to Francesco Borromini,
Chiesa Nuova, Rome

been identified.[13] Similarly, attributions suggested by the stylistic qualities of vestments such as those from the Church of Sta Bibiana (CAT. NO. 40), or the altar frontals from the Lateran with the arms of Alexander VII (CAT. NO. 45) and of Cardinal Flavio Chigi,[14] have still to be supported by documentary evidence.

Where the connection between the designer and his so-called minor works cannot be established, the appreciation of artistic personality may be impaired for lack of that detailed dimension represented by such works as vestments. However, because of their specific connection with the wearer or donor (who may be distinguished in more senses than one by his armorial bearings), vestments give a vivid impression of individuals, whom they also portray, no less effectively than paintings and sculptures, externalising their sacred character by literally clothing the idea with visible form.

The papal vestments that have exceptionally survived the vicissitudes of history give a vivid impression of how far reality could approach the idealised world, which paintings, tapestries, and sculptures (cf. CAT. NOS. 1, 4, 6, 7, 12, 13, 46, 48 and 49) depicted only illusionistically, even if with the advantage of being able to show the participation of celestial beings. The effect of the vestments should be imagined in the context of sacramental action, combining solemn ritual movements with liturgical texts enunciated in equally superb musical settings. Together with the surrounding architecture, sculpture, and paintings, vestments played an integral part in the overall visual concept of sacred space, and this is reflected in their stylistic developments, which match those of the other arts, sometimes preceding them in innovation.

Another prerequisite for the service of the altar, namely the crucifix and set of six candlesticks (see CAT. NOS. 24 and 25), was no less the object of the solicitude of popes and of the attention of such artists as Algardi[15] and Bernini. Besides being furnished with other essential fittings comprising the chalice and paten, as well as the wine and water cruets (for which there is documentary evidence of Bernini's involvement on at least one occasion),[16] altars were adorned sometimes with reliquaries.

These were often made in the form of busts cast in silver from models which had been provided not infrequently by Algardi or Bernini.[17] Very few of these splendid masterpieces of silverwork have survived. Those that had not already been melted down to be refashioned (as was almost invariably the case with secular table-fountains and dishes, as well as with braziers and candlesticks) were reduced to bullion for their cash value to meet the exactions imposed by Napoleon in the Treaty of Tolentino as a ransom for the promise – promptly dishonoured – not to invade the Church States.[18]

The exceptional survival of the bust of St Bibiana (CAT. NO. 16) is extremely fortunate, not least on account of its quality of rare beauty. It possesses a fresh immediacy gained from a revived interest in early Roman Christianity, wherein seventeenth-century artists found spiritual values to match the external forms of classical art. A reconciliation of the sacred with the profane was thus brought about by the abolition of what would have been considered false distinctions between them. With its archeologising quality, the bust of St Bibiana conveys an impression of remoteness in time as well as a sense of continuity into the present. (St Bibiana, like St Cecilia at the end of the sixteenth century,

18

Alessandro Algardi
Design for a Medal with
St Agnes and the Façade of
S. Agnese in Agone
Art Gallery of Ontario,
Toronto (Inv. no. 69/36)

was literally exhumed.) Underlying this return to sources there is also an implicit apologetic, intent on demonstrating the permanence of pristine Christianity, to vindicate the contested legitimacy of the Roman Church.

Among the choir of early Roman virgin martyrs whose cult gained new impetus in the course of the seventeenth century, whether or not as the result of fortuitous findings (known as miraculous inventions) of relics, St Agnes was the recipient of particularly lavish honour. It was hoped that by the winning evocation of her exemplary purity, the continuing immodesty openly flaunted in public places such as Piazza Navona would be held in check, and that, stirred by the emotion of standing on the site of the lupanars that she had sanctified by her heroic endurance of tor-

ment, visitors would desist from their evil ways and follow her footsteps in the path of righteousness.[19]

The rebuilding of the church dedicated to St Agnes in Piazza Navona (see FIG. 18 and CAT. NO. 27) soon led to emulation between the most important contemporary artists, who began replacing one another in rapid succession. This resulted in a remarkable compendium of styles representative of the highest artistic achievements that could be attained in Rome to match the best work of antiquity. In completion of this semi-private and semi-public commission of a church-sized palace-chapel for the household of his relatives, Innocent X (see FIG. 19) exercised the munificence expected of his office by ordering a "secular" monument of profane ap-

pearance – Bernini's famous fountain (CAT. NO. 26). However, as is declared by the accompanying inscription, it was intended to provide food for thought, and indeed the form that Bernini gave to the allegorical representation of the Four Rivers embodies several layers of witty allusions, in which much emphasis is given to the providentiality of the Pope's rule.

The genuine discernment and sincere enthusiasm of the patronage of the future Alexander VII is manifested by the closely contemporary integration of the more modestly-scaled but no less universally allusive and personally prestigious family chapel begun by Raphael for Agostino Chigi in Sta Maria del Popolo (CAT. NOS. 21 and 22). As the result of the personal influence of such a refined poet as Urban VIII, or the enlightened interest in architectural matters displayed by Alexander VII,[20] artists were able to shape from the natural world an image of the ideal harmonious order that contemporary cosmology perceived also in the music of the heavenly spheres. Thus the *Baldacchino* over the high altar of St Peter's (FIG. 5) evokes the heavenly Jerusalem descended on Earth. The arms of the colonnaded Piazza (FIG. 10 and CAT. NO. 37) reach out to form a drum encircling the sky into the shape of a dome whose circumference is thus perceived as the extremities of the horizon. The universal reverberations of the blessing *Urbi et orbi* thereby become virtually audible to one's eyes.[21]

One can almost see the sound of the trumpets so vigorously blown by the Fames in Bernini's engraving-design (CAT. NO. 37). The similar doubling of Fame over the entrance to the Scala Regia (*cf.* CAT. NO. 30), which gives access from the Sacred Apostolic Palaces to St Peter's, is juxtaposed with the display of the motif of sphinxes (see FIG. 20). This seems to indicate a conscious reminiscence of the poetic associations deriving from the nature of a threshold. For the sphinx is a reminder that only the wise who can solve the riddle put to Oedipus can pass in safety. They are heartened by the trumpet-call of Fame exhorting them to courage and glory. But for the unworthy, the other face of Fame is fear and shame.

A rich sample of the imaginative associations on which artists could embroider – sometimes even literally, as with the Barberini vestments (see FIG. 21 and CAT. NO. 40), which include the *Impresa* (FIG. 22) of the bees flying towards the laurel tree – is expounded by Giovanni Ferro in his compendium *Teatro d'Imprese* published in Venice in 1623 and dedicated to Maffeo Barberini, who was to become Pope Urban VIII the following year. Many of the surprising conceits ex-

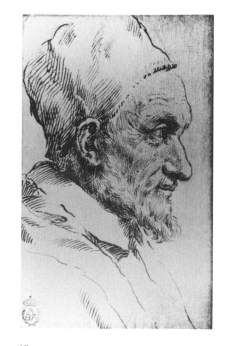

19

20

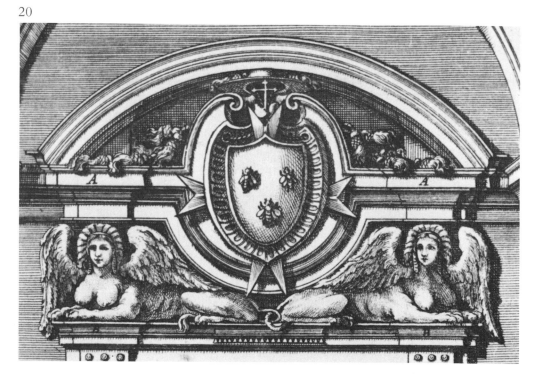

19
Alessandro Algardi
Pope Innocent X
drawing,
Academia de San Fernando,
Madrid

20
*Overdoor with Sphinxes
in the Palazzo Barberini*
engraving by Alessandro Specchi
after Bernini,
from D. De Rossi,
Studio di architettura civile,
Vol. I, Rome 1702, fol. 45
Bibliotheca Hertziana, Rome

21
*Embroidery Design with
the Barberini Bees*
from the Febei Album,
Orvieto

22
*Engraving of the Impresa
of Maffeo Barberini,*
HIC DOMUS
from Giovanni Ferro's
Teatro d'Imprese,
Venice 1623,
Vol. II, p. 72

pressed in the figurative language of art, such as those that can be read from the tomb of Urban VIII, are paralleled in Ferro's text.[22] In the crucible of the artist's fiery imagination they have been fused into a single image that possesses all the eloquence of oratory, and the compellingly persuasive "splendour of a distinct, clear, and noble idea," "ordered, clothed, and adorned with perfection of grace and tenderness."

21

22

Notes

1. F. Bonanni, *Numismata Summorum Pontificum Templi Vaticani Fabricam Indicantia. . .* Rome 1715, para. 2 (v).

2. "Medals struck from every kind of metal as tokens of the great name and illustrious memory of your predecessors, O Most Blessed Father . . . while I see that everything is dispersed by the voracity of time, or by the envy of men of perdition, or through the negligence of the ignorant, and that at the same time the illustrious deeds of the Supreme Pontiffs therein recorded vanish away. . . do I consign to these pages that on account of their greater permanence the age may be consulted, and for the eternity among Men of the glorious name of the Roman Pontiffs. . ." F. Bonanni, *Numismata Pontificum Romanorum quae a tempore Martini V. usque ad annum M. DC. XCIX. . . . in lucem prodiere*, Rome 1706, para. 2 (orig. ed. 1699).

3. *Cf.* n.1.

4. The conceit becomes even more paradoxical in a reissue of the medal produced in 1663 with a framing mount, also unmistakably a design by Bernini (*cf.* a documented frame of 1665 in M. Worsdale, "Le Bernin et la France, un 'tableau de marbre' et les compositions de gravures de dévotion," *Revue de l'Art*, Vol. 61, 1983, p. 64 and fig. 2). Inside the locket the two faces of the medal are backed by sheets of bronze imitating paper curling at the edges. The same inscription refers to them as "these pages more permanent than bronze."

5. *Cf.* the skeleton in foreshortening "feet first" rising from his recumbent position in Bernini's drawing for the projected tomb monument to Doge Giovanni Cornaro (illustrated in M. e M. Fagiolo dell'Arco, *Bernini: una introduzione al gran teatro del barocco*, Rome 1967, scheda 148, where the usual negative interpretation is applied). *Cf.* also the lost cherubs gathering the grass of the field and crowning a skull with a wreath, originally intended as part of Bernini's design for the de Silva Chapel in S. Isidoro (recorded in an engraving by Domenico de Rossi illustrated *ibid.*, p. 235). The inlaid-marble altar frontal in the same chapel is the first example of a design that was later to be frequently copied. It consists of light in the form of a cross of rays emerging from the darkness and chasing back the clouds illusionistically represented in alabaster. More explicit representations of time literally arrested, showing him in fetters, later appeared in such works as Domenico Guidi's tomb for Cardinal Lorenzo Imperiali in S. Agostino and in Filippo Parodi's tomb for Francesco Morosini in S. Nicola dei Tolentini in Venice.

6. John 5: 25, 28–29. The relationship between this passage and the conceit that informs Bernini's papal tombs, especially that of Alexander VII, is more evident from the Latin in which the future-perfect "audierint" is employed, and the term translated as "graves" in the Douai version can evoke the grander images that one would associate with "monuments."

7. Maffeo Barberini's *Poemata* went through numerous editions both before his election and until after his death. Bernini illustrated the editions of 1631 and 1638. The engravings are made to appear to curl up at the edges, again to emphasize the rôle of paper in immortalising and diffusing an image originally incised on a metal plate.

8. From the inscription on the memorial to Cardinal Francesco Alciato in Sta Maria degli Angeli which bears the date 1580: VIRTVTE VIXIT, MEMORIA VIVIT, GLORIA VIVET.

9. The rôle of the figure of the Pope as an effigy in the overall composition is confirmed by Cardinal Rapaccioli's verses cited by F. Baldinucci, *Vita del cavaliere Gio. Lorenzo Bernini*, Florence 1682, p. 17 (quoted by H. Kauffmann, *Giovanni Lorenzo Bernini, Die Figürlichen Kompositionen*, Berlin 1970, p. 130). In an unpublished funerary oration, we are exhorted by Fame herself to dry our tears, for beyond appearances Urban is more alive than ever: "Non è morto URBANO anzi ha lasciato d'esser mortale, erano improprie del suo merito queste bassezze terrene, poiche chi vive come lui nel mondo, può pretender per giustitia il passaggio ch'egli ha fatto nel Cielo" (Biblioteca Apostolica Vaticana, MS Barb. lat. 4461 "I Singulti della Fama in morte del Glorioso Pontefice Urbano VIII All'Em.mo et Rev.mo Principe Card: Franc. Barber.no del Dottr. Francesco Paolo Speranza" fol. 63).

10. Numerous chronicles describe the processions led by the Orfanelli, followed by the Putti Letterati, the confraternities, religious orders, consistorial advocates etc., in a rigorous ascending hierarchical order over which there constantly arose disputes for precedence often ending up in open battles.

11. *Cf.* P. Fréart de Chantelou, *Journal de voyage du cavalier Bernin en France*, Paris 1885, p. 47 (6 July 1665).

12. For Bernini's connection with the drapes for the pilasters of St Peter's *cf.* CAT. NO. 31. Borromini's responsibility for the drapes which are still hung at the Chiesa Nuova for the feast of St Philip Neri, indefinably evident from their formal qualities, is implicitly confirmed by the correspondence from Virgilio Spada, which also indicates that Borromini was indeed ultimately the author of the Spada Chapel at S. Girolamo della Carità. For, although the ideas were laid out by Virgilio Spada, it still required the intervention of an artist to design the details of the decoration, which is what the chapel consists of almost entirely. Borromini's drawings for the floor and for an alternative altar frontal still survive. As for the marble-inlay imitation of drapes, Virgilio Spada states that he would re-employ the pattern of those that had been made not long previously for the Chiesa Nuova. The similarity between the two is such that there can be no doubt that the drapes at the Chiesa Nuova are those referred to by Virgilio Spada. Their reuse for the Spada Chapel implies

that they were no less a part of Borromini's work under Virgilio Spada's supervision at the Oratory and therefore suitable to complement the altar frontal and the paving strewn with cut flowers designed specifically for the Spada Chapel. Like the floor, the original ceiling represented a recondite allusion to the Virgin Mary in the guise of the constellation Virgo which, even if it were not recognised, would at least still have been pleasing to the eye (*cf.* the epigraph quoted under the title of the present essay, published in full by M. Heimburger Ravalli, *Architettura, Scultura e Arti Minori nel Barocco Italiano. Ricerche nell'Archivio Spada*, Florence 1977, pp.112–113). A detail of the drapes from the Chiesa Nuova was reproduced without attribution in A. Santangelo, *Tessuti d'arte italiani dal XII al XVIII*, Milan 1958, pl. 76, cited by M. Andaloro in exh. cat. *Tesori d'Arte Sacra di Roma e del Lazio dal Medioevo all'Ottocento*, Rome 1975, no. 260, where it is erroneously stated that the drapes are now lost.

13. For documentation of embroidery designs by Bernini, Pietro da Cortona, and Romanelli, *cf.* exh. cat. *Bernini in Vaticano*, Rome 1981, nos. 241, 242. For Algardi's connection with drawings for damasks, *cf.* J. Montagu, *Alessandro Algardi*, New Haven and London 1985, I, p. 251, n. 75.

14. Described but not illustrated in exh. cat. *Tesori d'Arte Sacra. . .* Rome 1975, no. 155. The accompanying set of vestments together with the altar frontals and vestments in Siena, one of which is illustrated in E. Ricci, *Ricami*

italiani antichi e moderni, Florence 1925, pl. XLII, are all connected with Cardinal Flavio Chigi (created 1657, died 1692).

15. For Algardi's candlestick designs, *cf.* J. Montagu, *Alessandro Algardi*, New Haven and London 1985, I, pp. 189 and 190, fig. 219.

16. Information kindly provided me by dom Cipriano Cipriani, O.S.B. Olivet., former Archivist of the Reverenda Fabbrica di San Pietro.

17. For Algardi's reliquary and portrait busts of saints, *cf.* J. Montagu, *Alessandro Algardi*, New Haven and London 1985, I, p. 10; II, cat. L.46, 47; L.60; 76 L.C.2; 76 C.3; 78–89 A.C.I. For a lost bust of St Eustace attributed to Bernini, *cf.* R. Wittkower, *Gian Lorenzo Bernini, the Sculptor of the Roman Baroque*, London 1966, p. 269, cat. 81 (39). For the free-standing half-figure model of St Agnes for the relief in the crypt of the church in Piazza Navona, probably intended to serve also for an independent silver cast, *cf.* M. Worsdale, "Le Bernin et la France. . ., *Revue de l'Art*, Vol. 61, 1983, p. 65, fig. 10.

18. *Cf.* L. von Pastor, *Storia dei papi*, XVI, Rome 1934, part III, chap. xvi.

19. It would seem that no irony was intended in the remark that the figure of St Agnes inspired devotion although she was quite naked (*cf.* F. Titi, *Descrizione delle pitture, sculture e architetture esposte al pubblico in Roma*, Rome 1763, p.132).

20. Alexander VII's assertion that he was a "dilettante" of architecture from his youth (*cf.* G. Incisa della Rocchetta, "Gli appunti autobiografici di Alessandro VII nell'Archivio Chigi," *Mélanges Eugène Tisserant*, Vatican 1964, VI, p.449) is borne out by many of the rough pencil-sketches ascribed to Bernini, but which are in fact by Alexander's hand. This is unmistakably evident where there is an annotation written in the same pencil, as in the drawing showing the idea of the arms of the colonnade of Piazza S. Pietro as an anthropomorphic representation of the embrace of the church, of which the cupola is to be imagined as the head crowned with the papal tiara (*cf.* exh. cat., *Bernini in Vaticano*, Rome 1981, no. 138). The higher quality of some of the sketches drawn with the same pencil on the same page indicates that Alexander's statement in his diary that he "designed" together with Bernini is to be taken in the literal sense of drawing rather than making projects (*cf.* R. Krautheimer and R. Jones, "The Diary of Alexander VII, Notes on Art, Artists and Buildings," *Römisches Jahrbuch für Kunstgeschichte*, 15, 1975, p. 200; and no. 137, p. 206).

21. The familiarity of the idea of hearing through one's eyes is exemplified by the commentary on the frontispiece designed by Bernini for a book written by the nephew who later assisted him at his deathbed: "the infinite mercy of the Lord God has now ordained with special providence that by the hand of a devout artist should be drawn the image of the Savior Crucified. . . so

that, represented by such means to the eyes of the man of flesh, your heart should be more readily induced to hear and obey his celestial instructions. Open therefore the ear of the heart while you fix your eye on the devout image, or read these pages." (F. Marchese, "Unica speranza del peccatore che consiste nel sangue di N.S. Gièsu Cristo. . . Rome 1670, cited by I. Lavin in "Bernini's Death," *Art Bulletin*, LIV, 2, 1972, pp. 162–171, here quoted from the reprint with translation of the footnotes in G. Bauer, *Bernini in Perspective*, Englewood Cliffs, New Jersey 1976, p. 118, n. 21).

22. Among the themes discussed above to be found in Ferro is the sphinx to which he gives the motto *'agl'indovini sol sicuro è il varco'* (II, p. 634). For the double significance of the trumpet, *cf. ibid.*, p.700. For the Platonic image of the wings of the soul, *cf. ibid.*, p. 31 and p. 116 under the heading *'caterpillar, silkworm.'* For the significance of the quill-feather pen as ensuring elevation to the stars on the wings of fame, *cf. ibid.*, p. 551. The influence of Ferro on the tomb of Urban VIII and on many other works by Bernini will be further discussed in a separate context. For the greater longevity of paper, *cf. ibid.*, pp. 185 and 186, where direct reference is made to Maffeo Barberini and the immortality of his name earned by virtue, principally that of his poetry. From Ferro's exegesis of the significance of the motif of the *Impresa* (*cf.* FIG. 22 and CAT. NO. 40) with bees and a laurel it is worth quoting extensively to

show the poetic associations on which imaginative artists could draw (*cf. ibid.*, pp. 73 and 77): "The most illustrious Lord Cardinal [Maffeo] Barberini... wishing to make an impresa to show how his forbears had come from Florence to Rome... took the body, and the motto, from Vergil [*Aeneid* 7]... Therefore, having taken the words HIC DOMUS [here a home] he applied them to the Bees above the Laurel, which, because in Vergil they represent foreigners and strangers, such as were Aeneas and his Companions, wherefore we can say that this Lord took the Bees with their meaning in Vergil, representing by these, which also form the body of his coat-of-arms, his forbears who came from Florence to live in Rome, and that was at the time of Paul III... As regards the body, HIC DOMUS [applies] because the Laurel is consecrated to Apollo, nor is it ever struck by lightning, and Bees are sacred to Jove, and Varro calls them birds of the Muses. That tree [is] of science, of triumph, of poetry, of rule, of immortality, of chastity, and likewise the Bee of eloquence, poetry, continence, clemency, diligence, art, long and prosperous life, happiness, peace and union: Thus can one truly say that he has signified his choice of a dwelling-place, where his own operations are to roam, in every virtue and the things we have related, of which Bees and the Laurel are the Symbol, whereof one can say that he has possessed himself, having spread and communicated the sweetness of his Poetry in his works, collected and brought to light among the many that have been dispersed and lost, and which he who tasted their sweetness saw that they were being wronged by not being consecrated to Phoebus, and communicated to posterity: besides that intelligence which he pursues in the affairs that he manages as Prefect [of the Segnatura di Giustizia] in which one can see the diligence of the Bee; in his actions and manners candour and purity, which things promise him the immortality of his name, union of hearts, rule over minds, happiness and prosperity in his actions."

GYDE VANIER SHEPHERD

The Art of Revelation:

The Baroque Tradition in Quebec, 1664–1839

A work of art is a bid for uniqueness,
it stands as a whole, an absolute,
and yet it is part of a system of
intricate relationships…
It becomes immersed in the flow
of time, it belongs to eternity.

Henri Focillon,
Vie des Formes, 1943 ed. [transl.]

23
Reliquary of
Father Jean de Brébeuf,
1664–65
The Musée des
Augustines de l'Hôtel-Dieu
in Quebec City has
graciously consented to
the loan of this silver
masterpiece as a complement
to *Vatican Splendour*
(Inv. no. A-100)

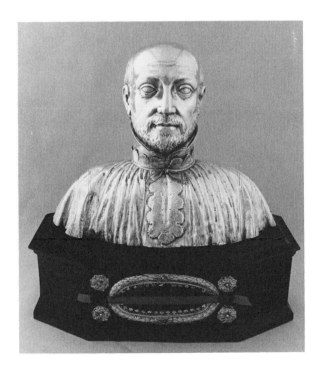

The patronage of Catholic religious orders, infused with the spirit of Christian mission, permeated the colonization of New France and laid the foundations of Canadian art. The Jesuits were in New France as early as 1611, Champlain brought the Recollets to Quebec in 1615, and the Sulpicians were established in Montreal in 1657. Marie de l'Incarnation arrived in Quebec with the Ursulines in 1639. In addition to propagating the faith, these orders established convents, schools, and hospitals, and indelibly formed Catholic taste for Italian and French, Renaissance and Baroque art. Strains of classic grandeur and idealized sentiment endured in the religious art of Laval's New France until the golden age of Quebec painting in the nineteenth century. An early example is the posthumous portrait in silver commissioned by the family of Father Jean de Brébeuf, of the Jesuit who was martyred in Huronia in 1649. Made in Paris by an unknown French artist in 1664–65 and presented to the Jesuits in Quebec, the *Brébeuf Reliquary* (FIG. 23) is set on a coffin-shaped based containing fragments of the missionary's skull and bones. It is moving in its simple pathos and reminiscent of Greek and Roman, and French Renaissance portraiture. Probably related to the Huret engraving published in François du Creux's *Historiae Canadensis seu Novae Franciae* in 1664, this splendid silver head is an ideal, almost Constantinian, emblem of heroism.

The mask-like character of the Brébeuf bust is in high contrast to the brilliant naturalism of Bernini's marble portraits. It is nevertheless a coincidence of history that a superb bronze version of the Italian sculptor's marble *Bust of Louis XIV*, attributed to Jérome Derbais, was placed in Quebec's Place Royale on 6 November 1686. The *Effigie du Roy* indicated on the cartographer Jean-Baptiste-Louis Franquelin's view of Quebec City of 1688 is probably this bust. It was removed from Place Royale about 1700 and replaced only in

1948 with another copy presented by the French Government. Bernini sculpted the marble original, which is now at Versailles, during his visit to France in 1665. Its vision of the French Sun King, which looked to Louis XIV's contemporaries like both Jupiter and Alexander the Great, would have made as powerful an impression in old Quebec as Brébeuf's noble effigy.

The Recollet Claude François took the religious name of Frère Luc (Saint Luke the Evangelist and patron saint of painters, legend has it, did portraits of Mary and Jesus) and in fifteen months in Quebec fashioned a permanent legacy of ecclesiastical art. The most important painting known in early Canada was long attributed to this "Painter to the King," who came in 1670 to help re-establish the Recollet Order in Quebec and to reconstruct its buildings. *France Bringing the Faith to the Hurons of New France* (FIG. 24) is now associated with the Jesuit Huron mission which, with Brébeuf and others, began in 1626. In an age coloured by the teachings of Galileo, a vaporous sky opens to a sun-burning heaven, where the Holy Trinity sits enthroned holding the Globe, accompanied by the Holy Family. Anne of Austria, mother of Louis XIV and Regent from 1643 to 1660, personifies a crowned France in a royal robe before whom the Indian kneels, already cloaked in her power. At the centre of the painting a deep perspective of the St Lawrence River leads to a distance (France?) where heaven and earth join. The key to this union is the tableau of revelation held in the right hand of France, whose left hand points to the Beatific Vision. France's vessel is at anchor behind her. The head of the Huron Indian and the two simple chapels behind him are, like the *Brébeuf Reliquary*, inspired by the engraving of the martyrdom of Brébeuf and Lalemant by Grégoire

24

Huret. This monumental work of devotional art is a memorial of Christian evangelization guaranteed by the State. France stands in a classic pose not unlike Simon Guillain's bronze figure of Anne of Austria, dated 1647, now in the Louvre.

Frère Luc arrived in Quebec in the time of Monseigneur François-Xavier de Montmorency-Laval, the Pope's Vicar Apostolic of

24
France Bringing the Faith to the Hurons of New France,
about 1670
Monastère des Ursulines,
Quebec

25
Claude François, called Frère Luc
The Assumption of the Virgin, 1671
with altarpiece and tabernacle in

25

26

New France (1659–74), who became the first
Bishop of Quebec (1674–85). Laval's sympa-
thies were with the Jesuits, oriented to Rome,
in the wake of the Council of Trent and the
Counter-Reformation of the sixteenth cen-
tury. Frère Luc himself studied with Poussin
and other French artists in Rome after work-
ing with Vouet in Paris. His paintings of the
Assumption (FIG. 25), the *Holy Family with a*
Huron Girl (FIG. 26), and the *Virgin and Child*
(about 1676) come from the eye of an artist
who has absorbed the form and colour of six-
teenth- and seventeenth-century Italian art.
Direct observation of Renaissance and early
Baroque art from Raphael, Fra Bartolom-
meo, and Michelangelo to Annibale Carracci,
Reni, and Bernini, in the light of a resurrected
world of antiquity, gave Frère Luc every pos-

sible motif of Christian iconography and classical form. He might even have known Rubens' paintings of the Marie de' Medici series, executed in Paris in the 1620s.

His *Assumption* (FIG. 25), painted against a background evocative of the St Lawrence and the Quebec Rock, is a dramatic apparition arrested in mid-flight for the veneration of the faithful, a reminder of Christ's Transfiguration and Resurrection; it was commissioned by the Intendant Jean Talon and bears his arms. It is a typical Baroque devotional picture, intended to be exalting and appealing in its piety, set high above the altar of the Catholic Mass, into a formal and decorated architecture. The later addition of an altarpiece with tabernacle by Noël Levasseur in 1722, said to be after Louis LeVau's design of about 1660 for the Collège des Quatre-Nations in Paris (now the Institut de France), completes the Italianate ensemble. This design could have been known to the Quebec sculptor from an engraving by the French artist Pérelle. The Collège was unique in Paris for its Roman Baroque grandeur, inspired by Borromini in the wake of Michelangelo's great St Peter's.

The *Holy Family with a Huron Girl* (FIG. 26), also shown before a distant view of Quebec, is a more intimate 'holy picture' for private contemplation, the Huron Girl gently welcomed by Joseph and blessed by the Christ Child, taking the place usually reserved in European art for John the Baptist. It may have been the painting that at Laval's request was placed on a church tower to entreat divine intervention against Phips' attack on Quebec in 1690 (miraculously, the attack failed). Under Laval and the Jesuits the devotion to the Holy Family became a *leitmotif* of Quebec's seventeenth-century religious art. Frère Luc's large *Virgin and Child* at Sainte-Anne de Beau-

pré, an unusual subject of the presentation of the new-born Child to the Father who is symbolized by heavenly light, must have been intended to appeal directly in its naturalism to the Indian convert.

The focal point of the Baroque Catholic and "Roman" Church interior was clearly and dramatically the altar, with a painted or sculpted vision of heaven and a canopy or *baldacchino* above it. At the heart of Catholic ritual is the celebration of the Holy Mass and of the Sacraments. The epicentre of the Mass or Eucharist is the re-enactment of the Last Supper on the altar-table, the transubstantiation of bread and wine into the Body and Blood of the crucified and risen Christ. The central instruments of the Mass are the container of the consecrated wine – the chalice – and the shallow dish for the Host – the paten. The silver-gilt "Laval" chalice and paten of about 1673 were probably given to the first Bishop of Quebec by Louis XIV in 1674. Decorated with scenes of the Marriage of the Virgin, the Annunciation, the Visitation, the Nativity, the Presentation, the Adoration of the Magi, and Pentecost, and with the figures and symbols of the Theological Virtues and the Four Evangelists, these sacred vessels by Nicolas Dolin (today in the Séminaire de Québec) are fine and rare examples of French seventeenth-century art in Canada.

One of the principal vestments worn by the celebrant or priest at the Mass is the chasuble. A richly embroidered French example of the period (FIG. 27), which belonged to the Jesuits in Quebec, bears the monogram 'IHS' (the first three letters of the name of Jesus in Greek, which the Jesuits adopted) on the front and the symbol of the Lamb (Christ) on the Cross, with the seven seals of the Apocalypse, on the back. At the moment of consecration of the bread and wine at the altar,

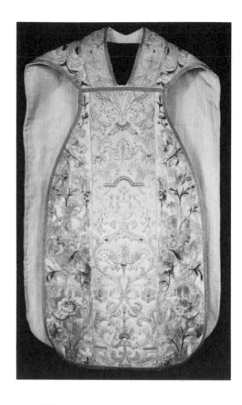

27
Chasuble, 17th century
silk embroidery with
gold- and silver-thread
Musée des Augustines de
l'Hôtel-Dieu, Quebec

28
Baldacchino, about 1695
painted and gilded wood, with
altar by François Baillairgé
L'Eglise de Neuville
(Portneuf), Quebec

44

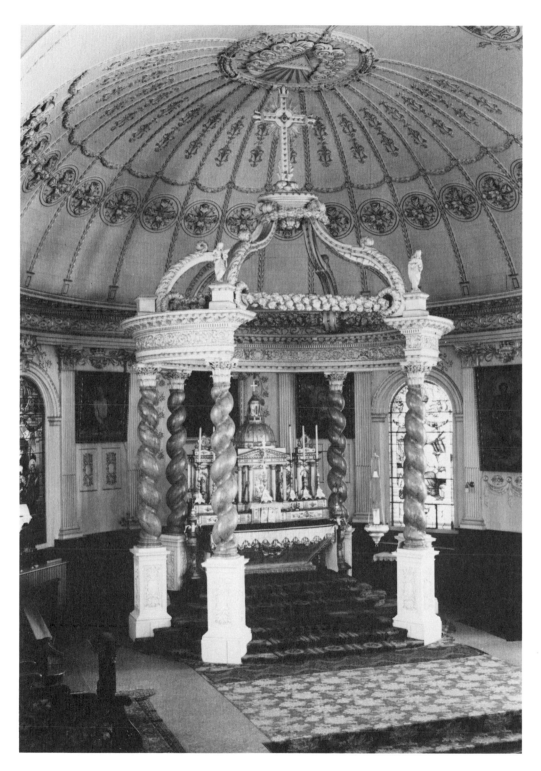

with the glowing tabernacle and crucifix in the centre and the flickering light of the altar candles on either side, the embroidered gold and silver threads would have been meant to shine with a divine radiance. This chasuble serves as a touchstone for the tradition of brilliant embroidery established by the Ursulines in Quebec. An altar frontal from the Church of Notre-Dame in Montreal attributed to Jeanne Le Ber (whose brother Pierre Le Ber painted the portrait of Marguerite Bourgeoys, founder of the teaching order of Notre-Dame), who would have learned embroidery with the Quebec Ursulines in the 1670s, is one of the few masterpieces of this art to survive. As a decoration for the front of the altar – as a kind of regal tablecloth – the glitter it would have added to the spectacle of the Mass can be imagined.

Acting as a revelation of and gateway to Paradise, the architecture and decoration of the Baroque altar and altar-canopy was a reflection of the spectacular architecture of the church as a whole and particularly of its façade. This tradition was transplanted to seventeenth-century Quebec in wooden imitations, although much has been lost in war and fire, altered by restoration, or moved at times of later redecoration. The origin, significance and date (about 1695) of the *Baldacchino* now at Neuville (FIG. 28) have recently been discovered and published by the Quebec scholar John R. Porter. It was commissioned by Monseigneur Jean-Baptiste de La Croix de Chevrières de Saint-Vallier for the chapel of the original Bishop's Palace in Quebec. De Saint-Vallier was the second Bishop of Quebec (1688–1727), whose appointment by Louis XIV was confirmed by Pope Innocent XI. The design of the remarkable woodwork was at the time known to derive from the *Baldacchino* of the Church of Val-de-

Grâce in Paris (1645–67), which was in turn inspired by one of the marvels of the Baroque age: Bernini's majestic bronze *Baldacchino* (1624–33; see FIG. 5) in St Peter's. During his trip to Paris at Louis XIV's invitation in 1665, Bernini was asked to design an altar canopy for Val-de-Grâce at the behest of Anne of Austria. Although his scheme was not carried out, Gabriel Le Duc's design was certainly based on Bernini's masterwork in Rome.

Already in the years 1670–95 other French artists and craftsmen had followed Frère Luc to plant the seeds of church decoration and wood-carving in the Quebec of Laval and Talon. At the outset the Séminaire de Québec, founded by Laval in 1663, employed some of the first French artisans in New France, who taught their craft to both seminarians and laymen through a form of apprenticeship. One of the most prominent of these was a priest, Jacques LeBlond de Latour from Bordeaux. An exquisite gilded wood *Angel with Trumpet* of the 1690s from St-Romuald d'Etchemin, highlighted and sensitively described by John Porter in the exhibition and catalogue *Le Grand Héritage*, is an early example of this production. Made to crown a pulpit canopy, this "angel of the Good News" is rooted in the antique both in the pose and in the daring execution of the drapery. (Could the sculptor have seen Bernini's Louis XIV bust in Quebec's Place Royale?) The pulpit itself was originally commissioned for the Church of Quebec's Hôpital-Général. The analogue of wood-carving in Quebec silver was initially inspired by the French Baroque and its Italian sources, although later production was much simpler and more restrained. The Parisian Guillaume Loir's *Virgin and Child* of 1731–32, now with the Sulpician Fathers at Oka, is more sophisticated and brilliantly fashioned than the

"Laval" chalice and paten. The beautiful "Queen of Heaven" with her royal Child is associated with the Sulpician mission at Oka of the 1740s and was carried in procession on the Feast of the Assumption. The Baroque ideal of sublime nature in a classical guise thus continued to serve the ritual and influence the style of religious art in Quebec well into the eighteenth century.

Pierre-Noël Levasseur was one of the most prominent Quebec-born sculptors of this inheritance. His gilded wood statues of SS. Peter and Paul of 1742 now at Charlesbourg, near Quebec City, are the Canadian successors of Loir's *Virgin and Child*. His masterpiece, the *Altar Wall of the Ursuline Chapel* (FIG. 29) in Quebec City, is unique in Quebec for having survived time and fire al-

29
Pierre-Noël Levasseur
Altar Wall of the Ursuline Chapel,
1726–36
painted and gilded wood
La Chapelle des Ursulines, Quebec

most entirely in its original form and context. Carved between 1726 and 1736, the grand and elaborate structure in painted and gilded wood is in the classical form of a triumphal arch, derived from engravings of French Baroque adaptations of Italian church façades. It is both an entrance to Paradise and a tableau of revelation. St Joseph and the Christ Child between two angels in the upper zone, together with St Augustine (left) and St Ursula (right) in the middle zone, on either side of a French seventeenth-century painting of the Nativity, are placed in an architecture of fluted columns topped with Corinthian capitals, and a classic entablature. Decorative panels in the lower zone include reliefs of Saints Peter and Paul and the Four Evangelists. The threshold of this gateway to heaven is the altar of the Eucharist, with its elaborate tabernacle and altar-front, where embroidered frontals would have been hung on special feasts. Inspired by European models in marble, stone, and bronze, the painted and gilded wood altar walls of Quebec were extraordinary fabrications.

The Quebec art historians François-Marc Gagnon, Laurier Lacroix, and others have shown how extensively engravings of European art were circulated in New France from as early as the 1630s, first as instruments of religious conversion, later as models for the copyist. The French Royal Academy of Painting and Sculpture, modelled on Italian precedents, was founded in 1648 in Paris. It was followed, in 1666, by the establishment in Rome of the French Academy, dedicated to the same purposes of the study of antiquity and the copying of ancient sculpture. It was at this time, in the 1670s, that Frère Luc and his French and Canadian successors laid down the roots of Quebec's religious art. The arrival in Quebec in the early nineteenth century of the Abbé Philippe Jean-Louis Desjardins' collection of paintings, rescued from the iconoclasm of the French Revolution, re-infused religious art in Quebec once again with the Baroque spirit of the French Academy. The Abbé Desjardins, who had been in Quebec from 1793 to 1803, sent from France in 1816–20 some 200 religious paintings, including works by Simon Vouet and Claude-Guy Hallé. In 1817 the collection began to be exhibited, auctioned, and subsequently could be found in the churches and institutions of Quebec (later some were acquired by the artist Joseph Légaré). The Vouet *St Francis of Paola Reviving His Sister's Child*, painted before 1655, was bought in the early 1820s by the Fabrique of Saint-Henri de Levis, where it remains. Joseph Légaré probably copied it about 1821 while it was still exhibited in Quebec at the Hôtel-Dieu. Faithful to the seventeenth-century French original, which depicts in a marvellous *tableau vivant* a miracle set against an altar reminiscent of Bernini's *Baldacchino* in St Peter's, Légaré, in the version at the National Gallery, acknowledged his dependence on Baroque pathos in the painting of devotional art. About 1828, Légaré went on to revive Domenichino's *Last Communion of St Jerome* (CAT. NO. 4) by painting a version of this great seventeenth-century composition from an earlier copy at the Ursulines. Jean-Baptiste Roy-Audy's copy of *The Baptism of Christ* by Hallé, also from the Desjardins collection, was executed in 1824 and is in the Musée du Quebec. Roy-Audy was one of many artists to make Hallé's work one of the most revered Baroque compositions of nineteenth-century ecclesiastical art in Quebec.

Antoine Plamondon was commissioned by the Sulpicians in 1836 to paint a monumental series of paintings of the Stations of the Cross for the Church of Notre-Dame in

Montreal. In 1839, for his *Deposition from the Cross* (FIG. 30), he used as a model and extensively copied a painting by the French artist Jean Jouvenet of the same subject, from about 1708. He may have seen Jouvenet's original work in France before returning to Canada in 1830 from a period of study in Paris. More certainly he would have known Jouvenet's painting from a copy commissioned by the Sulpicians with six other Stations of the Cross, for the oratories and chapels of the Way of Calvary at Oka, Quebec, and installed there about 1742. They are now to be found in the Church of the Annunciation in Oka. Plamondon also possessed a copy of Poussin's *Martyrdom of St Erasmus* (CAT. NO. 7) as Jean

Trudel has discovered. Its composition too would have influenced his rendering of Christ's Supreme Sacrifice. Although Plamondon's *Stations* were sadly never placed in Montreal's Notre-Dame, several have survived and are today in the collection of the Montreal Museum of Fine Arts. His *Deposition from the Cross* is animated by the dramatic ritual of the French and Italian Baroque influenced by the Neoclassicism of David. Plamondon rediscovered the expressive mime in Quebec's ecclesiastical art reaching back almost 170 years. He reverently charged his fine *pietà* with exalted religious emotion, movingly depicting the intervention of – and faith in – the divine on earth.

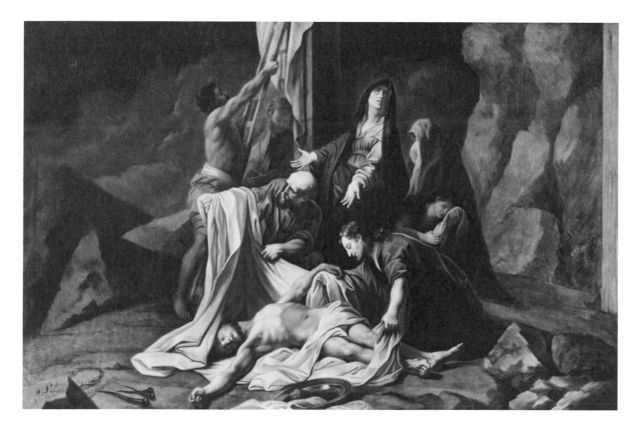

30
Antoine Plamondon
The Deposition from the Cross, 1839
after Jean Jouvenet,
oil on canvas
The Montreal Museum of Fine Arts
(Inv. no. 961.1326)

Illustrations and Catalogue

Ludovico Carracci (BOLOGNA 1555–1619 BOLOGNA)

The Trinity with the Dead Christ and Angels with Instruments of the Passion

Oil on canvas, 172.5 × 126.5 cm
Pinacoteca Vaticana
(Inv. no. 1249)

The origin of this work is unknown and it is not listed in either Malvasia's life of the artist (1678) or his guide to the pictures in Bologna (1686). Its entry into the papal collections at the end of the 17th century occurred when Cardinal Flavio Chigi (d.1693) bequeathed it to Pope Innocent XII (see Prof. Carlo Pietrangeli, "La Pinacoteca di Pio VI," *Bollettino Monumenti Musei e Gallerie Ponteficio*, III, 1982, p. 147, no. 7, where he quotes the late Marchese Giovanni Incisa della Rochetta's indication of this picture cited as Ludovico in an inventory dated 1698). It was included in the Carracci exhibition of 1956 (no. 17); the attribution having meanwhile been lost, it was recognized as the work of Ludovico Carracci by Roberto Longhi, explaining its not being included in Heinrich Bodmer's monograph of 1939. Where Cardinal Flavio acquired this painting by Ludovico is not known. Possibly it was an inherited family possession, for its tenebroso style would have appealed to the Sienese spirit that nurtured Vanni and Salimbeni (it is listed only as Carracci on p. 60 of an inventory dated 1666–69 made of the pictures in Cardinal Flavio's palace at SS. Apostoli; Chigi Archives, no. 702, Biblioteca Apostolica Vaticana).

The Carracci cousins had formed an academy of painting in their native Bologna in 1584, at which some of the foremost painters of the first two decades of the 17th century were trained. When Annibale was called to Rome in the service of Cardinal Farnese (see CAT. NO. 2) and Agostino to Parma to paint frescoes in the palace of Duke Ranuccio Farnese, Ludovico remained in Bologna to school a new generation of painters. Their work is visible to an extent, though much damaged, in the cloister decorations of the monastery of S. Michele in Bosco, which they executed under Ludovico's direction in 1604. Clearly not of the same vitality as the frescoes the three had painted in Bologna in the 1580s and early 1590s, nevertheless Ludovico's later style combines linear grace with contrasting light effects. Charles Dempsey has commented, "The naturalness of Ludovico's art is profoundly rhetorical…unlike Annibale, he shunned the model of ancient art, being less concerned with a metaphysical ideal of natural perfection than with expressing a mystic experience of devotional intensity" (in *The Age of Caravaggio*,

Metropolitan Museum of Art, New York 1985, p.120).

Stylistically the painting of the Trinity belongs to the early 1590s when Ludovico also produced the famous Cappuccini altarpiece for Cento and the *Vision of St Francis* (Rijksmuseum). As in these works, the light illuminates the figures which are essentially in the dark, imparting them with an extraordinary intensity. Here Ludovico takes licence with the traditional way of representing the Trinity. Instead of the hierarchical arrangement of God the Father beneath the Holy Ghost, his arms outstretched behind the dead Christ still on the Cross (such as we find in Dürer or in the magnificent altarpiece by Ludovico's own pupil Guido Reni, painted for the Roman church SS. Trinità dei Pellegrini in 1625), Ludovico combines the Trinity with a scene of the Pietà. Here Christ's body rests in the lap, not of the Virgin, but of God the Father who wears an enormous cope or mantle (see, for instance, CAT. NO. 42). Attendants angels bear the instruments of the Passion; their figures are truncated and crowded into the composition, and the whole scene is viewed in perspective.

The question arises whether – like Giovanni Bellini's *Pietà* or *Burial of Christ* (Pinacoteca Vaticana, Inv. no. 290) or El Greco's very similar representation of the *Trinity* (1577–79, Madrid, Prado) – the work served as a *cyma* or upper portion of a large altarpiece, or whether it was meant as an overdoor in a sacristy. The painting is a very powerful image and was possibly intended for private devotion. Whether in his representation of God the Father, Ludovico meant to portray a particular pope – perhaps Gregory XIII (d. 1585), who was Bolognese – can only be guessed at until more is known about the commission.

C.J.

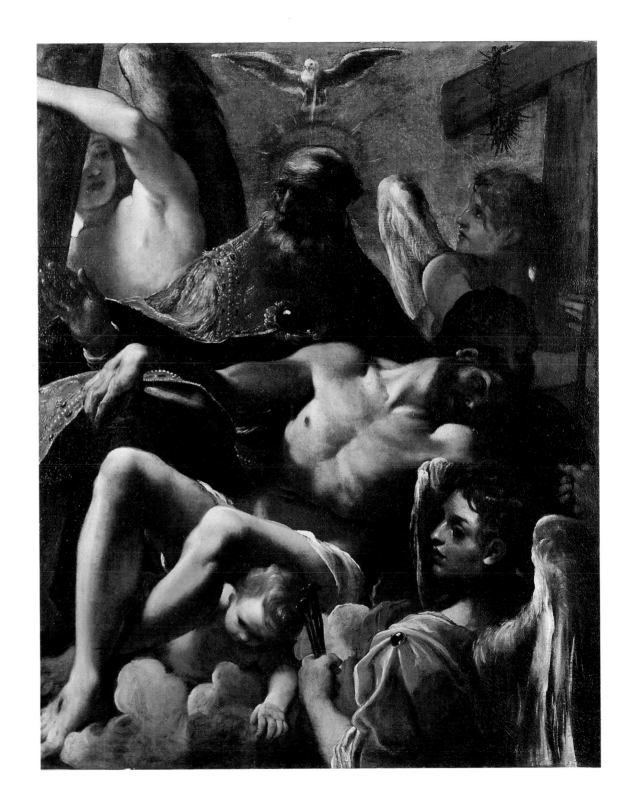

Annibale Carracci (BOLOGNA 1560–1609 ROME)

The Vision of St Francis

Oil on copper, 46.8 × 37.2 cm
National Gallery of Canada,
Ottawa (Acc. no. 18905)

Annibale was the most brilliant member of the Carracci family whose art academy in Bologna was established with the intention of revitalizing a decadent artistic spirit through a return to nature, involving the constant practice of drawing after life and a reassertion of the principles of Renaissance art. Their work was the visual expression of the optimistic spirit current in Bologna, arising out of Cardinal Paleotti's *Discorso intorno alle immagini sacre e profane* (1582), wherein he reflects on the recommendations made at the Council of Trent for using art as a means to stir and edify faith. Annibale's style developed rapidly with youthful trips to Parma and Venice before his definitive departure for Rome, where an ascendant classicism already apparent in his work was confirmed through the study of the Antique and High Renaissance art. He had been called to Rome by Cardinal Odoardo Farnese to paint frescoes in his palace built during the pontificate of Paul III. For the next decade Annibale concentrated his energies on the working out of a very complex decoration on the ceiling and walls of the Farnese Gallery, ostensibly mythological but with obvious moral overtones, producing a work of supreme classicism and monumentality which was a landmark in 17th-century painting. In this he was assisted by a number of Emilian pupils who followed him to Rome – Albani, Domenichino, and Lanfranco most notable among them – who themselves were to play an important rôle in Roman painting during the reign of Paul V.

This small copper panel, which provides such a contrast in scale to other works in the exhibition, also dates from Annibale's years in Rome and was clearly meant as a private devotional image. It was first noted in Bellori's biography of the artist (1642) to have been in the collection of a Monsignor Lorenzo Salviati. Annibale had painted for Cardinal Antonio Maria Salviati (d.1602) an altarpiece for the church of S. Gregorio Magno. It is possible Monsignor Salviati could have received this little panel through inheritance, although it does not occur in the inventories of the Cardinal's possessions drawn up in 1612 and 1634, by which time some works might have been dispersed. The scene represented is essentially the Post-Tridentine theme of the vision of St Francis where the Saint receives the Christ Child in his arms, such as we find represented in Pietro da Cortona's later painting of the subject (CAT. NO. 11; see E. Mâle, *L'art religieux du XVIIᵉ siècle,* Paris 1951, p. 174). Annibale's interpretation is a personal one and shows the Saint swooning at the image he sees before him, as if he feels unworthy to take the Child.

It is apparent that the copper strips added to the sides of the panel by the artist reflect a change in his intentions. Originally he had painted a building in the background at the right (pentimenti for which can be seen toward the left of the right-hand arch), but for some reason he saw fit to insert the more imposing architectural features which necessitated extending the width of the panel. Denys Sutton has drawn attention to the fact that the classical arches and architrave are reminiscent of those designed by San Gallo in the courtyard of the Farnese Palace. While painting the Gallery, Annibale, in fact, lived in the palace, though relations grew strained and his spirit was broken by the meagre sum with which the young Cardinal Odoardo Farnese rewarded his tremendous endeavour. One cannot help wondering if the architectural features were imposed on the artist or whether he inserted them by choice, perhaps feeling the classical figure of the Virgin required a more monumental background. The exquisite candour with which the figures are painted has led Donald Posner to suggest a date after 1597, when a reappearance of Correggesque intimacy and painterly style occurred in Annibale's work (see his monograph *Annibale Carracci,* II, no. 91, 1971, for further provenance and relevant bibliography).

C.J.

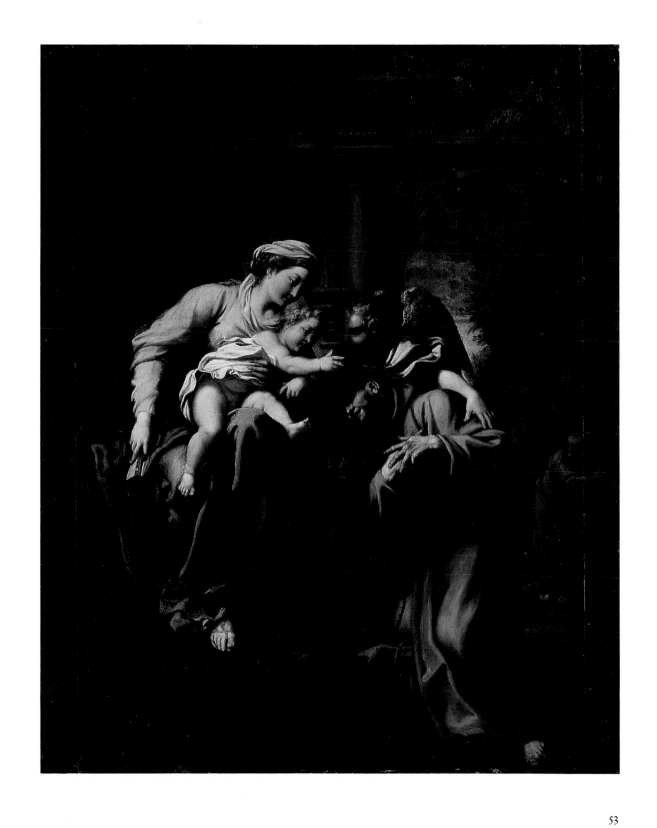

Peter Paul Rubens (SIEGEN 1577–1640 ANTWERP)

The Entombment

After Caravaggio
Oil on oak panel, 88.3 × 66.5 cm
National Gallery of Canada,
Ottawa (Acc. no. 6431)

The appearance of a Fleming among the predominantly Italian artists represented in this exhibition should not be surprising given the very active rôle northern artists played in Rome throughout the century. Although Rubens did not remain in Italy (he arrived there in 1600 in the service of Vincenzo Gonzaga, Duke of Mantua, and returned to Antwerp in 1608), he spent several years of study in Mantua, Genoa, and Rome, not only copying after the Italian masters but producing works of his own as well. In Rome he painted for the Chiesa Nuova a canvas for the main altar incorporating an image of the Virgin and Child, together with various saints – Gregory the Great being the principal one. Because of disturbing reflections on the surface of this picture when placed above the altar, Rubens withdrew it (he took it back to Antwerp with him; it is today in the museum in Grenoble), and substituted three separate panels painted on slate to alleviate the problem with the first work. These were executed 1606–08.

During his work on these paintings for the high altar, Rubens came into intimate contact with Caravaggio's picture of the *Entombment*, or *Deposition* as it is also known, painted three or four years earlier for the Vittrici Chapel in the same church (now Pinacoteca Vaticana, Inv. no. 386; see Dr Fabrizio Mancinelli, *The Vatican Collections*, Metropolitan Museum of Art, New York 1983, no. 85; and Sheldon Grossman, *The Deposition*, National Gallery of Art, Washington 1984). Rubens was undoubtedly impressed by this painting, as it is one of the most compelling Baroque religious pictures, and he made this copy after it with minor variations. For stylistic reasons the copy is thought to date from after Rubens' return to Antwerp, so it must have been based on drawings made on the spot. Caravaggio's composition of the *Entombment* shows six figures crowded into the foreground plane almost entirely filling the dimensions of the canvas and seemingly projecting forward from it. It is a dramatic picture, full of pathos, all the more so because of the use of unidealized types, such as one might find in the streets of contemporary Rome.

The directness and conviction expressed in Caravaggio's religious works can, in part, be explained by the teachings of St Philip Neri (d.1595), whose foundation of the Oratory was based on the need, as he saw it, to make more direct contact with the faithful through preaching. In 1575 Pope Gregory XIII granted him the Church of Sta Maria in Vallicella. Here a new and larger church, the Chiesa Nuova, was constructed and subsequently, on the adjacent property, the Oratory meant for preaching and musical performances as well as to house the fathers and library. Paintings of the *Visitation* and *Nativity* produced by Barocci for the Chiesa Nuova were particularly prized by St Philip Neri, and it is clear that Rubens was influenced by their sense of colour.

It is not known what immediate purpose Rubens' copy served; it is, however, interesting to note the modifications he made in Caravaggio's design. Rubens' figure of Christ is less idealized, the eyes realistically sunken in death, as too, the mouth which is distinctly open; whereas Nicodemus, no longer the Roman citizen who had deliberately engaged the eye of the viewer, is now a more anonymous figure, with red beard, looking into space. The dramatic gestures of the arms of the Virgin and Mary Cleophas have been subdued, the two having been regrouped at the left of the composition. John's foot has been placed lower down on a step at the left of the composition and the shadowy figure of Joseph of Arimathea has been introduced at the right. Finally there is a greater feeling of space, with the indication of an arch behind. These changes move in the direction of Rubens' drawing of the *Entombment* in the Rijksmuseum, Amsterdam (c.1615, see J. Held, *Rubens: Selected Drawings*, II, London 1958, pl. 35). He was to paint the subject again in a more elaborate form as seen in the altarpiece of the Church of St-Géry at Cambrai (Held, *op. cit.*, I, fig. 34). This free copy on panel is documented from 1710 in the collection of the Princes of Liechtenstein until it was acquired by the National Gallery in 1956.

C.J.

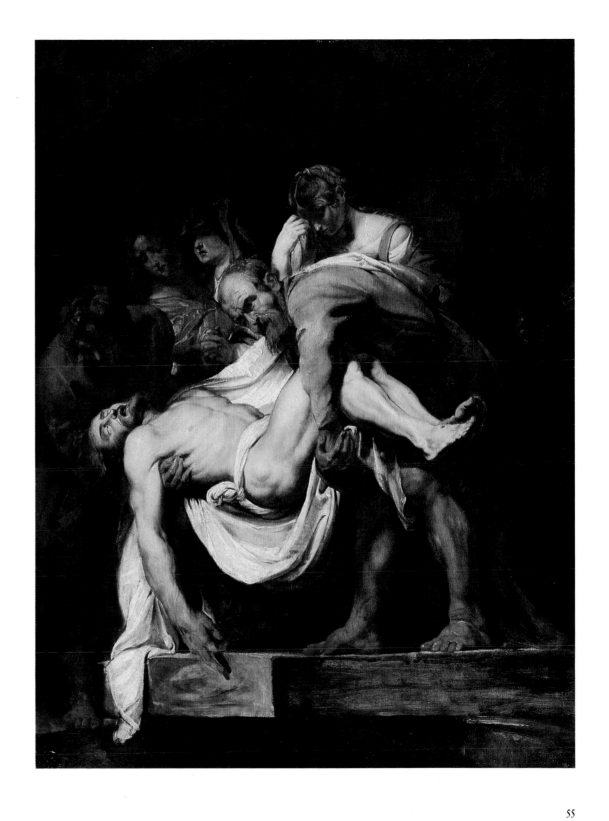

Domenico Zampieri, called il Domenichino (BOLOGNA 1581–1641 NAPLES)

The Last Communion of St Jerome 1614

Oil on canvas, 419 × 256 cm
Insc. l.l. *DOM ZAMPERIVS BONON / FA. MDCXIV*
Pinacoteca Vaticana (Inv. no. 384)

We know from a contemporary account that Cardinal Pietro Aldobrandini returned to Rome from his villa at Frascati for the unveiling of Domenichino's painting on the high altar of S. Girolamo della Carità on the Saint's feast day, 30 September 1614. As Cardinal-Protector of the Compagnia di S. Girolamo, Aldobrandini may even have been responsible for this commission being awarded to Domenichino, who, though he had just completed frescoes in churches in Rome and nearby Grottaferrata, had yet to paint an altarpiece. An advance payment for the painting dated 10 August 1612 has just been published, but a second installment was not paid before April 1614, suggesting the bulk of the work to have been done between then and the summer of 1614 when a frame was ordered (see Elizabeth Cropper, "New Documents concerning Domenichino's 'Last Communion of St. Jerome'," *The Burlington Magazine*, CXXVI, March 1984, pp. 149–151). These documents reveal that the artist was justifiably paid a substantial 240 *scudi* for his efforts (contrary to his Roman biographers, Passeri and Bellori, who report that he was paid a paltry sum), for not only is the altarpiece of rather exceptional size, but with *The Last Communion of St Jerome* Domenichino conceived one of the true masterpieces of Baroque painting (see Richard Spear, *Domenichino*, New Haven and London 1982, no. 41, for a summation of its history).

Jerome, who lived from c.345 to c.420, was responsible for the *Vulgate*, a translation of the Scriptures from Greek and Hebrew into Latin, making them more accessible to the Christian world. For this reason he was designated one of the Fathers of the Western Church. The subject of Domenichino's altarpiece was not usual, portrayals of the Saint in his study or in the wilderness accompanied by his faithful lion being much more common. However, Domenichino's former teacher Agostino Carracci had represented the scene of the Saint's last communion some two decades earlier for S. Girolamo della Certosa in Bologna. When Domenichino visited Bologna in the spring of 1612, he would have renewed acquaintance with Agostino's picture, and Spear reports he owned some of Agostino's drawings for it. Domenichino borrowed from it the general grouping of the foreground figures and the description of

an interior space articulated with features from classical architecture and a centrally-placed arch through which a landscape can be seen. He worked over the composition, reversing and reducing the number of figures below while increasing that of the small angels flying above, at the same time raising the height of the arch so that a much more substantial view of landscape occurs. By way of copious and surprisingly vigorous drawings (some forty of these survive mostly at Windsor Castle, where they were catalogued by Sir John Pope-Hennessy in 1948) the artist reworked and modified his composition to produce a painting of extraordinary intensity achieved through a careful weighing and balancing of physical features and colour. Richard Spear has pointed out that Domenichino did not portray (as had Agostino), Jerome's disciples as members of the Hieronymite order founded only in the 15th century, nor did he strictly follow the account by the Pseudo Eusebius of the Saint's last hours, but rather he sought a more historically accurate telling of the scene, including a turbanned figure and the kneeling subdeacon in Greek liturgical vestments as a suggestion of Bethlehem, where Jerome died.

This reassessment and enhancement of Agostino's composition was clearly overlooked by Giovanni Lanfranco when he commissioned François Perrier to engrave a copy of the Bolognese altarpiece, which he distributed in Rome some years later trying to discredit Domenichino when they were both vying for the important commission to paint frescoes in the Church of Sant'Andrea della Valle. The reputation of *The Last Communion of St Jerome*, however, has long outlived Lanfranco's aspersions, often being compared with Raphael's *Transfiguration*. Copies of it abound (see Spear, p. 176). In 1797 along with other treasures, Domenichino's altarpiece was carried off by Napoleon's troops to Paris where it remained until 1815 when it was returned with other recuperated works to the Vatican.

C.J.

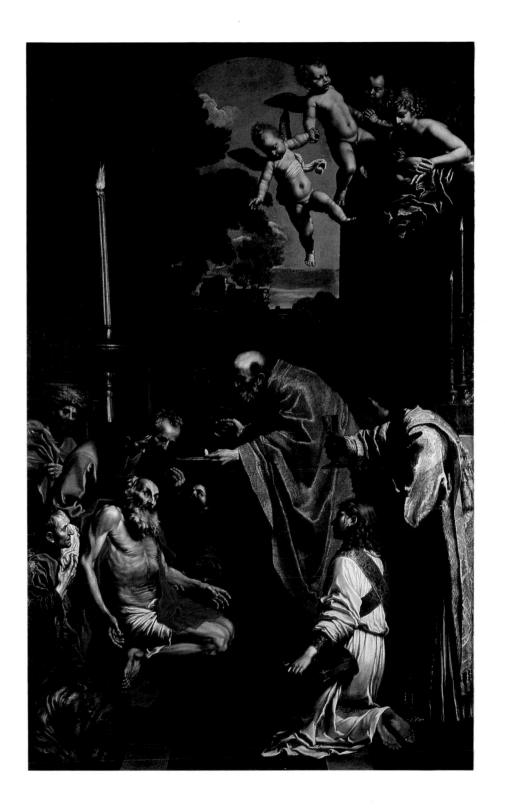

Giovanni Francesco Barbieri, called il Guercino (CENTO 1591–1666 BOLOGNA)

Mary Magdalene 1622
Oil on canvas, 222 × 200 cm
Pinacoteca Vaticana (Inv. no. 391)

This picture belongs to the two brief years when Guercino was in Rome, summoned there by the newly elected Pope Gregory XV, who as Cardinal Archbishop of Bologna had similarly called the young artist from his native Cento to paint pictures for him (*Susanna and the Elders, Lot and his Daughters,* and *St Peter Resuscitating Tabita,* see Denis Mahon, *Il Guercino: il catalogo critico dei dipinti,* Bologna 1968, pp. 44–50). The presence in the Capuchin church in Cento of one of Ludovico Carracci's early masterpieces was to have a formative influence on Guercino, and in Bologna he must have been aware of the fundamental effect the Carracci and their academy had had on painting in that city. Though never a Carracci pupil *per se,* he did adhere to their essential practice of drawing.

In Bologna and in the intervening years at the papal court in Ferrara, Guercino had developed a vigorous style based on contrasting light effects. Of the surprising number of works Guercino managed to execute in Rome, the enormous altarpiece he painted for St Peter's and the brilliantly illusionistic ceiling in Cardinal Ludovisi's villa on the Pincio were to have a catalytic effect on Roman High Baroque art. The Aurora ceiling, in complete contrast to the one Reni had painted for Cardinal Borghese ten years earlier, achieved with its foreshortened figures what both Albani and Domenichino had attempted unsuccessfully in their decorations of patrician palaces, and was to change the character of secular ceiling painting. The *Death and Burial of St Petronilla* altarpiece was of equal importance, particularly in the emotive aspect implicit in religious art of the period. In the foreground two men, as realistically portrayed as Caravaggio would have painted, lower the Saint into her tomb. The figures on the plane behind serve as a spiral to join the lower half of the composition to the upper part, which Caravaggio would have left bare while focusing only on the pathos of the scene, but where a more optimistic Guercino shows the Saint received into heaven as a reward for her earthly suffering. This movement from an earthly realm up to a heavenly one, spelled out in very clear and concrete terms, was to be further exploited by Pietro da Cortona and Bernini in their church decorations.

By contrast, this painting is a much simpler work, although the angel's gesture towards heaven does imply an alternative to the Magdalene's suffering, and physically the composition is worked out on the same principle of contrasting and receding diagonals. The picture was painted as the high altar to the Church of Sta Maria Maddalena, popularly known as the *Convertite,* formerly on the Corso but suppressed under Napoleon, hence the presence of the work in the Pinacoteca. According to Dr Fabrizio Mancinelli (*The Vatican Collections,* 1983, no. 87), following damage caused by a fire in 1617, Paul V had charged Cardinal Aldobrandini with the restoration of the church. The commission may have been awarded Guercino before the Cardinal's death in 1621, for an engraving after the altarpiece by G.B. Pasqualini is dated 1622.

The painting is rather unusual both in its shape for an altarpiece and in its iconography. Rather than the Magdalene lamenting in the wilderness, Guercino portrays her mourning at Christ's tomb attended by two angels, one of whom presents for her examination a nail, while the crown of thorns and Christ's raiment are depicted on the stone sepulchre. Denis Mahon has astutely observed (1968, p. 112) that the figures have gained in sculptural quality over those of Guercino's earlier Emilian works.

C.J.

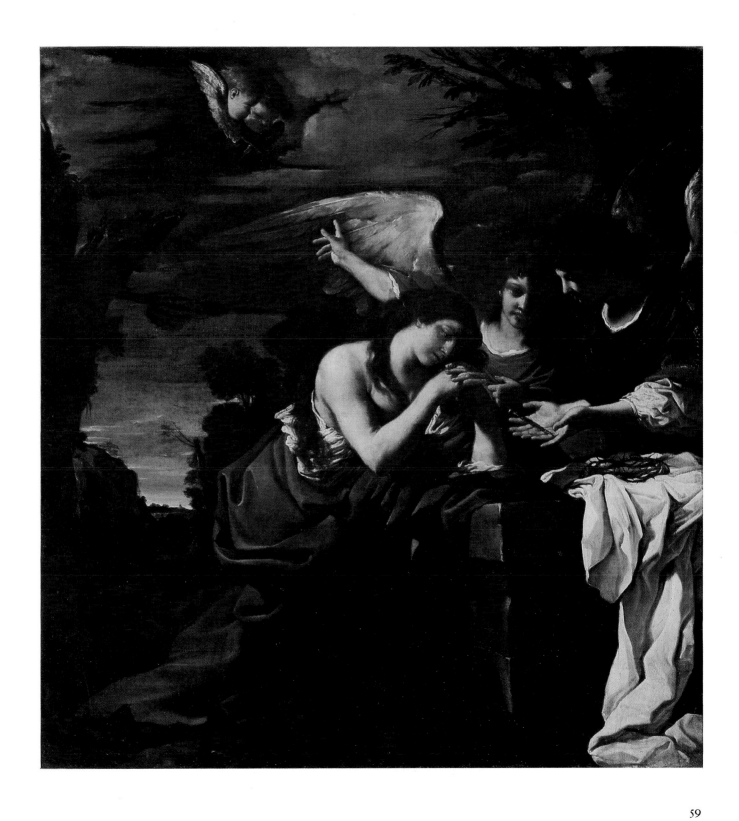

Andrea Sacchi (ROME 1599–1661 ROME)

St Gregory and the Miracle of the Corporal

Oil on canvas, 285 × 207 cm
Reverenda Fabbrica di S. Pietro
(Inv. no. 1700)

St Gregory the Great was pope at the end of the 6th century. Born into a patrician family, he trained in the Roman civil service before undergoing a religious conversion, after which he withdrew from public life. In 579 he was sent as the papal representative to the Byzantine court, to be recalled in 586 to serve as counsellor to Pope Pelagius II. When the latter succumbed to a plague in 590, Gregory was chosen as his successor. Threatened by Lombard invasions, Gregory had to pay heavy tributes in order to save Rome. Thus, the populace increasingly came to regard him as their temporal as well as spiritual leader, and a measure of independence from the Eastern empire was thereby gained. Gregory updated the bureaucracy governing the outlying papal provinces in Sicily, Africa, Corsica, Sardinia, and Gaul. He also corresponded with the Patriarchs of the Eastern Church in Antioch, Jerusalem, Alexandria, and Constantinople. Aside from his own extensive writings on spiritual matters, he was to modify the form of the liturgy involving the lay public in the mass. In 597 he sent missionaries to Britain headed by Saint Augustine of Canterbury. He was nominated one of the four Fathers of the Western Church in 1298.

St Gregory is buried in St Peter's Basilica, and it was thus logical that the Congregazione della Reverenda Fabbrica should wish for an altarpiece representing one of the events from his life. The name of Andrea Sacchi was presumably put forward by his early protector, Cardinal del Monte. Receiving an advance payment in January 1625, Sacchi had completed and requested payment for the altarpiece by September 1627 (see Ann Sutherland Harris, *Andrea Sacchi*, Oxford 1977, pp. 3ff. and 52, no. 9). Sacchi's finished painting is a skilled composition much indebted to the example of Barocci, particularly in the warm colours and the rich materials of the vestments. The soaring architectural background of the painting echoes the monumental proportions of St Peter's itself.

The subject illustrates one of the miracles associated with Pope Gregory, one which contains a degree of ambiguity in the title. The corporal is the white linen cloth upon which the Host and the Chalice are placed during the celebration of the Mass.

Early Christian ritual decreed that the cloth had to be of unembroidered white linen, such as was the cloth in which Christ's body was buried. Essentially the scene represents the miracle of the *brandeum* (*brandea* – of which there is a collection in the Vatican Museums – were pieces of linen venerated for having touched the bodies of the early Christian martyrs) as recounted by Joannes Diaconus (lib. II, par. 42). There the legates or ambassadors from an unnamed source, but later associated with the Emperor Constantine or his daughter Constantia, appealed to the Pope for holy relics. Gregory complied, giving them relics sealed in pyxes. The curious ambassadors, opening these on their way home, saw only linen cloths and returned forthwith to Rome to confront the Pope whom they found celebrating Mass. Gregory, in response to their doubting the genuineness of the *brandea*, took one and pierced it with a knife causing blood to flow, thus demonstrating that it had taken on the corporality of the martyr it had formerly shielded. In Jacopo de Voragine's *Golden Legend*, the cloth in question was from the dalmatic of John the Evangelist.

Sacchi's composition shows the ambassadors awestruck by the miracle that takes place before their eyes. One of them at the left and the deacon at the right hold two of the pyxes, while the Saint, wearing a chasuble, stole, and maniple, stands before an altar on which we see the papal tiara, the dove of the Holy Spirit is shown hovering near his head.

The success of Sacchi's altarpiece won him the protection of the Barberini family and resulted in other commissions for St Peter's. As happened with most of the important works from the period, Sacchi's *Miracle of St Gregory* was replaced in St Peter's with a mosaic copy in the 18th century. It, too, was taken to Paris for the Musée Napoléon. On its return, it was first exhibited in the newly-founded Pinacoteca, but was subsequently moved to the Reverendo Capitolo or Chapter House of St Peter's until it was cleaned in 1983, revealing numerous pentimenti, when it was again placed in the Pinacoteca Vaticana.

C.J.

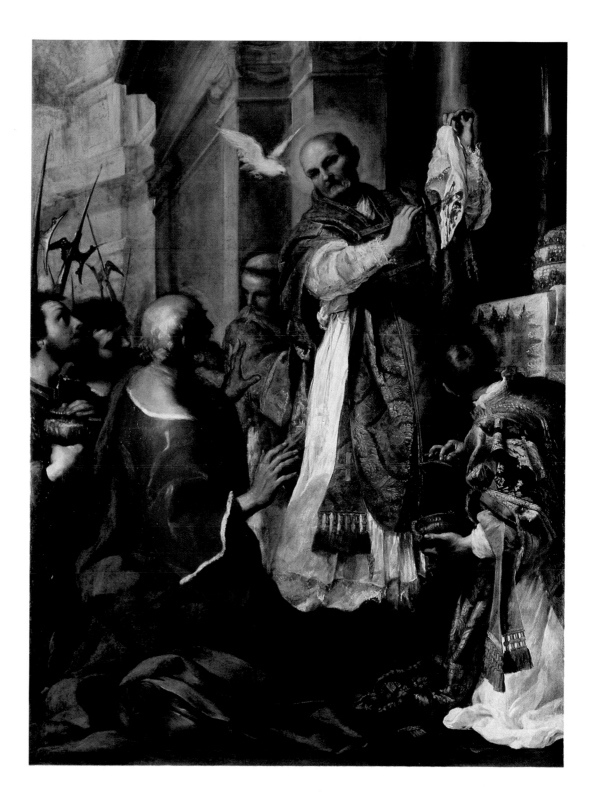

Nicolas Poussin (LES ANDELYS 1594–1665 ROME)

The Martyrdom of St Erasmus 1629

Oil on canvas, 320 × 186 cm
Insc. l.l. *Nicolaus Pusin fecit*
Pinacoteca Vaticana (Inv. no. 394)

Poussin came to Rome in 1624, after a brief sojourn in Venice, in the wake of the Neapolitan poet, the Cavaliere Giovanni Battista Marino (d.1623), once a member of Cardinal Aldobrandini's household before becoming a favourite at the court of Marie de' Medici. Poussin had made drawings for Marino in Paris, based on scenes from Ovid's *Metamorphoses*. Marino's letters of introduction led ultimately to Cardinal Francesco Barberini who, on his return from Paris in 1626, commissioned the young artist's early masterpiece the *Death of Germanicus*. This picture, today in the Minneapolis Museum of Fine Arts, shows Poussin to have made good use of the intervening years in the study of Roman antiquity perhaps at the instigation of Cardinal Francesco's secretary and librarian, the well-known antiquarian Cassiano dal Pozzo. Delivered in January 1628 (see P. Rosenberg, "La Mort de Germanicus," *Revue du Louvre*, Vol. 197, p. 13), its success moved Cardinal Barberini the following month to negotiate for Poussin the important commission of the altarpiece in St Peter's illustrating the martyrdom of the early Christian saint, Erasmus. This work, on a much more imposing scale than the *Germanicus*, is executed in quite a different vein, showing Poussin to have mastered the drama and rhetorical language of Baroque painting. Just how he achieved this will be discussed in the following entry for the artist's finished oil sketch for this painting.

Erasmus, Bishop of Formia, was martyred under the persecutions of Diocletian in 303. A letter of 590 to the then bishop of Formia from Pope Gregory the Great attests to the fact that the body of Erasmus was preserved in the cathedral there. The story of his martyrdom by evisceration, his entrails being wound around a mariner's windlass, is probably apocryphal. The altar honouring the memory of this Saint in Old St Peter's presumably dates back to the time of Pope Gregory's letter. A manuscript by Jacopo Grimaldi, archivist of the Basilica, records its removal at the time the old church was demolished for the construction of Maderno's nave, and in 1624 the Congregazione della Reverenda Fabbrica di S. Pietro deliberated that the altar should be placed in the right transept of the new Basilica next to the one dedicated to SS. Processus and Martinianus (see CAT. NO. 9). Poussin received the commission to paint an altarpiece only on 5 February 1628 (O. Pollak, *Die Kunsttätigkeit unter Urban VIII: Die Peterkirche in Rom,* Vienna 1931, p. 549; see Anthony Blunt, *The Paintings of Nicolas Poussin,* London 1966, no. 97). The final payment made to the artist is dated 20 November 1629, although this may be a bonus he received; already the documents for the more substantial payment of 12 July 1629 refer to the picture as done. Although Sandrart recounts that Valentin's altarpiece with SS. Processus and Martinianus, finished the same year, was more favourably received, this could have been the author's personal preference. Poussin's much lighter palette and the classical elements tempering the drama of the scene created a more modern rendering, and one which was to have considerable influence.

By virtue of its location (undoubtedly a point of pilgrimage for French artists as long as the Académie was to send *pensionnaires* to Rome) *The Martyrdom of St Erasmus* provided a prototype for scenes of martyrdom, the typical components being, aside from the specific martyr, a priest pointing to the sculpted image of a pagan god, a mounted Roman soldier in charge of the execution, a token indication of Roman architecture, and angels descending with martyrs' palm towards the unfortunate, yet triumphant, victim.

According to Dr Fabrizio Mancinelli, Poussin's altarpiece was replaced in the 18th century by a mosaic copy and sent to the Quirinal Palace. It was carried off to Paris with the rest of Napoleon's booty and on its return was duly installed in the Pinacoteca established by Pope Pius VII (*The Vatican Collections,* no. 86).

C.J.

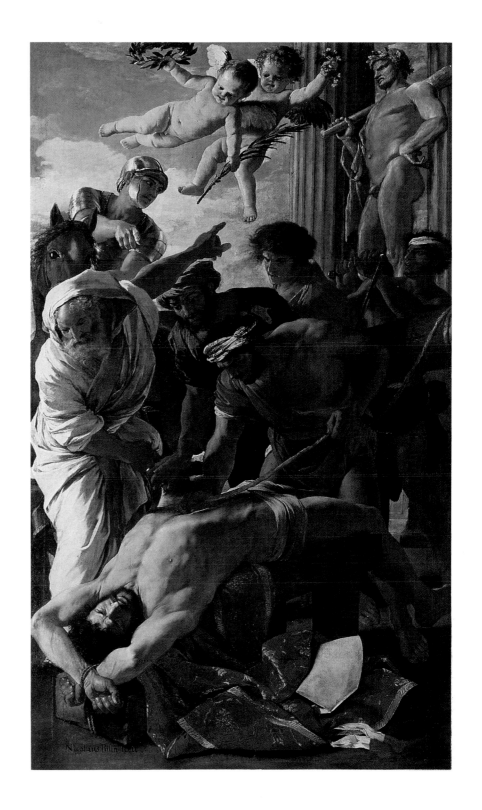

Nicolas Poussin (LES ANDELYS 1594–1665 ROME)

Modello for *The Martyrdom of St Erasmus* 1628

Oil on canvas, 100 × 74 cm
National Gallery of Canada,
Ottawa (Acc. no. 16992)

This is a finished oil sketch or *modello* for Poussin's altarpiece, commissioned on 5 February 1628 (see CAT. NO. 7). There seems to have been some initial confusion as to who the artist assigned to this commission ought to be (see Giuliano Briganti "L'altare di sant'Erasmo, Poussin e il Cortona," *Paragone*, 123, 1960, pp. 16–20, pl. 24). There were several false starts, and it was only at the point when Pietro da Cortona abandoned the project that Cardinal Francesco Barberini intervened and put forward Poussin's name for the Erasmus altar.

This was an exciting opportunity for the young artist, although Poussin was not left entirely free in his choice of representing the Erasmus theme. Two precedents were close at hand. First, there had been an altarpiece of unknown date and authorship of this same subject in the Old St Peter's, which was rejected either for its condition or for the fact that it may not have been considered of sufficient quality for the new interior. Its appearance is recorded among the engravings of thirteen altarpieces from the Old St Peter's executed by Jacques Callot (Lieure, no. 28). Secondly, Poussin could not have ignored the drawing for this altarpiece submitted by Cortona. Moreover, it is possible that he also went to see the treatment of this subject recently painted by Carlo Saraceni for the cathedral in Gaeta. Both the Callot engraving and Saraceni's painting show the scene taking place before the emperor Diocletian, whereas Cortona's drawing had eliminated this feature, substituting what appears to be the sculpted image of Minerva in a niche. There the figure of a priest bending over the diagonally-stretched-out Erasmus points backwards in *contrapposto* towards Minerva in the same manner as Cortona had employed when executing frescoes in the Church of Sta Bibiana (1624). This feature is picked up by Poussin, and we find it in both of his surviving preliminary drawings as well as the finished composition (see A. Blunt, *The Drawings of Nicolas Poussin*, V, London 1974, p. 85).

In his drawings Poussin experimented with various solutions, first with the energy emanating from the centre of the composition towards the extremities, as in Caravaggio's *Martyrdom of St Matthew* in the French church in Rome and Guido Reni's *Massacre of the Innocents* originally in the Church of S. Domenico in Bologna (which Poussin likely saw on his journey to Rome), before he returned to Cortona's design with a diagonal emphasis. Blunt has also drawn attention to Venetian features such as the vertical accent provided by the columns, which derive from Titian's famous *Pesaro Madonna* in the Frari church in Venice. The lighter palette and painterly quality evident here and in the altarpiece itself have as much to do with the current revival of interest in Venetian painting stimulated by Titian's *Bacchanals* in the Aldobrandini collection as they do with the imitation of the Carracci and the Bolognese school. All these features are present in the oil sketch except for minor variations, such as the columns not yet being fluted; a knife and stone, forming part of the foreground detail, are eliminated in the painting. The *modello* is also slightly broader in scope than the painting, where the raised foreleg of the horse at the left and part of the column at the right are cut.

This *modello* was recorded in an inventory of the collection of Cardinal Francesco Barberini in 1630. Copies of it are also recorded in the Barberini archives, one of which is identifiable with that in the collection of the late Marchese Giovanni Incisa della Rochetta. The *modello*, like the *Death of Germanicus* by the same artist, remained with family heirs until early in this century. It was purchased by the National Gallery in 1972, and was the subject of a Gallery publication by Jane Costello in 1975. The frame that surrounds it, though not original to the picture, is clearly a Barberini frame from the period, as indicated by the ornament of bees and laurel. It was purchased separately in Rome.

C.J.

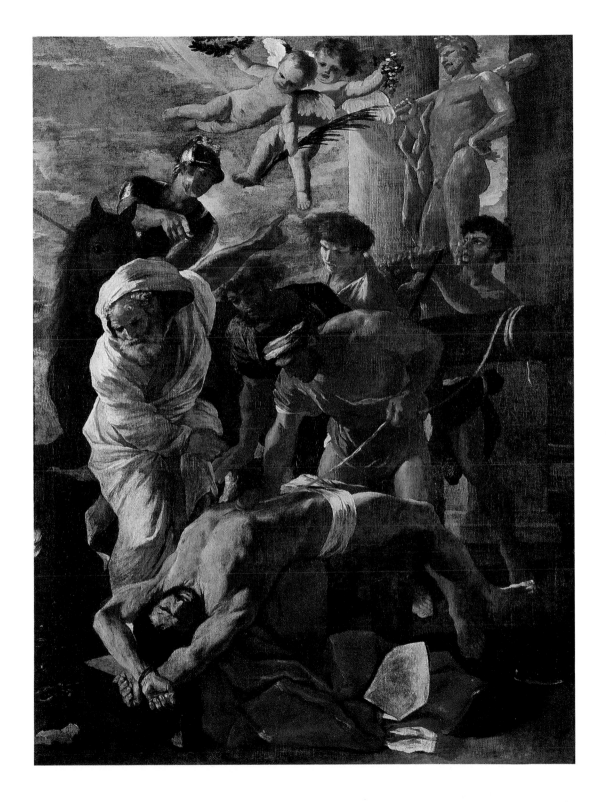

The Martyrdom of SS. Processus and Martinianus 1629

Oil on canvas, 302 × 192 cm
Pinacoteca Vaticana (Inv. no. 381)

Processus and Martinianus were two Roman soldiers charged with guarding St Peter in the Mamertine prison. They were baptised by him with water from a spring he miraculously caused to flow in his cell. Condemned by the Emperor Nero, they were martyred on the Via Aurelia, where their tomb is to be found and where subsequently a basilica was erected. Under Pope Paschalis I (817–24) their relics were transported to St Peter's.

Because of their link with the titular saint and because they conformed to the Counter Reformation recommendations for subjects of martyrs from the early church, it was decided by the Congregazione della Reverenda Fabbrica di S. Pietro that there should be an altarpiece honouring them in the new basilica. Initially there was some indecision as to who should be assigned the commission. Documents reveal that on 10 September 1626 it was first awarded to the Bolognese painter Giacomo Sementi, a former pupil of Guido Reni. Yet on 14 May of the following year the name Pietro da Cortona appears opposite the citation of the chapel of SS. Processus and Martinianus (O. Pollak, *loc. cit.*, pp. 78 and 85). Shortly thereafter, at Cardinal Francesco Barberini's intervention, the commission was given to Valentin (9 May 1629; Pollak, p. 541). A scene of St Peter baptising Processus and Martinianus was added some years later by the Roman artist Giuseppe Passeri.

Valentin arrived in Rome only shortly after the death of Caravaggio, and his work, like that of Manfredi and Vouet, was profoundly influenced by Caravaggio's chiaroscuro style and, to some extent, his subject matter. Living on the Via Margutta in the parish of Sta Maria del Popolo, Valentin frequented northern artists who chose this area of Rome as their domain. Something of the tenor of their bohemian existence can be discerned in his scenes of taverns with card players, gypsies, and musicians gathered around a table.

His biographers record that Valentin was protected by Cardinal Francesco Barberini, whose portrait he painted before 1628, and for whom he produced a *Beheading of John the Baptist*, now lost, and an *Allegory of Rome* (today in the Villa Lante outside Rome), a rather exceptional subject in Caravaggesque circles for its grandiose and rhetorical treatment. Generally Valentin practised a rather less extreme form of Caravaggism than his contemporaries, the stark chiaroscuro mitigated by a feeling for colour and surface texture. The cast of figures that frequent his compositions also have a unique charm, and at times, provocative appeal. Valentin died in his early forties in Rome. A taste for his work was carried back to France by Nicolas Tournier, who had been his pupil in Rome, and may have been introduced into aristocratic circles by Cardinal Mazarin, who had been part of the Barberini household before taking up the position of nuncio in Paris. Mazarin possessed a number of paintings by Valentin, which passed to the French Crown on his death.

As the artist's only known commission for an altarpiece, *The Martyrdom of SS. Processus and Martinianus* is on a grand scale and has a vertical format, unlike most of his compositions. Valentin's debt to Caravaggio's *Martyrdom of St Matthew*, in the Contarelli Chapel of the French church S. Luigi dei Francesi, is obvious in the dark background, the dramatic spiral of violence around the central figures, and the angel descending with martyr's palm. There is also an awareness, particularly in the figure at the right seen from behind, of Domenichino's fresco *The Flagellation of St Andrew* in the Oratorio of St Andrew, S. Gregorio Magno, and more so of Poussin's just completed *Martyrdom of St Erasmus* in the adjacent chapel of St Peter's. The position of Valentin's foreground martyr tied to the rack is particularly reminiscent of the stretched torso of Erasmus; and Valentin has also introduced into the scene, though in a less dominating position than with Poussin, a Roman priest who still points to the pagan statue he had admonished Processus and Martinianus to heed. Like most of the pictures in St Peter's this altarpiece was replaced in the 18th century by a mosaic copy.

C.J.

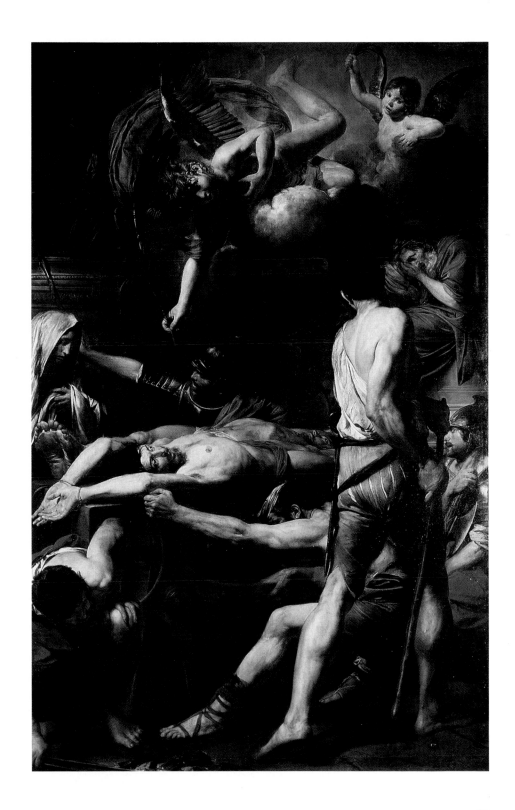

Andrea Sacchi (ROME 1599–1661 ROME)

Portrait of Cardinal Lelio Biscia

Oil on canvas, 134.3 × 99.7 cm
National Gallery of Canada,
Ottawa (Acc. no. 305)

The suggestion that this unidentified portrait of a cardinal might be Cardinal Lelio Biscia (c.1573–1638) was put forward by Ann Sutherland Harris in the *Bulletin of the National Gallery of Canada* (no. 14, 1969, pp. 9–15; see also her monograph on the artist, Oxford 1977, no. 9). She also confirmed the attribution of the painting to Andrea Sacchi, which had first been suggested by Hermann Voss and later supported by Robert Enggass. By a process of elimination, taking into consideration all the other portraits of cardinals Sacchi is known to have painted, the identification of Biscia as the sitter is inevitable. From an inventory of the artist's studio at the time of his death, we know that a "ritratto con il Cardle. Biscia" was there. This deduction is further confirmed by an engraved likeness of Biscia that occurs in J.F. Tomasini's *Elogia Virorum Literis & Sapientia Illustrium...* published in Padua in 1644 (Vol. II).

The portrait is clearly unfinished, which would explain why it remained in the artist's studio and bears no identifying characteristics other than the likeness of the sitter, who is depicted with obvious sympathy. In his right hand he holds a cardinal's *biretta* and in his left a document which might have borne, in a finished state, the identity of the sitter and the artist's name. The background is undeveloped and the vestments are treated with a sketchy flamboyance, which undoubtedly would have been subdued had Sacchi completed the portrait.

Lelio Biscia was appointed cardinal on 19 January 1626. Ludwig von Pastor described him as a close associate of Cardinal Ludovisi (*History of the Popes*, XXVIII, London 1938, p. 49). Late in 1626, his name occurs in the documents concerning payments made by the Congregazione della Reverenda Fabbrica di S. Pietro and it is repeated with a frequency that would suggest he was part of that body (see O. Pollak, 1931, pp. 83f., 230, 232, etc.). Presumably as such he would have had contact with the Bolognese painter Guido Reni, who returned to Rome to paint a fresco of the Trinity in the Basilica, the same ill-fated altarpiece which was to be awarded to Pietro da Cortona upon Reni's abrupt departure, thus leaving Poussin to paint *The Martyrdom of St Erasmus* (CAT. NO. 7). According to Reni's biographer Malvasia,

Cardinal Biscia at this time ordered a painting of the Magdalene from Reni – but which the artist, not having yet received a deposit, gave to Cardinal Francesco Barberini, who admired it in Reni's studio (see D. Stephen Pepper, *Guido Reni*, New York 1984, p. 258, no. 118, for details).

Biscia is associated with another more important commission, although not a personal one. As Vice-Protector of the Camaldolese order, he would have been instrumental in awarding to Andrea Sacchi in 1631 the commission for his famous *Vision of St Romuald*, at which time he may have ordered his portrait from the artist. Like so many of the pictures in this exhibition, it too was carried off to Paris by Napoleon, and on its return became part of the collection of the Pinacoteca Vaticana. Curiously, a small version of the St Romuald was in Sacchi's studio at the time of his death, together with this portrait. Ann Sutherland Harris points out that Sacchi used the unfinished portrait of Biscia as a model in painting his portrait of Cardinal Giori.

C.J.

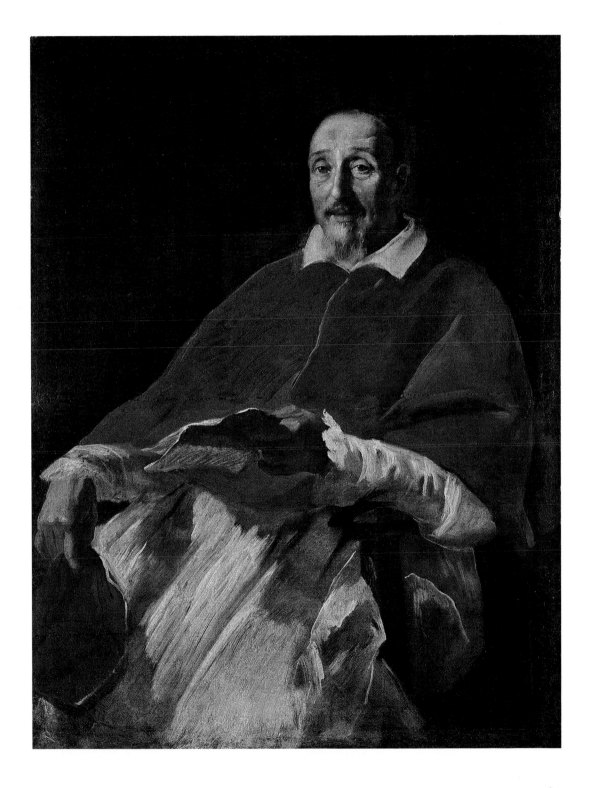

Pietro Berrettini, called Pietro da Cortona (CORTONA 1596–1669 ROME)

The Vision of St Francis

Oil on canvas, 227 × 151 cm
Pinacoteca Vaticana (Inv. no. 405)

The subject along with others showing the Stigmatization of St Francis and St Francis adoring the Crucifix were favourites in 17th-century painting, and reflect the post-Tridentine recommendations for using art as a means for inspiring a resurgence of Christian faith. The Capuchin order, founded in 1529 and devoted to St Francis, played an important rôle in the Catholic Reformation and in promoting Franciscan themes, as evident in the famous altarpieces by Federico Barocci (in Urbino) and Ludovico Carracci (at Cento), and in smaller devotional works such as those by Caravaggio (now in Hartford, Conn.) and Annibale Carracci (see CAT. NO. 2). Pietro da Cortona's rendering of the scene is very straightforward and describes how St Francis received into his arms the Christ Child during a revelation he had of the Virgin. In the left foreground we see the crucifix he had been contemplating and his breviary, while in the background his companion St Leo is seen in the act of reciting the rosary.

Pietro da Cortona had first painted a larger altarpiece of this same composition for the Montauto Chapel in the Church of the SS. Annunziata in Arezzo (c.1641; see Giuliano Briganti, *Pietro da Cortona*, Florence 1962, p. 223, no. 80, where two *bozzetti* or *modelli* are cited in the collection of the Hermitage Museum in Leningrad). This version of the picture was commissioned by Pope Alexander VII – as the stars (his emblem) on the frame would indicate – for the papal summer palace at Castelgandolfo. The palace had been constructed by Urban VIII, but the decoration of the interior was largely the work of Alexander VII. It was here, during the Chigi pontificate, that Bernini built the church dedicated to the recently canonized S. Tomaso di Villanova, for which Pietro da Cortona was also commissioned to paint the main altar.

Pietro Berrettini's Tuscan origin had placed him in good stead not just with the Chigi, who came from Siena, but with the Barberini and the Sacchetti, whose families also came from Tuscany. In Rome from an early age, Pietro's first works showed the strong imprint of Roman antiquity, and it was natural, therefore, that he should have come to the attention of the antiquarian Cassiano dal Pozzo. In late 1624 following the uncovering of the tomb of St Bibiana, Urban VIII awarded him the commission to paint frescoes illustrating scenes of her life and martyrdom (see CAT. NO. 16 for more information concerning this Saint). In 1627 he submitted a design for the altarpiece of St Erasmus to be painted in St Peter's (see CAT. NO. 8), but abandoned this for the more advantageous commission to paint the Trinity in the Chapel of the SS. Sacramento also in the Basilica. Soon after followed frescoes on the vast ceiling of the *gran salone* of the Barberini Palace, which were to establish his name as a decorator *par excellence*, thereafter sought by the Medici to paint a suite of rooms in the Pitti Palace, Florence, and later by the Pamphilj for the ceiling of the gallery in their palace on the Piazza Navona. Over a period of years he also painted frescoes in the Chiesa Nuova, first in the sacristy, then the enormous dome, and finally scenes from the life of St Philip Neri on the ceiling of the nave.

Pietro da Cortona obviously had the organizational skills to carry out such extensive projects without losing any of the freshness and *brio* of his smaller works. In 1652 he was commissioned to make cartoons for the mosaics which were to decorate various cupolas in St Peter's, and in 1655 the newly elected Alexander VII charged him with the responsiblity to decorate the Gallery in the papal palace on the Quirinal (mostly destroyed during the Napoleonic era, but a good account of which is given in S. Jacob, "Pierre de Cortone et la décoration de la galerie d'Alexandre VII au Quirinal," *Revue de l'Art*, XI, 1971, pp. 42–54).

C.J.

Carlo Maratta (CAMERANO 1625–1713 ROME)

Portrait of Pope Clement IX 1669

Oil on canvas, 145 × 116 cm
Pinacoteca Vaticana (Inv. no. 460)

Giulio Rospigliosi had begun his career under Urban VIII. He was a gifted poet and wrote the libretto to an early opera, *S. Alessio*, which was staged at the Palazzo Barberini. He was a noted patron for whom both Poussin and Claude made pictures. Between 1644 and 1653 he was in Madrid as nuncio, and under Alexander VII was made cardinal in 1657, succeeding him as Pope Clement IX (reigned 1667–69) only ten years later. (See FIG. 11 and CAT. NO. 32 for works relating to Clement IX.)

Carlo Maratta was trained in the studio of Andrea Sacchi and was an accomplished draughtsman. He painted primarily altarpieces, which became increasingly monumental in his combination of Baroque and Classicist tendencies, such as can be seen in the *St Augustine* altarpiece for Sta Maria dei Sette Dolori in Rome (1655) or the *Death of St Francis Xavier* (1674–79) in the Gesù. The two altarpieces he painted on the subject of the Immaculate Conception, that in the Church of Sant'Agostino in Siena with SS. Thomas of Villanova and Francis de Sales, and the one ordered by Cardinal Cybo for Sta Maria del Popolo showing the Evangelist explaining the doctrine to SS. Gregory, John Chrysostom, and Augustine, are both very important, a distinct progression in iconographical interpretation over the works Guido Reni and Murillo had made earlier in the century. (See E. Mâle, *L'art religieux après le Concile de Trente*, Paris 1932, pp. 46–47.) In Wittkower's words, "He re-established a feeling for the dignity of the human figure seen in great, simple, plastic forms and rendered with a sincerity and moral conviction without parallel at the moment" (*Art and Architecture in Italy 1600–1750*, 3rd rev. ed., Harmondsworth 1973, p. 337). During the last quarter of the century Maratta had control of all the major artistic commissions in Rome. Like Pietro da Cortona before him, he made cartoons for mosaics to decorate the ceiling in St Peter's. He also painted the fresco on the ceiling of the great hall in the Altieri Palace.

This *Portrait of Pope Clement IX* is one of the most compelling portraits of the 17th century. Curiously there are fewer painted portraits of the popes than one would imagine, most of the familiar portraits being the imposing marble or bronze busts, or the posthumous statues on papal tombs. Maratta's portrait is clearly based on one Velazquez had painted of Innocent X during a visit to Rome in 1650, but loses nothing to it in brilliance. They are of similar size and show the Pope three-quarter length seated at an angle to the picture plane. According to Bellori, that of Clement is said to have been painted when the Pope was already ill, indeed he is said to have fainted during one of the sittings, yet the artist affords him the dignity of his office. The Pontiff appears in full command. Seated on a throne bearing finials with his insignia, he stares out at the viewer; a book from which he has been reading is in his hand, and a bell is on the table, at his other side. Next to the bell is a folded paper bearing the artist's dedication and signature. The luminosity with which the velvet of his costume is described is balanced by the intensity of his facial expression. Bellori records how, on seeing Maratta's portrait of Cardinal Jacopo Rospigliosi who had been raised to the purple in 1667, Clement IX had ordered one to be painted of himself. This portrait of the Pontiff had been sold from the Rospigliosi collection and, according to Dr Fabrizio Mancinelli, was acquired by Louis Mendelssohn of Detroit, who donated it to Pius XI in 1931 (*The Vatican Collections*, no. 89). Amelia Mezzetti lists autograph replicas in the collections of the Hermitage and the Duke of Devonshire (see her fundamental article "Contributi a Carlo Maratti," *Rivista dell'Istituto Nazionale d'Archeologia e Storia dell'Arte*, IV, 1955, pp. 253–357).

C.J.

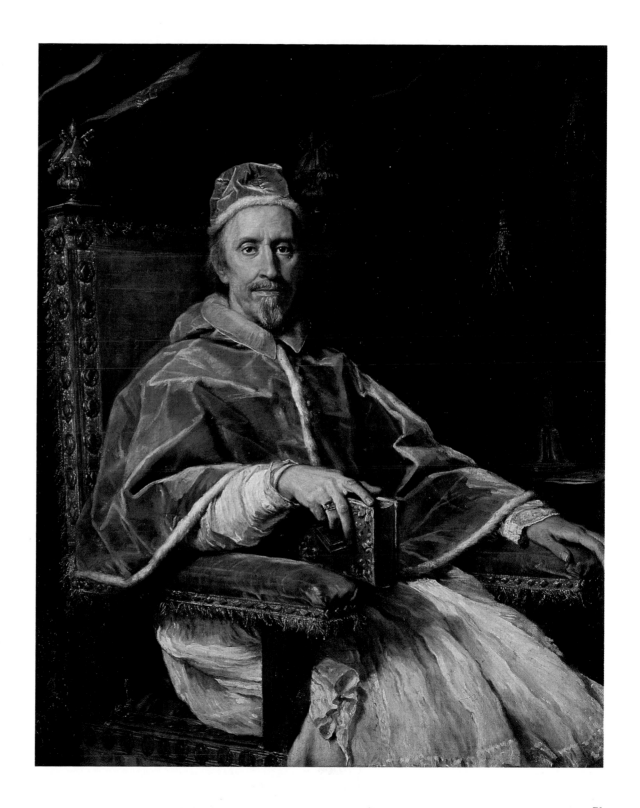

Gian Lorenzo Bernini (NAPLES 1598–1680 ROME)

Bust of Pope Gregory XV

Marble, 83.2 (with base) × 62.3
× 32.4 cm
Collection of Joey and Toby
Tanenbaum, Toronto, on loan
to the Art Gallery of Ontario

★ Only in Toronto

Despite the brevity of his reign (February 1621 to July 1623), there exists an unusual number of portraits of Gregory XV. This can partially be explained by the presence in Rome, or more accurately the return to Rome as a result of his election, of a number of Bolognese artists whom he favoured with sittings, among them Guercino, Reni, and Domenichino. Bernini's bust of Gregory XV, as indeed the later posthumous one executed by Algardi for the Sacristy of Sta Maria in Vallicella, is a much nobler interpretation than many of the paintings, in part because the Pontiff is represented bare-headed and with a bishop's cope around his shoulders. The nature of the material is such that the beard and moustache are more clearly defined than in paint; in Bernini's bust the beard is square, projecting and deeply cut, and the moustache is broader and curls up at the edges. The forehead is creased, veins are noticeable at the temples and there are lines beside and beneath the eyes. The pupils are cut, unlike Bernini's earlier bust of Paul V where the eyes are left blank, and the lips are parted. The cope that he wears, in reality no doubt heavy with embroidery in metallic threads, weighs down on his shoulders in an oppressive fashion more reminiscent of Taddeo Landini's bust of Clement VIII at the Villa Aldobrandini in Frascati than in Bernini's earlier bust of Paul V. This adds to the impression of fatigue.

The diary of Bernini's uncle states that by September 1621 the sculptor had made three busts of Gregory XV, one in marble and two in bronze, and that he had been rewarded with the Cross of the "Cavalierato di Cristo" and henceforth could use the title of "Cavaliere" (see Wittkower, *Gian Lorenzo Bernini*, London 1981 ed., pp. 179–181, no. 12, where all versions of the bust excepting the present one are discussed). One of these bronzes was possibly that cast by Sebastiano Sebastiani for Cardinal Scipione Borghese, today in the Musée Jacquemart André, and the Ludovisi one is presumably that in the Museum of Art, Carnegie Institute, in Pittsburgh. All trace of the marble bust is lost after the 17th century, although it would be assumed that it passed into the collection of the Ludovisi Boncompagni heirs.

The present bust made its appearance on the London art market in 1978 and again in 1980. It is known that it had been purchased in Italy in the mid-19th century by the fifth Earl of Lanesborough in whose family it remained until a few years ago, the attribution to sculptor and sitter meanwhile having been lost. In comparison with the documented bronze busts of Gregory XV, there can be no doubt that they represent the same person, and they are essentially identical except that in the marble, the borders of the cope nearly meet at the lower edge and the detail of the parted lips is more pronounced. It is therefore very tempting to see this marble as the missing Ludovisi one, although a clear provenance cannot be documented and the rather mechanical treatment of the borders of the cope has caused some hesitation. Professor Irving Lavin, the only Bernini scholar thus far to have mentioned it in print, is convinced of its authenticity and plans to discuss it more fully in a forthcoming article (see his announcement in "Bernini's Bust of Cardinal Montalto" in *Jahrbuch der Hamburger Kunsthalle*, III, 1984, also printed in *The Burlington Magazine*, January 1985, pp. 32–38, fig. 44). The bust has minor damages in the left forehead and chips in the left side of the cope, apparently from something having fallen on it, as neither the nose nor beard have suffered. The tomb of Gregory XV, though a much later work, is in the family church of S. Ignazio begun in 1626 by Cardinal Ludovisi to commemorate the Saint's canonization in 1622.

C.J.

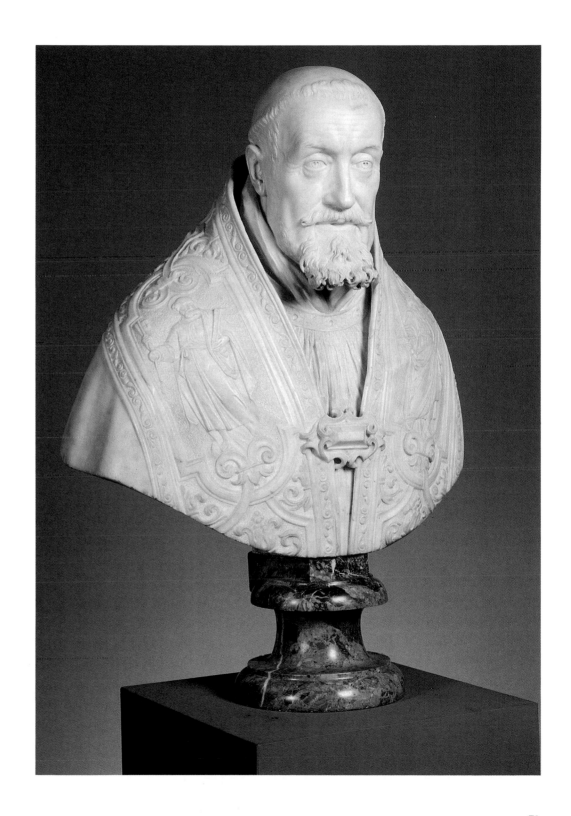

Gian Lorenzo Bernini (NAPLES 1598–1680 ROME)

Bust of Pope Urban VIII 1632

Marble, 94.7 (with base) × 68.8 × 34.4 cm

National Gallery of Canada, Ottawa (Acc. no. 18086)

★Only in Ottawa

In the draft of a letter to Bernini dated 4 June 1633, Lelio Guidiccioni praised busts of the Pope and of Cardinal Scipione Borghese which the sculptor had made the previous year. Guidiccioni's letter must refer to this bust that Bernini made in Rome before Urban left for his summer residence at Castelgandolfo, and to the other marble bust of the Pontiff that remained with the Barberini family until very recently, which is now in the Galleria Nazionale d'Arte Antica in Palazzo Barberini. The letter is quoted in full by C. D'Onofrio, *Roma vista da Roma*, Rome 1967, pp. 381–388. Indeed, these two marble busts are identical in all but the smallest of details and both are of the highest quality in execution. One might well wonder why two identical busts would be commissioned, and why the artist would spend his time making an exact replica of a work he had already created, but the circumstances become obvious on a closer inspection of the Ottawa example. At the back of the Pope's cap (or *camauro*), there is a very distinct crack in the surface of the marble, and a minor flaw can also be seen running along the left side of the *mozzetta* or cape which covers his shoulders. It would appear that at an advanced stage of carving the bust, these flaws came to the surface and that Bernini decided, or was instructed, to carve another bust in identical fashion. Curiously this same set of circumstances plagued the sculptor in the execution of his two busts of Cardinal Scipione Borghese, for which there are payments recorded in December 1632. Given the closeness in date of these four busts, one might speculate that the marble blocks were cut from the same quarry in which similar flaws occurred in the geological formation of the stone.

These four busts are among the most brilliant in Bernini's career. (It is interesting to note that the artist had made preparatory drawings for them; these are rare in Bernini's graphic œuvre, although he was prone to making caricature sketches.) The busts are of similar proportions, all of them over life-size. What that of Urban loses to Scipione in spontaneity, it gains in monumentality, altogether more in keeping with the subject. Bernini had already made busts of Paul V and Gregory XV (CAT. NO. 13), as indeed he would of the Pamphilj, Chigi, Rospigliosi, and Altieri popes who followed, yet this portrait of Urban has a degree of expressiveness that is unusual both in the sensitivity and intensity with which it is conveyed that perhaps comes from his degree of intimacy with Urban. Nor is Bernini hindered with having to portray his subject in full papal regalia as he had in the tomb figure (1628). Here the relative casualness in the folds of his *camauro* and *mozzetta* give movement and life to the expanse of marble which might otherwise have appeared rigid, just as the lines around the eyes, the slight frown of the brows and the face turned just off centre contribute a feeling of both compassion and authority caught in a fleeting expression. Guidiccioni comments that, though armless, the way the right shoulder is slightly raised and the folds of the *mozzetta* fall are such as to suggest the Pope had just raised his right hand, as if to tell someone to rise to his feet (D'Onofrio, *loc. cit.*). Here Bernini created a truly memorable portrait, and one of the masterworks of Baroque sculpture.

Details of the commission and where the busts of Urban were displayed are not immediately clear. One of them and the bronze replica (CAT. NO. 15) are referred to in Palazzo Barberini in Girolamo Teti's *Aedes Barberinae ad Quirinalem*, published in Rome in 1642. Among the numerous busts of Urban VIII cited in the Barberini Archives, the marble is specifically referred to in the *Stanza di Parnaso* of the Barberini Palace in the inventory of Cardinal Antonio Barberini's possessions, cautiously drawn up a few months prior to the death of his uncle ("Un ritratto di N. Sig.re Papa Urbano VIII – di marmo, con peduccio di marmo *di mano del Bernino*," see Marilyn Aronberg Lavin, *Seventeenth-Century Barberini Documents and Inventories of Art*, New York 1975, p. 182: IV, inv. 44, no. 684). The first version of the bust is thought to have been in a Swiss private collection since the war. It was published there by Professor Wittkower ("A New Bust of Pope Urban VIII by Bernini," *The Burlington Magazine*, CXI, 1969, pp. 60–64) and acquired by the National Gallery of Canada in 1974.

C.J.

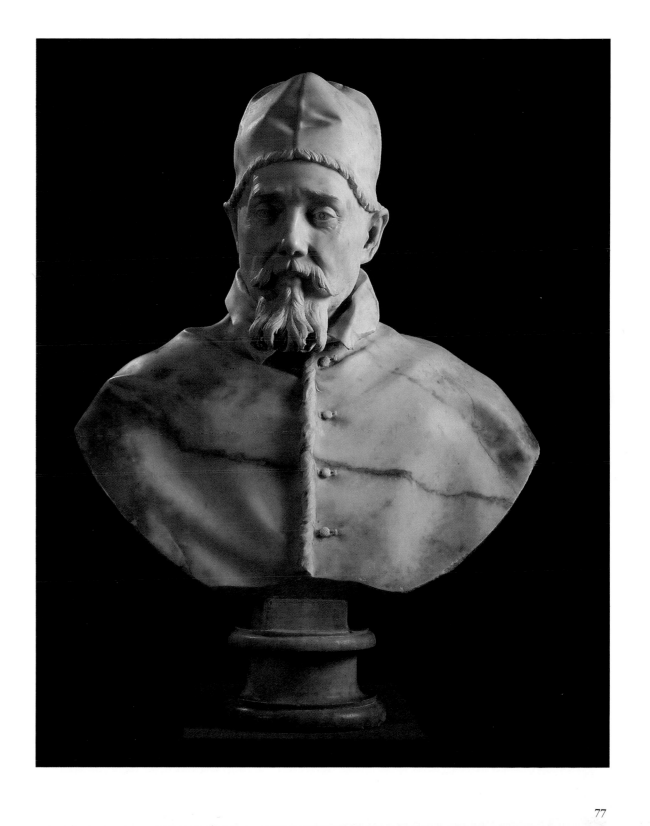

Gian Lorenzo Bernini (NAPLES 1598–1680 ROME)

Bust of Pope Urban VIII 1632

Bronze, 100 (with base) × 73 × 41 cm

Biblioteca Apostolica Vaticana, Museo Sacro (Inv. no. 2427)

This bronze bust is a replica of the marble bust (see under CAT. NO 14) that Bernini made of the Pope during the summer of 1632. It is clearly documented by a reference to a pedestal having been brought to Palazzo Barberini late that same year, on which it is specifically mentioned a bronze bust of the Pontiff was to be placed (see I. Lavin, "Duquesnoy's 'Nano de Créqui' and two busts by Francesco Mochi," *The Art Bulletin*, III, 1970, p. 141, no. 65). The following year a wooden niche for this sculpture was commissioned from Giovanni Battista Soria to be inserted into the panelling in the library of the same palace (see Valentino Martinelli, *I Ritratti dei Pontefici*, Rome 1956, p. 38, no. 76). In 1902 the contents of the Barberini Library, one of the outstanding 17th-century libraries, was acquired by the Vatican Library together with this panelling, the niche, and bust (see Olga Raggio, *The Vatican Collections*, no. 26). It is evident that this bronze bust is based on the marble version now in the Galleria Nazionale d'Arte Antica in Palazzo Barberini, for the folds in the drapery of the right shoulder are slightly more pronounced than with the Ottawa version, and Bernini has also introduced in it the conceit of representing a horizontal crease in the *mozzetta* where it had been folded. Both these features are repeated in the bronze version.

It is not documented who cast this bronze for Bernini, although we know that Sebastiano Sebastiani had cast those of Paul V and Gregory XV ten years earlier; while about a decade after this version of Urban VIII, Ambrogio Lucenti was to cast the magnificent bronze bust that is still in the Cathedral of Spoleto (R. Wittkower, 1981 ed., p. 187, no. 19(5)). Soon after being made a cardinal in 1606, Maffeo Barberini had been given the See of Spoleto. Urban VIII undertook the restoration of this church, ordering from Bernini in February 1640 the enormous bronze bust (h. 1.32 m), which portrays him with papal tiara and richly embroidered cope (the beautiful effigies of SS. Peter and Paul denote not only the skillful invention of Bernini but also the very high degree of craftsmanship of the bronze-founder). Here Bernini conveys with remarkable sensitivity and insight the advancing years of the Pontiff, whose death would come two years later (payments to Bernini occur between 1640 and 1642, those to Lucenti continue until 1644).

The problems of casting bronze in this period were such that a bronze bust was by no means a second and less expensive choice. Rather it was a question of aesthetics, and bronze was possibly thought more durable, although time has taught us otherwise. Soon after his election Urban VIII had put Bernini in charge of the Vatican foundry. In 1625 Urban gave the hospital of SS. Trinità dei Pellegrini (which cared for pilgrims, who were especially numerous during the Jubilee year), a bronze bust of himself; but this, like Algardi's counterpart of Pope Innocent X (also cast by Ambrogio Lucenti), was to disappear during the Napoleonic invasion; they were probably melted down (see Jennifer Montagu, *Alessandro Algardi*, New Haven and London 1985, II, no. 155). Another bronze bust of Urban was recorded in the collection of Louis XIV, and may be identifiable with that today in the Louvre (Wittkower, *op. cit.*, no. 19(4)).

C.J.

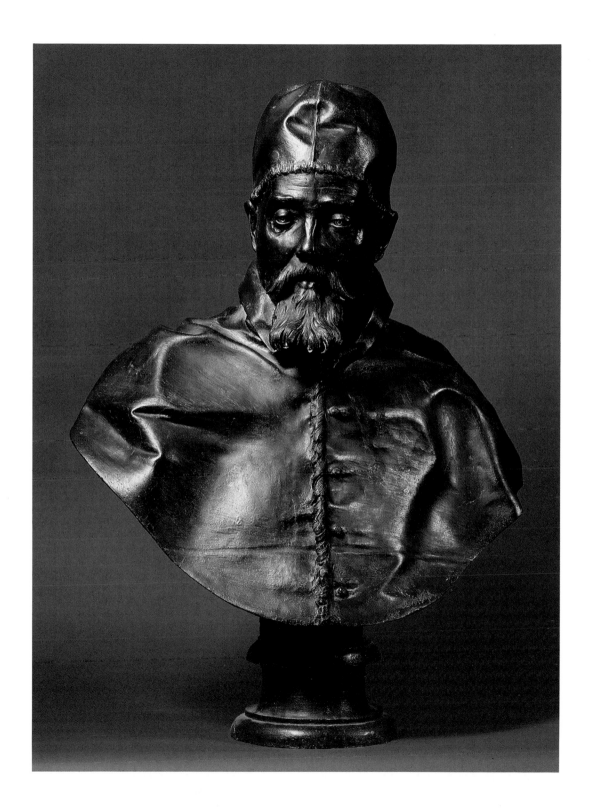

Reliquary Bust of St Bibiana

Cast, chased silver; Base of gilt bronze, engraved at the back: *EX. DONO. FABRITII. LOCATELLI. ORSINI/ CAN. BAS. S. MARIAE MAIORIS/ MDCCCIV/ F. RIGHETTI F. ROMAE.*, coats-of-arms of F. Locatelli at sides, oval medallion at front, silver, inscribed: *S. /BIBI/ANA,*
28 × 17.5 × 13.5 cm
Sacristy of Sta Maria Maggiore, Rome

The engraved inscription at the back of the base informs us that it was donated by Fabrizio Locatelli, Canon of Sta Maria Maggiore, in 1804, and that it was made in Rome by F. Righetti. A date between the summers of 1609 and 1610 has been proposed for the bust by Sandra Vasco Rocca, who published it, with an attribution to Pietro Gentili (1563–1626; see S. Vasco Rocca, "Gli argenti di S. Maria Maggiore: reliquari di Pietro Gentili, Benedetto Cacciatore, Santi Lotti e della bottega di Vincenzo I. Belli," *Storia dell'Arte*, XV, 1983, 48, pp. 117–127, figs. 1–4). The payment documents recording his involvement with a project whose description could apply to the bust can indeed lead one to suppose that the bust is the work of Gentili. There are, however, minor discrepancies between the present bust and the one described in the payment documents, including the supposed removal of a gilded diadem, difficult to imagine as ever having featured on this work. Indeed the ribbon on Bibiana's hair is crown enough, and a worthy successor to the crown of flowers she wore in an earlier reliquary bust cited in a 1480 inventory.

No other work attributable to Gentili is known to have survived, and therefore no comparisons can be made beyond those with works produced by other artists up to 1610. The lack of any close similarities with the bust of St Bibiana could imply that its uniquely "advanced" quality should indeed be ascribed to Gentili. His other works might have provided a context in which the St Bibiana would have appeared less isolated and exceptional for such a date. However, a silversmith would almost invariably have worked from models provided by a sculptor (*cf.* J. Montagu, *Alessandro Algardi*, New Haven and London 1985, I, p. 10). There is no evidence for Gentili's providing his own models in other instances, and the fact that none is mentioned in the payment documents for his St Bibiana might simply indicate that he did not have to be reimbursed. The model could have been obtained by the patron in a separate transaction with the sculptor. It is not to be excluded therefore that the bust might be a later work, and that the documents might refer to a bust that the present one would have replaced (*cf.* INTRODUCTION, P. 39, N. 17). Such a hypothesis raises the questions of when this may have occurred and by whom the bust was designed and cast.

whom the bust was designed and cast.

Sandra Vasco Rocca points out that the few comparable works prior to 1610 (such as those by Gulielmo della Porta and Stefano Maderno, an exception being Francesco Mochi's *Virgin of the Annunciation* of 1603–08), show less affinity with the St Bibiana than do the later works which she cites. The closest in composition as well as in "classical feeling" of form is Duquesnoy's St Susanna, dated 1629–31 (*cf.* J. Montagu, *op. cit.*, I, p. 17). Bernini's *Countess Matilda*, dated 1633–37 (*cf.* R. Wittkower, *Gian Lorenzo Bernini, the Sculptor of the Roman Baroque*, London 1966, cat. 33) could almost be St Bibiana herself, grown to matronly nobility. Traces of Mannerism can still be found in the generalised features and perfectly classical profile of the earlier works. However, in the St Bibiana these attain a natural grace rarely encountered before Bernini's translation into sculpture of the idealised feminine beauty typified in painting by the works of Annibale Carracci in the Farnese Gallery (1597–1604), Domenichino's *St Cecilia* at S. Luigi dei Francesi (1613–14), and Guido Reni's *Aurora* (also 1613–14).

The Church of Sta Maria Maggiore possessed an earlier reliquary bust of St Bibiana – the one recorded in 1480 – which contained the head of the Saint. The relic would have been transferred to Pietro Gentili's bust of 1609–10. In 1624 the headless remains of the Saint were recovered in her titular church. On this occasion Pope Urban VIII commissioned Bernini to renovate the Church of Sta Bibiana, and to sculpt a marble statue of Bibiana for the high altar, at which time Pietro da Cortona painted frescoes on the life of the Saint. The completion in 1626 of Bernini's new image (*cf.* R. Wittkower, *op. cit.*, cat. 20) could have provided an opportunity for replacing the bust by Pietro Gentili. If this did occur, however, it must have postdated the publication in 1627 of Domenico Fedini's account of the life of the Saint, in which such a circumstance would undoubtedly have been mentioned for the added luster it would have reflected on the prestige of the Chapter of Sta Maria Maggiore responsible for the Church of Sta Bibiana.

M. W.

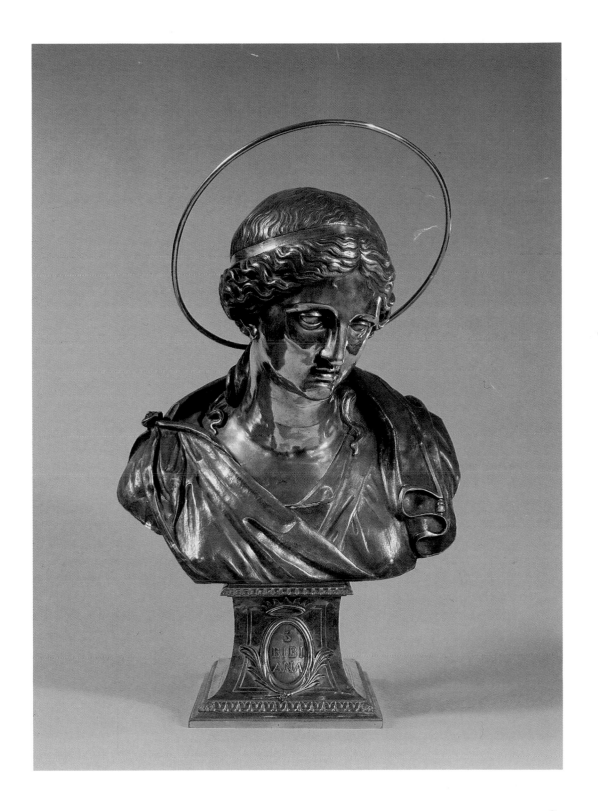

Gian Lorenzo Bernini (NAPLES 1598–1680 ROME)

Charity

Study for the tomb of Urban VIII.
Terracotta, 41.5 cm
Biblioteca Apostolica Vaticana,
Museo Sacro (Inv. no. 2422)

Bernini shows Charity as a fulsome figure (slightly attenuated in the marble) of generous motherhood smiling at the child tugging at her cloak and raising his right leg and arm as he convulsively cries to be fed at the breast like his somnolent brother in her arms. The terracotta evokes the softness and mobility of the bodies modelled with great virtuosity. A sense of balance in the stance of Charity emerges even through her voluminous drapery, which does not impede a reading of the multiple movement as she turns round while continuing to climb the rocky path that rises towards the sarcophagus (*cf.* FIG. 13). The texture of her drapery is contrasted between the lighter tunic and heavier cloak. The face of the weeping child is admirably expressive in its distortion of the features which, by the softness of the modelling, almost appear to change rather than remain permanently fixed. The same lightness of touch can be seen in the details such as the cupped right hand of the sleeping child, and in the rhythmic curve of the fingers of Charity's right hand, rendered with extraordinary succinctness of means and abundance of effect.

Together with other terracottas, this model of Charity for the tomb of Urban VIII was transferred to the Vatican Library in 1923 as part of the donation of the Chigi Library by the Italian State, which had acquired the Palace in Piazza Colonna in 1917. Photographs in the Chigi Archives, now also in the Vatican Library, show the terracottas on a stand in the Chigi Library. Other small sculptures can be seen in other photographs, which also show many of the drawings by Bernini, moved for a time to Ariccia and now in the Chigi Archives, then still framed and embedded in the walls to form part of an overall decorative scheme that linked them through painted motifs such as ribbons and swags. Many of these terracottas and drawings had previously adorned the villa of Cardinal Flavio Chigi at the Quattro Fontane. In an inventory drawn up intermittently between 1666 and the reign of Clement IX (1667–69), only one terracotta is identified as Charity, measuring approximately two palmi, i.e. 44 cm (Biblioteca Apostolica Vaticana, Archivio Chigi 702, fol. 116 v; cited by O. Raggio, "Bernini and the Collection of Cardinal Flavio Chigi, *Apollo*, CXVII:255, 1983, pp. 368–379, fig. 10).

This is probably the final small-scale model from which a full-scale version would have been prepared. Since the marble block for the statue was trimmed in 1634 (*cf.* R. Wittkower, *Gian Lorenzo Bernini*, 1966, cat. 30), the design must have been more or less definitively established by that date, and probably already so by 1631 when the block was purchased. A document of 1630 indicates that it had not yet been decided whether the figures of Charity and Justice were each to be accompanied by two children or three. However, it is not specified whether this would involve an increase or a reduction in relation to the number of children envisaged when the tomb was commissioned in 1627. In a drawing (*cf.* H. Thelen, *Francesco Borromini. Die Handzeichnungen*, Graz 1967, C.36), dating not later than 1630, when the marble incrustations of the niche and the base of the monument were undertaken in a form very close to that shown in the drawing, Charity adopts a considerably different pose and attends two children. Since the model for casting the bronze statue of Urban VIII was begun in 1628, and the drawing shows the design almost exactly as executed, the drawing may date just before work on the niche, for which it would have served as a guideline to the masons. This would suggest that an increase, rather than a reduction, of figures was being considered in 1630. If it was economy that prevailed over extravagance, it may have been not so much for financial reasons (on the contrary, the tendency was towards lavishness, as exemplified by the development of the designs for the *Baldacchino* and the *Cathedra Petri*) – but because there would have been insufficient space and no useful purpose for a third child, especially in relation to Justice. The interruption of work on the tomb from 1631 to 1639, with the exception of some preliminary work on the Charity in 1634, is probably to be explained by Bernini's numerous other commitments such as the completion of the *Baldacchino*, the carving of the St Longinus, and the design of the tomb of the Countess Matilda.

M.W.

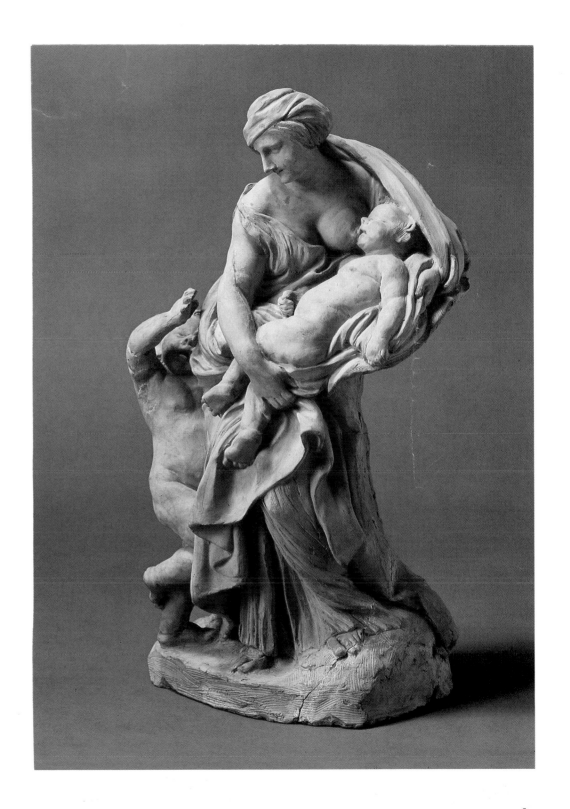

Charity

Terracotta, 39 cm
Biblioteca Apostolica Vaticana,
Museo Sacro (Inv. no. 2423)

It is not possible to identify this figure with any certainty as one of the several statuettes mentioned in the earliest of the inventories (*cf.* CAT. NO. 17) of Cardinal Flavio Chigi's possessions. It is smaller than the model of Charity at the tomb of Urban VIII, which is therefore the more likely to be that referred to by name and measured at approximately two *palmi*. It might, however, correspond to the Charity mentioned in the inventory of 1692 (cited by O. Raggio, *Apollo,* CXVII:255, 1983, p. 379, n. 21), and would seem, therefore, to have entered Cardinal Flavio Chigi's collection after 1666–69, being found at his villa at the Quattro Fontane by 1692.

It has generally been thought that this terracotta is a *bozzetto* or sketch by Bernini of an earlier idea for the Charity at the tomb of Urban VIII. However, even if the intention in 1630 had been to reduce the number of children from three to two (*cf.* CAT. NO. 17), that would not be sufficient grounds for the identification of this *bozzetto* as an earlier work – and anyway it shows four children. Nor can it be thought of as a development of the much better rendered and more plastically defined model. Indeed, the comparison between the two is all in favour of the latter. The present Charity is not so firmly poised in her overemphatic *contrapposto*, nor is the modelling so evocative. There is almost no contrast between the textures of the drapery; and the flames of the reversed torch held by the child on the right are scarcely distinguished from the ground. The legs of the sleeping child are awkwardly flattened, as are the arms of those embracing on Charity's left. This sketchiness gives the *bozzetto* a certain vivacity and delicacy, especially in the sharp incisions that define the minute features of the faces, which is quite different from the powerful evocation of mass and movement and the bold stylization of form to create effects of light and shadow that give Bernini's terracottas that same softness of dough or wax that he aimed at and attained in marble.

It is not to be excluded that Bernini's sketches in the late 1620s were considerably different from the better-known examples of a later date (*cf.* I. Lavin, "Calculated Spontaneity. Bernini and the terracotta sketch," *Apollo,* CVII, 1978, pp. 398–405). The authenticity or otherwise of what have been thought to be models for early works, such as that at the Louvre for St Bibiana (*cf.* R. Wittkower, *Gian Lorenzo Bernini,* 1966, cat. 20), could be definitively established by comparing the fingerprints so clearly visible in the present terracotta, as in the St Bibiana, with those on the Daniel (CAT. NO. 21), or on the Ludovica Albertoni at the Victoria and Albert Museum.

Rather than attempt to replace an attribution that cannot at present be proved or disproved, it is worth pointing out that the present terracotta could equally well be an example of the lasting influence of Bernini's Charity at the tomb of Urban VIII, whose composition was later copied very closely, and indeed in the gesture of the right arm almost identically, by Giuseppe Mazzuoli in the figure of Clemency at the tomb of Clement X (*cf.* U. Schlegel, "Per Giuseppe e Bartolomeo Mazzuoli. Nuovi contributi," *Arte illustrata,* 5, 1972, p. 43, fig. 10).

M. W.

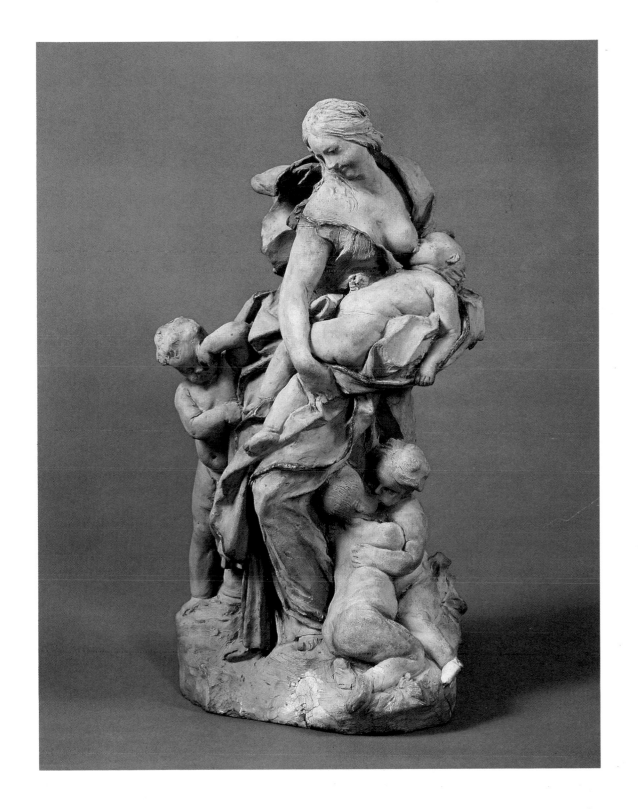

Alessandro Algardi (BOLOGNA 1598–1654 ROME)

The Baptism of Christ 1645–46

Terracotta, 48.7 × 47.8 cm
Biblioteca Apostolica Vaticana,
Museo Sacro (Inv. no. 2426)

This terracotta group, with another that the artist bequeathed to his patron Monsignor Cristofano Segni, was made in relation to a silver Baptism of Christ presented by Algardi to the newly elected Pope Innocent X, together with a Crucifix also in silver (see J. Montagu, *Alessandro Algardi*, New Haven and London 1985, I, pp. 82–86 and II, L.8 and 8.B.2; and the same author's earlier article "Le Baptême du Christ d'Alessandro Algardi", *Revue de l'Art*, 15, 1972, pp. 64–78). Both works are recorded in the collection of the Pontiff's nephew in 1666, but can no longer be traced and were presumably melted down. They are known, however, through bronze casts and, in the case of the Baptism, through this terracotta group, the Segni one also having been lost from view.

Documents of the Congregazione della Reverenda Fabbrica di S. Pietro record that a baptismal font was ordered from Algardi on 23 February 1646 at the direction of the Pope, who was aware that there was available in the papal foundry a sufficient quantity of metal for the purpose (Montagu, *op. cit.*, II, L.99). This commission was apparently a direct outcome of Algardi's gift of the silver group to the Pontiff at the instigation of Monsignor Segni (unless, of course, Segni had had prior knowledge of the Pope's intentions and had encouraged Algardi to submit the silver in an attempt to win the commission), but the project was not realized. Only under Innocent XII did Carlo Fontana make the font for St Peter's, at which time there was still a record of Algardi's design in the Fabbrica.

This terracotta group was recorded in the collection of Cardinal Flavio Chigi at the casino in the gardens of the Quattro Fontane as early as 1666, so it cannot have been that of Monsignor Segni, because the group willed to the latter is recorded with heirs in Bologna as late as the mid-18th century. Of the numerous bronze casts that exist, perhaps the finest – actually cast in several pieces – is that today in the Cleveland Museum, of which the base bears the arms of the Marchesi Franzone. Comparing the terracotta and bronze, it is apparent that the terracotta is lacking the figure of the baby angel who flies between the figures of Christ and the Baptist in the bronze, holding the extended mantle to Christ, its wing touching the rock on which the Baptist kneels. The terracotta bears signs of having been broken in various places and, given the irregular truncation of Christ's drapery where the angel's foot would have rested, it would appear that it had been lost rather than not yet conceived at this point. It should be noted, however, that the angel does not occur in an early rudimentary study for the Baptism which is in the Uffizi collection (see W. Vitzthum, "Disegni di Alessandro Algardi", *Bollettino d'Arte*, XLVIII, 1963, fig. 29). It seems clear, however, that Algardi's working model was that which he bequeathed to Segni. The quality of the Chigi example is such that it is held to be original by both Jennifer Montagu and Olga Raggio (*The Vatican Collections*, Metropolitan Museum of Art, New York 1983, no. 30) and, given its otherwise very finished quality, it may represent an autograph *ricordo* of the composition rather than a preparatory study.

Although Algardi was not to execute the baptismal font for the Basilica, other works by him in St Peter's include the enormous marble relief of *The Encounter of St Leo the Great with Attila* (1646–53) and the tomb of the Medici Pope Leo XI, who had reigned briefly in 1605. This monument was ordered from Algardi by his nephew Cardinal Roberto Ubaldini in 1634 and was largely completed in 1644, although only put in place in 1652. There the full-length marble representation of Leo XI is flanked by the figures of Magnanimity and Liberality. A somewhat damaged terracotta *bozzetto* for this last figure, quite different from the realized tomb figure, was recognized by Olga Raggio among those now in the Vatican ("Bernini and the Collection of Cardinal Flavio Chigi," *Apollo*, CXVII:255, 1983, p. 378, fig. 26).

C.J.

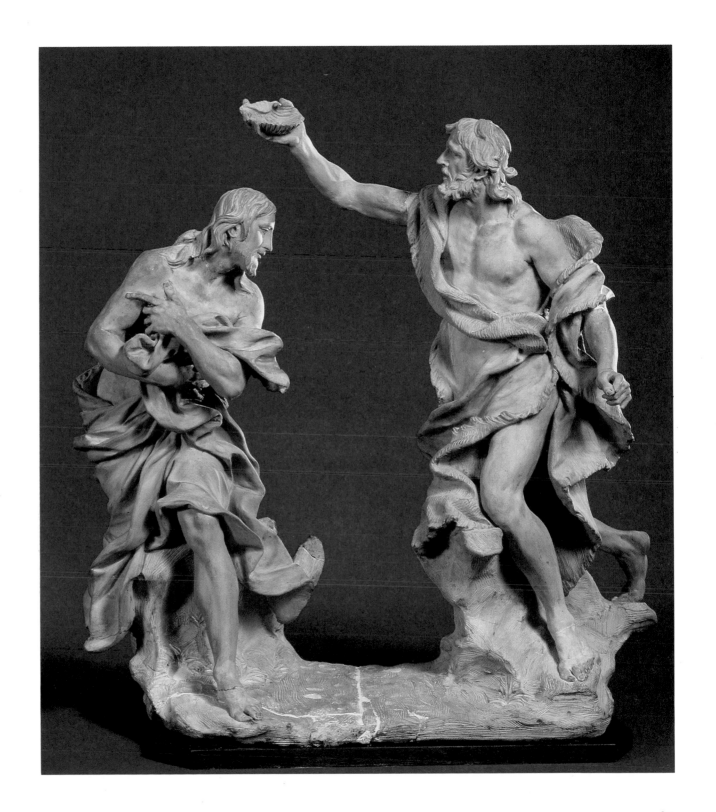

Alessandro Algardi (BOLOGNA 1598–1654 ROME)

Crucifix with 'Cristo Vivo'

Corpus, gilt bronze, 73 cm,
on ebony cross
Vatican, Archivio Segreto

Algardi is chiefly associated with the Pamphilj pontificate, when he was given major commissions at a time when Bernini was out of favour and the Barberini had gone into exile. He arrived in Rome in 1625, at which time he worked on restoring antique statues for Cardinal Ludovisi. Two drawings for a papal galley inscribed *Urbano* suggest that he was employed by the Barberini even in a minor capacity. He made the bronze relief with Jesuit Saints for the urn of St Ignatius Loyola in the Gesù (1629) and a marble statue of St Philip Neri for the Chiesa Nuova (1636–38). Chiefly he seems to have been occupied with the production of silver objects of both a liturgical and decorative nature. According to Bellori, early in the reign of Innocent X, Algardi presented the Pope with a silver Crucifix and a silver group of the Baptism (see CAT. NO. 19). The Crucifix was described as representing the live Christ, nailed to the cross with four nails and wearing a crown of thorns and loin-cloth. It measured three hands in height and was mounted on an ebony cross six and three-quarter hands high and three wide. Trace of this Crucifix and the Baptism is lost after the 17th century, and they are presumed to have been melted down (see J. Montagu, *Alessandro Algardi*, pp. 328–341), but they are both known through bronze casts, many of them gilded, of which the present example is one.

A drawing from Algardi's hand inscribed with his name and the date 1647 clearly relates to the Crucifix as known through the bronze replicas, especially regarding the direction of the head and the feature of four nails – three nails being the usual number. The loin-cloth swings out in the opposite direction, however. Two more working drawings in Modena and the Uffizi document Algardi's progression in perfecting this project (see C. Johnston, "Drawings for Algardi's Cristo Vivo," *The Burlington Magazine*, CX, 1968, pp. 459–460). The date on the first drawing (recently on the market and now belonging to David Tunick, New York) suggests that the silver crucifix given to the Pope must therefore postdate the silver group of the Baptism, because the latter was the basis for Algardi being awarded a commission for the baptismal font in St Peter's early in 1646.

Algardi's *Cristo vivo* is one of the most common images of this theme in the 17th century, together with the two types of the *Cristo vivo* and *Cristo morto* which Bernini designed a few years later for the altars in St Peter's (see CAT. NOS. 24 and 25). Bernini's crucifixes are approximately 25 cm smaller than Algardi's and have only three nails each. Usually the more classical of the two sculptors, Algardi in this case makes the more dramatic representation. There is a very clear swaying motion in the torso, sideways, in the opposite direction to that of the billowing loin-cloth, and back again with the knees. Apart from his smaller silver crucifix, Algardi executed a large *Cristo morto*, less animated in handling. This was the bronze made for Ercole Alamandini for his chapel in the Jesuit Church of Sta Lucia in Bologna, though never placed there. Jennifer Montagu has indicated that this was exhibited in the Bolognese Church in Rome for the obsequies of the Marchese Ludovico Fachinetti in April 1644, for which Algardi also designed the catafalque. From the Alamandini Palace in Bologna this work returned to Rome via heirs and was subsequently acquired by Cardinal Fesch, in whose sale in 1824 it was described as six feet high. The model for this large crucifix is the polychromed clay Crucifix today in the Chapel of the Palazzo del Governatorato in the Vatican (Montagu, 1985, II, 15.B.I), but it was given by Algardi the year before his death to the Chaplain of the Church of Sta Marta in the Vatican, for which Algardi's patron Monsignor Cristofano Segni erected a chapel. The bronze crucifix made for Agostino Franzone and today in the Church of SS. Vittorio e Carlo, Genoa, was also made after this model (Montagu, 1985, II, 15.C.3).

C.J.

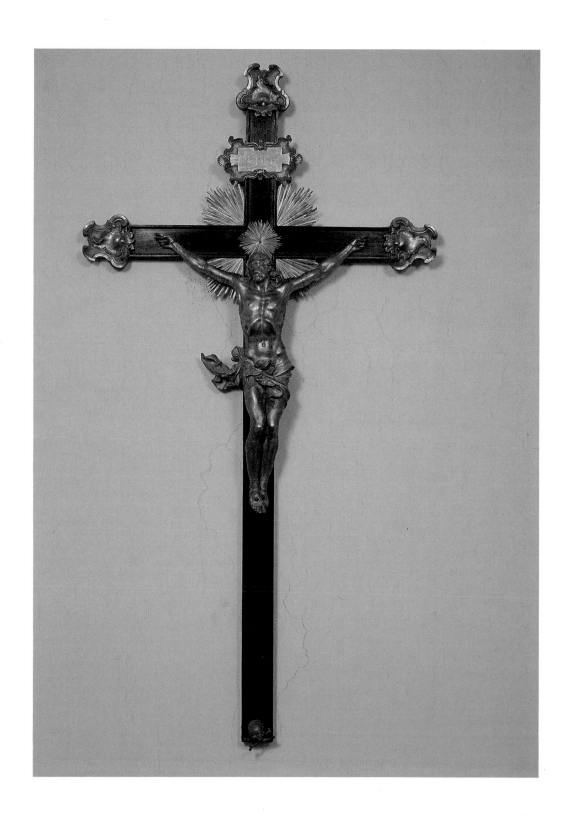

Gian Lorenzo Bernini (NAPLES 1598–1680 ROME)

Daniel in the Lions' Den

Study for the completion of the Chigi Chapel at Sta Maria del Popolo
Terracotta, 41.6 cm
Biblioteca Apostolica Vaticana, Museo Sacro (Inv. no. 2424)

The recent cleaning of this terracotta has removed any lingering doubts about its authenticity as an autograph work by Bernini. The confident sureness of the rapid modelling, that had been veiled by several coatings of bronze-coloured paint, is now clearly revealed. The precision in the definition of details had caused this piece to be considered a model rather than a sketch, and therefore more likely to be the work of a studio assistant. Such a high degree of finish was thought to be incompatible with the impatient fury of Bernini's genius. However, the notable differences in pose between the terracotta and the marble statue which occupies the niche in the Chigi Chapel in a way that tightens the compositional relationship between Daniel and the lion, suggest that the figure must have been further studied before the large model was prepared by assistants for Bernini to perfect. Bernini advocated taking great care over finish in drawing. The quality of his marble sculptures consists as much in the extreme refinement of surface treatment as in the play of light and shadow, the sense of energetic movement, the vitality of body, and the emotion of soul that they convey.

In the Daniel, Bernini has expressed through the composition the inner state of the prophet by externalising it in the flamelike form of the drapery, which enhances the upward tension of the gesture of ardent imploration for rescue from mortal danger. In relation to the pyramidal tomb which the statue flanks, the association with fire is reinforced by the more explicit imitation of flames evoked by the veining of the reddish-orange Porta Santa marble with which the pyramid is faced. Daniel is referred to in the Requiem Mass for the dead in which the offertory antiphon invokes their liberation from the mouth of the lion and from the deep pit. The floor-roundel designed by Bernini representing a winged skeleton emerging from the deep pit, represented by the black background implying the space of the crypt beneath the chapel, forms part of the narration of a single event in which Daniel is related across the space of the chapel to Habakkuk (*cf.* CAT. NO. 22) and each to the skeleton and through him to the Eternal Father in the cupola. A representation of Daniel is presupposed by the sequence of the events prefigured by the two prophets already present. Jonah, who was swallowed by a whale and cast up unharmed after three days, is an antetype of the burial and resurrection of Christ. Elijah, who was drawn up to heaven in a fiery chariot, foreshadows the Ascension. Daniel in the lions' den under the earth signifies the descent of Christ into Limbo. Habakkuk completes the sequence as the prophet of the universality of Redemption.

The complementary relationship between Daniel, Habakkuk, and the skeleton suggests that the subjects were determined contemporaneously. The date of the roundel is concealed in the inscription (now short of a word) which read: *Mors aD CaeLos Iter* – Death is the journey to the Heavens. The capital letters spell MDCLI, leaving the letters *ter* which is Latin for thrice. MCDLIter reads therefore as 1653. This date is confirmed by a contemporary document describing the roundel as a seal to the sepulchral crypt (*cf.* G. Cugnoni, "Agostino Chigi Il Magnifico," *Archivio della Società Romana di Storia Patria*, III, 1880, p. 440). This seems to indicate the awareness of the skeleton's association with the vision of Daniel together with whom the dead will be saved from the deep pit where they are sustained by the Eucharist, just as Daniel was by the food brought by Habakkuk without breaking the seal set by the King of Babylon on the stone rolled over the entrance.

The fact that models for the statues are not mentioned in the diary of Alexander VII would tend to confirm that they were commissioned before the conclave begun in January 1655, at which he was elected Pope in April. Cardinal Fabio Chigi's accounts do not appear to have survived. From payments made during his pontificate it is known that the marble of Daniel was completed by June 1657 (*cf.* R. Wittkower, *Gian Lorenzo Bernini*, 1966, cat. 58). In September 1653, Fabio Chigi, who had been created cardinal the previous year shortly after his return to Rome after an absence of over two decades, was negotiating with Algardi as well as Bernini who were each to carve a statue (*cf.* J. Montagu, *Alessandro Algardi*, 1985, p. 263, n. 6), implying that the subjects were already established.

M. W.

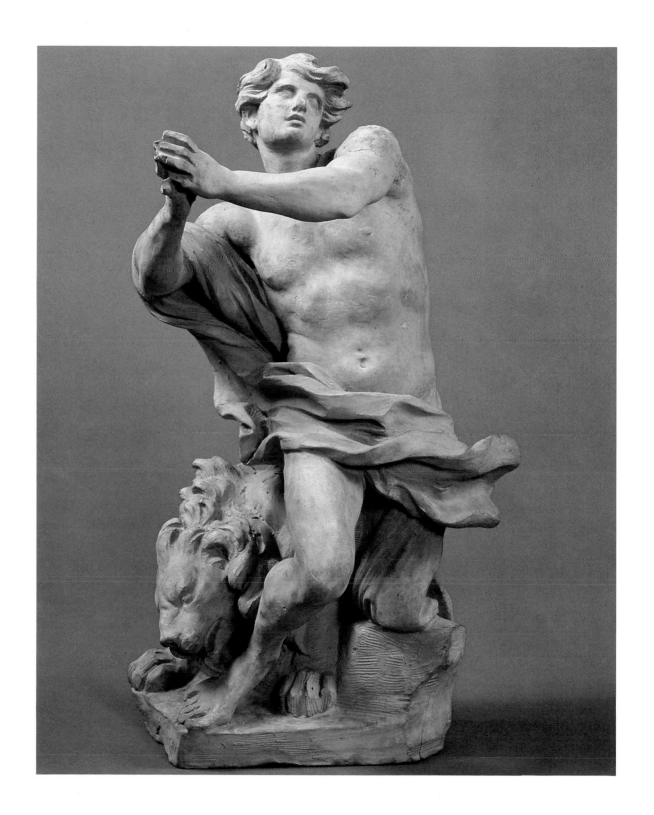

Gian Lorenzo Bernini (NAPLES 1598–1680 ROME)

Habakkuk and the Angel

Study for the completion of
the Chigi Chapel at Sta Maria
del Popolo
Terracotta, 52 cm
Biblioteca Apostolica Vaticana,
Museo Sacro (Inv. no. 2425)

Slightly larger than its companion-piece Daniel (CAT. NO. 21), and more fully defined in its details, this terracotta group of Habakkuk and the angel was probably the final model closely adhered to in the course of subsequent work, though with some slight modifications, which indicate that this is not a copy after the finished marble. Nor does it seem likely that Bernini would have delegated to an assistant the elaboration of those details that were to be essential to the quality of refinement and "perfection of grace and tenderness." At the stage represented by this model, when the ideas were still in Bernini's mind, there could not yet have been sufficient indication of his intentions for the surface treatment for an assistant to be able to interpret with such a degree of precision. A full-scale version could then be entrusted to the skill of an assistant and in varying measure perfected by Bernini. The marble would be blocked out, and in complex commissions such as the tomb of Alexander VII, carved almost entirely by other sculptors. Bernini would then give a few finishing touches.

The modelling of the present group is of astonishing virtuosity in the contrast between the maturity of Habakkuk's firmly built body, and the boyishness of the tender, almost chubby, angel. His soft locks are smoothly modelled to set them off against the crispness of the prophet's thick hair and beard. These contrasts are further reinforced by the different textures of their drapery, the heavy earthbound cloak of the prophet setting off the veil of the angel almost as light as the air through which he flies, scarcely needing his wings, which by their fluffiness serve more to express his nature as a spiritual being.

In the Chigi Chapel the group is placed diagonally across from Daniel towards whom the angel points, thus charging the intervening space through which he is about to transport Habakkuk, lifting him by a lock of his hair. The story is told in the Book of Bel and the Dragon, an apocryphal addition included in the Septuagint version of the Book of Daniel, of which the only existing Greek manuscript was in the Chigi Library (*cf.* R. Wittkower, 1966, p. 9). However, it is not this circumstance that could have determined the choice of subject, nor was the rearrangement of the statues in the present niches due only to compositional considerations. For the name of Habakkuk was already associated with the Chigi Chapel in a description that identifies him as the subject of the other pre-existing statue generally considered to represent Elijah (*cf.* G. Alberici, *Originis et caussae S. Mariae de Populo narratio*, Rome 1598, p. 14). In an unpublished description of the Chapel written in 1657 for Alexander VII, the author inaccurately attributes the identification as Habakkuk to Vasari, and states that in his opinion the sculpture should be identified as Elijah. Whether Bernini consciously or not relegated the pre-existing statue to the unequivocal rôle of an Elijah, his designing a Habakkuk provided him with the opportunity to link the composition with the Daniel as well as with the centre of the floor, itself related to the cupola, thus creating a kind of vortex that compels the eye to recognise the completed cycle of time that ends in the cupola where it began with the Eternal represented there.

Habakkuk is shown with the basket of food that he was taking to the workers in the field, in whose direction he is pointing. However, the angel appears and indicates Daniel's need. The Eucharistic significance of the food in the basket, underlined by the fringed cloth alluding to liturgical linen, is subtly reinforced by the effect of the apparent suspension of the basket over a void, which is more marked in the terracotta than in the marble. The block from which the latter was carved was transported in October 1656, and the completed group placed in the niche on the epistle side of the altar, the viewer's right, in November 1661 (*cf.* R. Wittkower, 1966, cat. 58). It is interesting to note that another terracotta figure of Habakkuk was recorded by P.-J. Mariette with other Bernini *bozzetti* in the collection of Pierre Crozat (sale: Paris 1750, cat. pp. 37-39, nos. 174 and 183).

M.W.

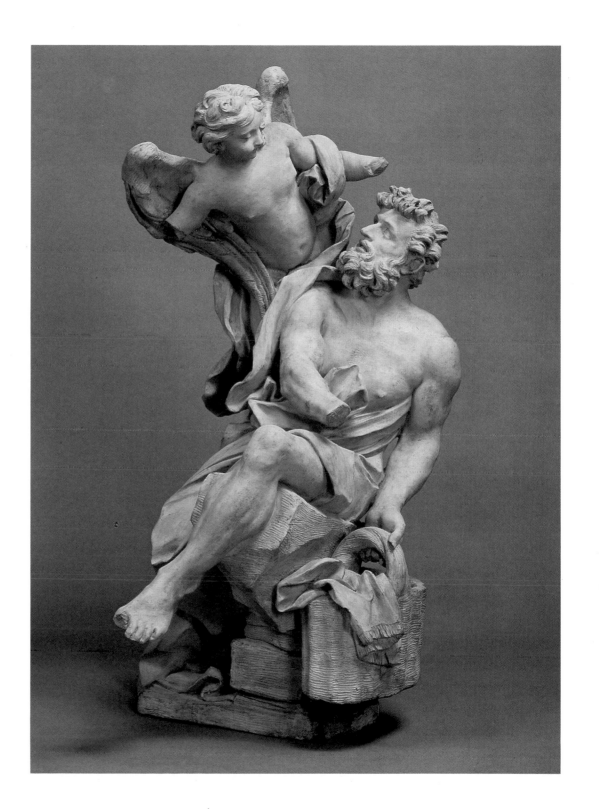

Gian Lorenzo Bernini (NAPLES 1598–1680 ROME)

Medallion Portrait of
Alexander VII

Cast bronze, dark brown patina,
flawed, 34 cm
Biblioteca Apostolica Vaticana,
Museo Sacro (Inv. no. 2049)

This portrait, and the obverse of the medal with Androcles and the lion on the reverse (CAT. NO. 28), are clearly derived from the same original model. The indication of Bernini's authorship on the engraving of the latter therefore applies also to the present medallion. The original drawing for the reverse is mentioned in Cardinal Flavio Chigi's inventory (*cf.* M. Worsdale, *Revue de l'Art*, Vol. 61, 1983, p. 71, n. 94), together with a round portrait drawing clearly associated with it, being approximately two centimetres wider than the medal. It may have been a reduction in scale of a larger drawing taken from life and also modelled in terracotta. The example of the present medallion visible in a photograph of Palazzo Chigi in Palazzo Colonna dating before 1917 may correspond with a terracotta medallion mentioned in the inventories of 1666–69 (Biblioteca Apostolica Vaticana, Archivio Chigi, 702, fol. 115v).

The somewhat caricatured portrayal is characteristic of Bernini's other profile portraits of popes, which seem to be deliberately schematic with a view to their translation into medals (*cf. Bernini in Vaticano*, nos. 282, 320). Another profile drawing has recently come to light (*cf.* M. Trudzinski, forthcoming catalogue of drawings at the Landesgalerie, Hanover), representing Clement IX (FIG. 11). It shows the same plasticity of the facial muscles typical of a sculptor's drawing for a work to be translated into low relief, requiring the animation of surface by strong highlights, obtained by subtle changes of level, creating the appearance of projecting forms, although their roundness is actually flattened. In the drawing, the eye has a similar globular appearance as that in the medallion. Clement IX is shown wearing the summer *camauro* or cap, which he also wears in the medals that may be derived from the portrait (*cf. Bernini in Vaticano*, no. 313, and more freely elaborated, no. 315). The profile drawing of Innocent X attributed to Algardi (FIG. 19) shows the Pope with the ermine-lined winter *camauro*, which is that worn in the medals that also appear to derive from it (CAT. NO. 27). The reversal of the direction of the portraits in the struck medals would tend to confirm the relationship, for in copying the model made in positive from the drawing, the engraver would copy it in the same direction in carving the die in negative, which would produce a reversal of the original. Successive medal portraits were probably derived from previous ones, as appears to be the case with the third annual medal of Clement IX (*Bernini in Vaticano*, no. 314), again reversing the image and therefore returning to the direction of the prototype, but further removed from it in fidelity of interpretation.

M.W.

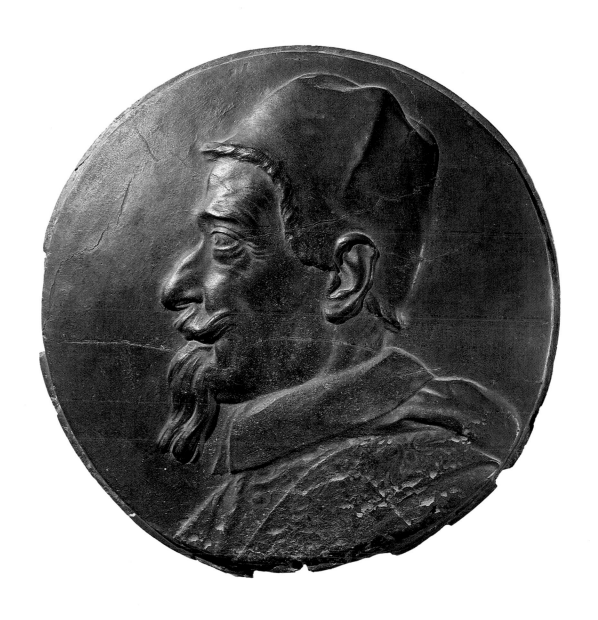

Crucifix with 'Cristo Vivo'
1659–61

Corpus, gilt bronze, 43 cm; Cross, bronze, warm brown patina, 185 cm
Reverenda Fabbrica di S. Pietro

Gian Lorenzo Bernini (NAPLES 1598–1680 ROME); Ercole Ferrata (PELLIO INFERIORE 1610–1686 ROME); Paolo Carnieri or Giovanni Artusi; Bartolomeo Cennini; Gio. Maria Giorgetti

25

Crucifix with 'Cristo Morto' and Candlesticks 1657–61

Corpus, gilt bronze, 43 cm; Cross, bronze, warm brown patina, 185 cm; Candlesticks (see overleaf), bronze, varying heights
Reverenda Fabbrica di S. Pietro

Gian Lorenzo Bernini (NAPLES 1598–1680 ROME); Ercole Ferrata (PELLIO INFERIORE 1610–1686 ROME); Paolo Carnieri; Bartolomeo Cennini; Gio. Maria Giorgetti

The altars in St Peter's are furnished with identical sets of six large candlesticks, and two smaller ones for low Masses, flanking a crucifix on a matching base displaying the Chigi mountains and star. There are two types of crucifix, one showing Christ dead, and the other alive still, as he cries the Seven Last Words. The *Cristo vivo* was designed later, but for the purpose of comparing the formal characteristics of each, it is preferable to consider them in their narrative rather than chronological sequence. The compositional curve that runs through the body of the *Cristo vivo* conveys a sense of writhing effort to raise the chest and gain breath to emit that final cry to Heaven. The curves are reinforced by concentrated repetition in the hair framing the head, which is also tilted upwards. The tension of the figure comes to a climax in the expression of the face accentuated by the circumflex formed by the eyebrows. By comparison with Algardi's earlier version of the same theme (*cf.* CAT. NO. 20) the effect is far more intense, especially in conveying the sense of exhausted strength. The way in which the hair falls to the shoulders effectively links the head to the body from which it is barely able to rise, transforming the upward movement into one of sinking downward. Thus the narrative range is completed, showing in a single image three successive moments. The next moment is represented in the *Cristo morto* where the body hangs straight down causing the knees to bend forward. In the *Cristo vivo* the left leg was set further back than the right, conveying the attempt to straighten the body. The hair of the dead Christ is still held back as if by the momentum of the sudden drop of the head. A moment later the face would appear veiled as the hair follows in the movement.

The models for the crucifixes were executed by Ercole Ferrata to designs by Bernini, those for the cross and candlesticks by Gio. Maria Giorgetti. R. Battaglia (*Crocifissi del Bernini in S. Pietro in Vaticano*, Rome 1942, pp. 9–10) remarked that the latter reflects the woodenness of the model from which they were cast in a way that fails to exploit the potential of bronze. However, this could be considered the achievement of an intentional effect successfully evoking, in spite of the metallic quality of bronze, the wood as such, which in liturgical hymnography is synonymous with the Cross extolled also as the Tree of Life. The extent of Ercole Ferrata's fidelity to Bernini's design has been much discussed. The presence of the model in Ferrata's studio has been considered to weigh in favour of the claim to a considerable share of authorship on his part, since he retained the original from which he could have further casts issued. However, Bernini's design would have taken the form of terracotta sketches. It may be no coincidence that a metal-coloured terracotta crucifix (larger by a third, though it is not stated whether that excludes the cross) is mentioned in Cardinal Flavio Chigi's inventory of 1666–69 (Biblioteca Apostolica Vaticana, Archivio Chigi, 702, fol. 125).

The crucifixes with *Cristo morto* were commissioned by the Fabbrica of St Peter's with the approval of Alexander VII in 1657. In 1669 the Pope ordered the second type with *Cristo vivo*. The uniformity, not without variation however, that these furnishings bestow on the altars of St Peter's, is characteristic of Alexander VII's concern for all-embracing planning, manifest in the commission of pilaster drapes for canonizations in St Peter's (*cf.* CAT. NO. 31) as well as in the gesture of the colonnade (*cf.* FIG. 10 and CAT. NO. 37) or in the numerous public works projects so assiduously listed in his diary. The medals issued in his reign follow an unusually regular format that seems to reflect the same concern with order. It was said of him that he was greatest in things of least importance, and least in things of greatest importance. However, the unfairness of the statement is well demonstrated by the wide scope even of apparently so minor a contribution as his commissioning altar furnishings. For these subtly prevent the Basilica from disintegrating into a heterogeneous assemblage of works vying for attention against a total effect of unified monumentality. Nor is it only the uniformity of furnishings that achieves this, but also their ability to hold their own by the strong presence conveyed through the extraordinarily powerful modelling of the figures, by no means overwhelmed by their vast surroundings.

M. W.

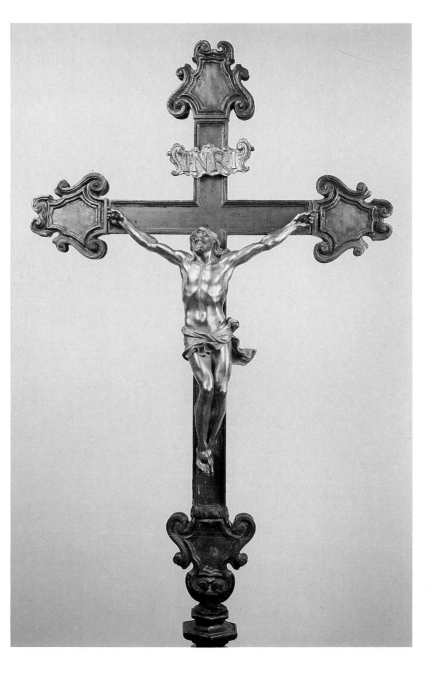
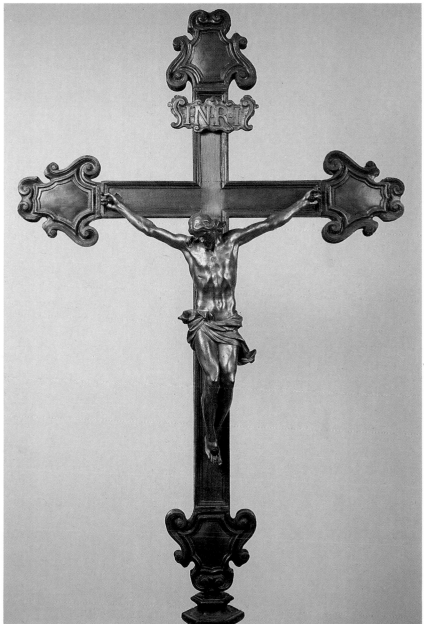

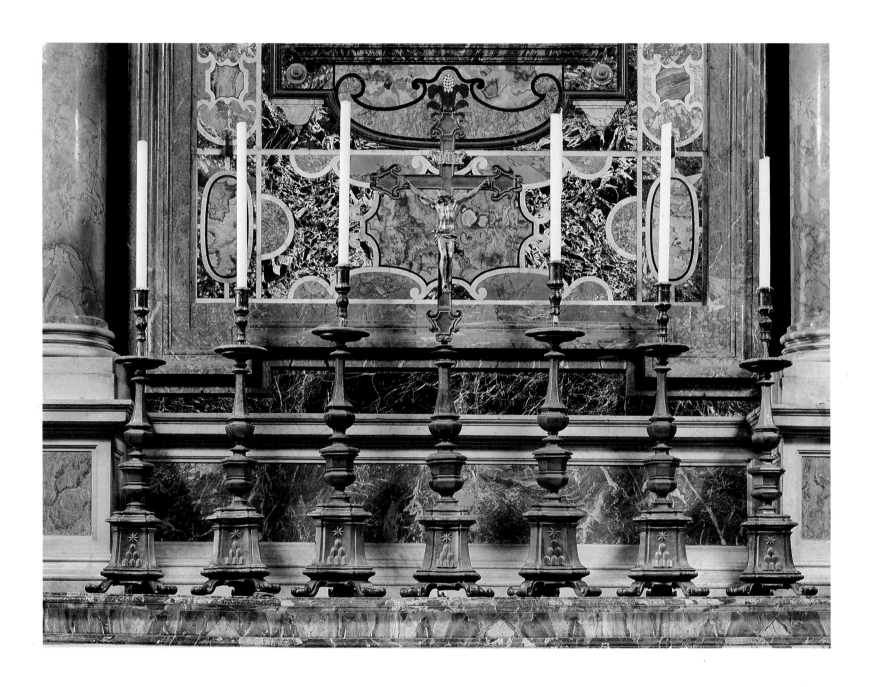

Gasparo Morone Mola (d.1669 ROME)

Annual Medal of Innocent X,
Year VIII, with the Fountain of
the Four Rivers in Piazza
Navona 1652

Struck bronze, warm brown
patina, 39 mm
Biblioteca Apostolica Vaticana,
Medagliere

The reverse of this medal is a re-issue of that used in 1648 for the laying of the foundations of the Four Rivers Fountain in Piazza Navona, and was intended to commemorate the fountain's inauguration in 1651. The view of the Piazza is oriented towards the south, showing Palazzo Pamphilj on the right, with its Belvedere, the Church of S. Giacomo degli Spagnoli on the left, and in the distance the dome of S. Andrea della Valle. One will notice that the personification of the River Plate on the right is making a gesture that was popularly considered to signify fear that the exorbitantly tall bell-towers of the neighbouring church of S. Agnese (designed by Bernini's rival Borromini, *cf.* CAT. NO. 27) would collapse. The Nile is shown with his head shrouded, to signify the River's unknown source, or as popular belief would have it, to protect himself from the ghastly sight of Borromini's "heretical" architecture.

Among the many legends inextricably intertwined in the history of the fountain there is the assertion that Bernini, in disfavour with Innocent X because of his association with the Barberini and disgraced by the dismantling of his bell-towers for St Peter's, had not been invited to submit a project but nonetheless succeeded in wresting the commission from Borromini. This much may well be true, as may the story that Bernini's design was brought to the Pope's notice by Prince Nicolo Ludovisi, who had become papal nephew by marriage. According to the biography by Bernini's son, Domenico, Prince Ludovisi commissioned the design without letting on that he intended to show the model to the Pope, but pretended that he wanted it for his own satisfaction. The story has it that he smuggled Bernini's model into the Pamphilj Palace in Piazza Navona, and placed it on a table in a room through which the Pope was to pass on his way out of a banquet. Interestingly, the typology of the fountain, with its low, dish-like water-basin, is that of a *trionfo da tavola* or table ornament made of edible materials (*cf. Bernini in Vaticano*, nos. 258 and 270, fig. p. 233). This context may even have been suggested by Bernini, so as to draw attention to the effect the completed work would have on the long table-like shape of the Piazza, which could probably be seen in the background through the window. That such may

indeed have been the intention of the design seems to be confirmed by the inscription on the south side of the base of the obelisk, which states that the fountain was munificently willed by Innocent X to provide amenity to strollers, drink to the thirsty, and food for thought (*meditantibus escam*).

The story that Bernini had the model cast in silver so as to appeal to the Pope's sister-in-law by the material rather than artistic value of the piece appears to be founded only on hearsay (*cf.* the contemporary letter published in S. Fraschetti, *Il Bernini*, Milan 1900, p. 180). There is no mention of a silver model in the biographies or in the Pamphilj inventories. The story may have arisen from the gilding of the model, which would also have conformed to the type of a sugar sculpture. The existing model is gilded. However, its origins are not entirely clear, for it does not appear to be mentioned in the early inventories of Bernini's household (unless it is the unspecified gilded model, which seems to be mentioned together with that for the Triton fountain "di Barberini"; *cf.* F. Borsi, C. Acidini Luchinat, F. Quinterio, *Gian Lorenzo Bernini, Il testamento, la casa la raccolta dei beni*, Florence 1981, p. 112). For discussion of the obverse portrait of Innocent X, *cf.* CAT. NO. 23.

M.W.

*Annual Medal of Innocent X,
Year X, with the Project for the
Church of S. Agnese in
Agone* 1654

Struck bronze, warm brown
patina, 38 mm (actual size)
Biblioteca Apostolica Vaticana,
Medagliere

The reverse illustrates the state in 1654 of Borromini's project for the Church of S. Agnese in Agone, whose foundations had already been laid from 1652 to the plan of Girolamo and Carlo Rainaldi, who were dismissed because the Pope had heard that their design was not highly considered and would therefore fail to impress. The commission passed on to Borromini who was also dismissed in 1657 as a result of complaints from the workmen, who claimed to have insufficient instructions from the absentee architect. The existing church is therefore considerably different from the project shown in the medal, which is already a simplification necessitated by the constraints of the format and the resilience of the material. The representation is effective, however, deriving its clarity from the reduction to essentials adopted by Borromini, who designed the medal for which his drawing survives (*cf.* G. Eimer, *La Fabbrica di S. Agnese in Navona*, Stockholm 1970, I, pl. LXXXIV, 120). His intentions were well served by the engraver of the die, Gasparo Morone Mola, whose somewhat linear interpretation achieves a very elegant balance of contrasts between light and shadow through a masterly distribution of plane surfaces and salient ridges.

The date of the medal, three years after the inauguration of the Four Rivers Fountain (*cf.* CAT. NO. 26), clearly reveals the legendary character of the disparaging gestures supposedly made by the River Plate and the Nile (and the assertion that the solitary statue of St Agnes on the façade is returning the compliment with the same coinage). A likelier interpretation emerges as one enters the Piazza on the short axis facing the church and sees the silhouette of the raised hand of the *River Plate* (the personification of the last of the continents to be evangelised) cowering from the light of truth represented by the church. The antagonistic relationship is all the more striking when the façade is illuminated by the morning sun, while the River Plate still remains in the shadow of the buildings on the opposite side. But as one moves round the fountain one realises that the River Plate's gaze is directed towards the obelisk which he fears is about to topple. This effect of double perspective transfers the significance of the church to the obelisk, which represents a ray of light coming down from on high. For, according to Athanasius Kircher, who advised on the restoration of the obelisk and inspired the iconography of the fountain, an obelisk is "the finger of the sun," as he expressed in a project for a sun-dial in Piazza S. Pietro (Biblioteca Apostolica Vaticana, Cod. Chigi H II 22, fol. 253).

If any deliberate irony had been intended, it would have been on Borromini's side, for in actual chronological sequence the last laugh is with the statue of St Agnes on the façade. However, the impropriety that this would imply in making light of sacred images is unthinkable in view of the prevalence of ecclesiastical censorship.

There exists a circular drawing by Algardi representing St Agnes on a cloud in front of a church (FIG. 18; *cf.* G. Eimer, *op. cit.*, p. 775), which may have been an alternative proposal for this issue. The obverse portrait is much closer to a drawing of Innocent X attributed to Algardi (FIG. 19) than are the bronze and marble portraits with which the drawing has been associated. The medal shows the same raising of the eyebrows resulting in a markedly furrowed forehead. It also shows the same wrinkling around the corner of the eyes, which have that same unusual alertness not to be found in other portraits of Innocent X.

M.W.

*Medal in Honour of
Alexander VII, with Androcles
and the Lion* 1659

Cast bronze, warm brown
patina, 99 mm
Biblioteca Apostolica Vaticana,
Medagliere

This superb large-module medal stands out amongst papal medals both for its exceptional monumentality and for its technique, reviving the long-neglected tradition of casting rather than striking. The design is possibly the most successful of all papal medals, rivalled only by those of the *Scala Regia* (CAT. NO. 30) and of the *Cathedra Petri* (CAT. NO. 29). The impression of softness conveyed by the thickness of the bronze achieves wonderful effects of shifting light over rippling forms, especially remarkable in the splendid silver example in the Cabinet des Médailles at the Bibliothèque Nationale in Paris.

The reverse shows a Roman soldier in an arena drawing back in surprise upon seeing the vigorous lion folding up before him and meekly rolling its head on the ground, more like a faithful lapdog with its tongue lolling out, intent on licking the foot of its master. The lion has its tail between its legs as if begging for pardon for having been so fierce just an instant before this sudden interruption of conflict. The compositional lines of two diagonals, one running along the lion's back and the other in the opposite direction through the soldier's raised sword down through his right leg, reinforce the rift that tears them apart. The soldier's sword-hand is level with the shoulder, visually blocking the downward movement of the stroke. Mouth agape, the soldier abandons the guard of his shield as he raises his other arm in astonished recognition of the lion that he, Androcles, had once befriended in the wild, removing a thorn from its paw. As the inscription proclaims on an illusionistic scroll, "The beast, too, remembers the kindness."

This episode, taken from the *Attic Nights* of Aulus Gellius, is recommended in Giovanni Ferro, *Teatro d'Imprese* (Venice 1623, p. 432) as a suitable subject to signify gratitude. The inscription on the upper border of the medal states that it was dedicated by Domenico Jacobacci in 1659 to his Munificent Prince, that is Alexander VII, who is portrayed on the obverse. The inscription on the engraving (FIG. 12), also designed by Bernini, publishing abroad the design, printed on paper more lasting than bronze (*cf.* INTRODUCTION, P. 29f.), enumerates Alexander's benefits to the Senate and People of Rome, on whose

behalf Jacobacci expresses gratitude for succour during the plague, for the building of streets, squares, fountains, and other public projects.

Androcles' tunic is still agitated by the momentum of his suddenly arrested movement. Commotion is spreading through the dense crowd of spectators, some of whom had been sitting perilously over the edge of the barrier and are shown still cowering away from the lion, whilst others seem about to descend into the arena. The device of involving the viewer by representing the reactions of other viewers is reminiscent of the effect of the onlookers in the Cornaro Chapel and of the comedy that Bernini recalled in 1665, in which the audience was confronted with a stage-set of another audience, making them feel as if they were the play (*cf.* C. D'Onofrio, *Fontane di Trevi, commedia inedita di Gianlorenzo Bernini*, Rome 1963, p. 94). The imagination completes the amphitheatre which seems to curve behind the onlooker who is thus placed at the forefront of the action in the middle of the arena. For discussion of the obverse, *cf.* CAT. NO. 23.

M.W.

Annual Medal of Alexander VII, Year VIII, with the Cathedra Petri 1662

Struck silver, 40.5 mm
Biblioteca Apostolica Vaticana, Medagliere

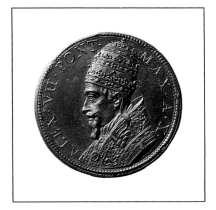

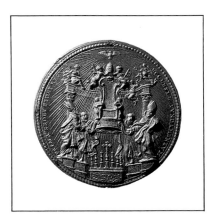

The reverse of this medal achieves extraordinary effects of light playing on its rippling surfaces. The unusually high relief, obtained from a deep cutting of the die, gives the figures a strong plasticity. This conveys the impression of spaciousness around the figures and the reliquary of the Chair of Peter, which appears to float, touched rather than supported by the tips of the fingers of the attendant Church Fathers. Although there is scarcely any perspective foreshortening, except in the bases of the statues and in the entablature of the columns passing "behind" the Chair, the medal evokes depth by the effect of transparence so admirably rendered by the rays that actually emanate light, by the way they reflect it and make it move along the ridges of the striations. Never could one apply to a medal, more appropriately than to this and especially to the examples in gold, the traditional generic epithet "splendid."

The original drawing (*cf. Bernini in Vaticano*, p. 296), so effectively translated by the medal-engraver Gasparo Morone Mola, reveals Bernini's authorship of the design, representing his project for the monumental composition in the apse of St Peter's, the *Cathedra* or Chair of Peter. Together with the *Baldacchino* over the high altar (*cf.* FIG. 5 and CAT. NO. 48) which frames the view from the nave (*cf.* CAT. NO. 31), the *Cathedra Petri* is the most imposing monument of papal splendour, whose divine source is expressed by the emanation of light from the Dove of the Holy Spirit. The material embodiment of that splendour is so convincing that it is no wonder that the popes had to be reminded, by the ritual burning in a flash of a piece of flax at their coronation, how the glory of this world passes away, or as the psalmist says: "Not to us, not to us, Lord, but to Thy name give the glory." The indication of the detailing on the altar frontal shows how such a feature was considered an essential part of the whole, from whose monumentality it in no way detracts, just as the reduction of the monument to the scale of a medal in no way diminishes it, but rather transmits that monumentality to the medal.

M.W.

*Annual Medal of Alexander VII,
Year IX, with the Scala
Regia* 1663

Restrike with the obverse of
year X
Struck bronze, darkish brown
patina, 41 mm
Biblioteca Apostolica Vaticana,
Medagliere

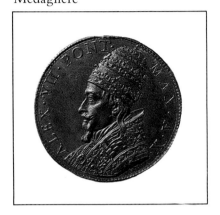

This reverse achieves a remarkable formal balance in the articulation of the plane by the simplest of means – the repetition of parallel lines – that create an effect of recession and ascent through space. The curling ends of the inscribed scroll create a further superimposed plane, from which the shield held by the Fames projects out still further. The compositional organization of the representation of the *Scala Regia*, the ceremonial passage between the Vatican Palaces and St Peter's Basilica, is so arranged that the lower steps come down right to the edge of the medal, thus giving viewers the impression that they stand on the very threshold. The original drawing (*cf. Bernini in Vaticano,* no. 304) by Bernini survives amongst inscriptions, many of them composed by Alexander VII, for medals and other projects. The *Scala Regia* is shown while still developing on the architect's drawing table, for the capitals are of the Corinthian order, as opposed to the Ionic in which it was finally built. The Vatican drawing is probably later than the marking of another drawing with a circle so as to adapt it for translation into a medal (*cf.* N. Courtright in exh. cat. *Drawings by Gian Lorenzo Bernini from the Museum der Bildenden Künste, Leipzig,* Princeton 1981, p. 245, n. 6), the making of a second drawing specifically for the medal may have proved necessary because the first had not originally been intended for that purpose, and the angle of the perspective and the complexity of detail were not suited to the compositional constraints of the medallic format; *cf.* the re-drawing of the design for the foundation medal of Bernini's proposed new Louvre (Chantelou, *op. cit.*, p. 163; 16 September 1665).

The *Scala Regia* or Royal Stairway was built as a three-dimensional perspective to compensate for the narrowing of the space available, already established by pre-existing buildings. Although the stairs can be used both ways, their primary function was to lead down from the Sala Regia in the Apostolic Palaces to the "House of the Lord" as the inscription on the medal proclaims. However, the viewpoint from which the perspective is determined is oriented upwards. This direction is clearly indicated by that of the equestrian monument of Constantine, which faces the onlooker entering from below, or which faces towards the exit as seen from the side at the landing, level with the Portico of the Basilica. The sharp diminution in the scale of the architecture achieves the effect of making the pope look monumental as he appears from around the corner of the higher flight of stairs, just as a cat next to the statue now at the back of the perspective built by Borromini in Palazzo Spada unwittingly assumes the appearance of a tiger. The pope seems twice as tall as his real height and, clothed in the papal mantle (*cf.* CAT. NO. 42) and carried shoulder high on the *sedia gestatoria,* his head reaches the stars in the coffered vault. The effect of such an apparition must indeed have seemed "a vision in the air" as a contemporary diarist (G. Gigli, *Diario romano,* ed. G. Riciotti, Rome 1958, p. 468; 27 May 1655) said of the Corpus Christi procession, for which Alexander VII had commissioned from Bernini an adaptation of the *sedia gestatoria* into a portable prie-Dieu (see FIG. 14).

M. W.

Gasparo Morone Mola (d.1669 ROME)

Annual Medal of Alexander VII, Year XI, with the Canonization of St Francis de Sales 1665

Struck bronze, reddish-brown patina, 41 mm
Biblioteca Apostolica Vaticana, Medagliere

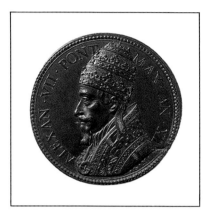

Again, this reverse achieves successful effects of distance and nearness. It represents Alexander VII presiding over the canonization of St Francis de Sales. His throne is set in the apse, which is viewed through the columns of the high-altar *Baldacchino*. Above the throne are the Chigi mountains and star, below an anticipation of the *Cathedra Petri* (CAT. NO. 29), then still under construction. The juxtaposition of the "glory" of rays with the Chigi coat-of-arms is reminiscent of a forty-hours' devotion of 1656 at the Gesù, that represented an allegorical elaboration of the mountains with reference to Queen Christina of Sweden's conversion to Catholicism. The description is indicative of the kind of interpretation that was thought appropriate. With regard to perspective technique, it applies equally well to the illusionistic effects of this and other medals such as that with Androcles and the lion (CAT. NO. 28):

> The machine was everywhere bright, but they could not discover from whence the light came, nor tell if it was in the Pictures, or borrowed from some Sun, assembled by art: so with many very pleasing deceits of near distances, and distance nearness, fixed flights, and endings without end, sweetly lost their curiosity, and had their devotion free, so as they might employ themselves wholly in those holy exercises. (J. Burbery, *History of the Sacred Royal Majesty of Christina Queen of Swedland*, London 1658, pp. 451 ff.).

The choice of this scene of canonization as the subject of an annual medal indicates the importance attached to the event as one of the outstanding features of that year, ranking with the major building projects illustrated in other annual medals. It shows the equal importance of temporary decoration, as much an integral part of the whole of St Peter's as the *Baldacchino* or the *Cathedra*, which themselves imitate and permanently embody the ephemeral spontaneity of the unrepeatable event, thus eliciting a heightened participation from the beholder.

M. W.

François Chéron (LUNÉVILLE 1635–1698 PARIS)

Medal of Clement IX,
Year III, with the Ponte
S. Angelo 1669

Cast bronze, reddish-brown with
black patina, 97 mm
Biblioteca Apostolica Vaticana,
Medagliere

The cast of the obverse was more successful than that of the reverse. Similar discrepancies occurred with the other cast medal of Clement IX with the project for the tribune of Sta Maria Maggiore (*cf. Bernini in Vaticano*, no. 315). A lead example of the present reverse (*cf. ibid.*, no. 316) with no obverse is much clearer and shows up the refinement of Chéron's technique, which is more classicizing and French than would appear from the rougher result obtained in the bronze. The component parts of the design would not seem particularly promising, but their disposition here is very effective. The scale of the flying Fame, again with two trumpets (*cf.* INTRODUCTION, P. 36), sets off the unusual expanse of the background surface which thereby achieves a sense of spaciousness, further emphasized by the distant clouds. The perspective of the arches of the bridge heightens the impression of projection and recession. The foreground scene of the fluvial divinity of the Tiber accompanied by the she-wolf and the twins Romulus and Remus establishes yet another plane, which projects even beyond the frame of the medal. It also creates the illusion of the distance covered by the water, thereby effectively rendering its abundant flow. The Ponte S. Angelo is shown with the parapet pierced by Bernini so that one could see the water as one crossed. On the pedestals stand the statues of angels displaying the Instruments of the Passion which were designed and carved under Bernini's direction.

M. W.

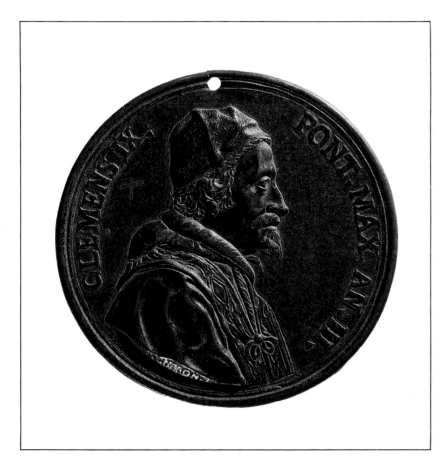

Giovanni Hamerani (ROME 1646–1705 ROME)

*Annual Medal of Clement X,
Year IIII, with an Allegory of
Religion* 1673

Struck bronze, black patina,
36 mm
Biblioteca Apostolica Vaticana,
Medagliere

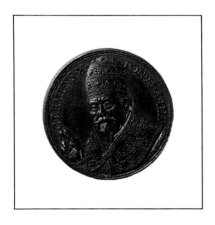

The figure pointing to the Cross is identified by
F. Bonanni (*Numismata Pontificum Romanorum...*,
Rome 1699, Vol. 2, Clementis X, XXIX) as the
Christian Religion, or the Roman Church, which he
compares with Noah's Ark, outside which there is
death, whereas within there is life, as the inscription
on the medal indicates. He states that Clement X
issued this medal to confirm the good, and to call
back the wicked from the path of perdition. The
intention is expressed with clarity and elegance in the
design. Most remarkable is the sweeping expanse of
desert landscape strewn with the wicked who have
strayed and lie fallen by the wayside. Unique among
papal medals is the vivid portrait on the obverse
showing the head in three-quarter profile. The di-
rectness of confrontation that this brings about gives
the impression of a virtual encounter. The traditional
profile portrait preserves an aura of hieratic aloof-
ness. This sudden coming face-to-face could have
seemed an intrusion on the part of the observer, were
it not for the blessing hand in higher relief causing
the rest of the image to recede further into the depth
of the field, thus maintaining a seemly distance,
keeping the recalcitrant at arms-length while reach-
ing benevolently out towards the good. The motif of
the blessing hand was used in one medal of the
16th century. Each of the few examples in the
17th century appears in medals closely connected
with Bernini (*cf.* S. de Caro Balbi, "Gian Lorenzo
Bernini e la Medaglia Barocca Romana," *Medaglia*,
Vol. 7, 1974, figs. 8a, 10; exh. cat. *Bernini in Vaticano*,
nos. 282, 283).

M.W.

34

*Annual Medal of Clement X,
Year V, with Fame Flying before
St Peter's Proclaiming the
Jubilee* 1674

Struck bronze, dark brown patina,
41.5 mm
Biblioteca Apostolica Vaticana,
Medagliere

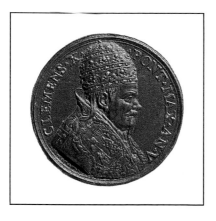

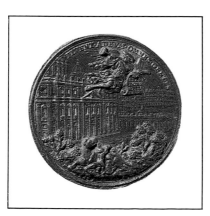

Giovanni Hamerani (ROME 1646–1705 ROME)

The figure of Fame is clearly reminiscent of the medal of Clement IX with the Ponte S. Angelo (CAT. NO. 32) from which the designer has also taken the she-wolf looking up at the messenger proclaiming the Jubilee to the delight of one of the twins. Fame's banner bears the inscription "in the splendour of the stars," alluding to Clement X's coat-of-arms which comprised six eight-pointed stars. The inscription above Fame proclaims that all peoples shall flow to him, presumably to the temple of Peter, where his successor as Vicar of Christ dispenses the treasures of divine grace. The obverse portrait shows Clement X crowned with the tiara and wearing the cope, whose orphrey shows a scene taken from the medal of the previous year illustrating the presentation to the Pope of a banner captured by John Sobieski from the Turks. The Pope's stars are visible above the "embroidered" scene and on the edge of the hood. The portrait type appears to be derived from that established by the profile drawing by Bernini (*cf.* exh. cat. *Bernini in Vaticano*, no. 320).

M.W.

Medallion Portrait of Innocent XI

Cast bronze, gilded and chased,
173 mm
Biblioteca Apostolica Vaticana,
Medagliere

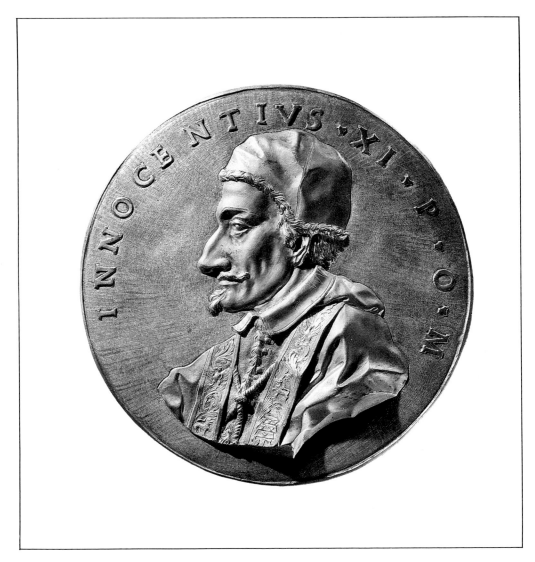

The technical prowess displayed in this very finely retooled cast and gilded bronze attains literal splendour by the variegation of faceted surfaces that reflect light with an abundance of effects. Set off against the stippled field, the smooth surfaces of the *camauro* or cap and *mozzetta* or cape evoke the sheen of velvet. They are slightly more highly burnished than the face, which has a more rugged plasticity, tantamount to caricature in the outsize proportions of the nose. The stole is "embroidered" with the Odescalchi emblems against arabesque volutes and a lightly stippled background. Further distinction of textures is made between the *mozzetta* and the linen collar, whose seams are engraved, as is that on the *camauro*. The ermine lining of the latter sets off the texture of the hair. These refinements seem to point to the work of an artist who combined the skills of an engraver with those of a metal founder. Furthermore, the sculptural quality of this medallion gives it the character of a relief rather than of a medal. The shoulders are shown in three-quarter profile. The awkwardness of this sharp *contrapposto* with the head, together with the uneasiness of the proportions, and the strangeness of the exaggerated emphasis of forms is reminiscent of just such an artist whose independent work shows similar features. The sculptor, founder, and engraver in question is Girolamo Lucenti, responsible for the Angel with the Nails on Ponte S. Angelo (*cf.* M. Weil, *The History and Decoration of the Ponte Sant'Angelo,* London 1974, p. 80). It has hitherto been suggested that this portrait might be associated with Giovanni Hamerani (*cf.* J. Spike in exh. cat. *Baroque Portraiture in Italy: Works from North American Collections,* Sarasota 1984, no. 56). However, he is not known to have produced any cast medals. Lucenti on the other hand signed several coins engraved for Innocent XI as well as a cast medal (*cf.* J. Varriano and N. Whitman in exh. cat. *Roma Resurgens. Papal Medals from the Age of the Baroque,* Ann Arbor 1984, no. 122). Lucenti's predilection for sharp angular folds is readily apparent in a medal of Clement X (*cf. Bernini in Vaticano,* no. 321 and p. 283) which contrasts with that by Giovanni Hamerani (*ibid.* no. 320) possibly based on a common source related to a drawing by Bernini (*ibid.* p. 307). The portrait of Innocent XI may indeed also be derived from a drawing by Bernini, who seems to have been regularly called upon to establish the features of the popes in a form suited to translation into medals (*cf.* CAT. NO. 23).

M.W.

Uniface Medal with the Arms of Alexander VIII

Cast bronze, warm brown patina, 87 mm

Biblioteca Apostolica Vaticana, Medagliere

This somewhat mysterious medal is dated by F Bonanni to the reign of Innocent XI. He makes no comment on it beyond the assertion that it is self-explanatory (F Bonanni, *Numismata Pontificum Romanorum...*, Rome 1699, p. 760, XVII). The motto translates as "He joined and gave the palm." However, the double-headed eagle and the band on the shield on its breast seem to be a spirited interpretation of the coat-of-arms of Alexander VIII Ottoboni, playing on its similarity with the bicephalous eagle of the Holy Roman Emperor, alluded to by the Imperial crown on one of the heads. The other head is crowned by the papal tiara. They both look up to the radiant cross chasing back the clouds. The sword in the talon of the papal half, the eagle's right and therefore the more dignified, is wrapped by the palm of

victory, whilst the Imperial sceptre is graced with the olive of peace. The implication is that united in faith they stand, laying their disputes aside so as not to fall divided in the face of the Turkish enemy, then still a threat to European security (*cf.* L. von Pastor, *Storia dei papi*, XIV, Rome 1962, p. 404f.).

R. Venuti mentions the medal amongst those of Alexander VIII. He asserts that it was cast in Germany by an artisan who expressed his name by the initials "P.H.M.," and that the meaning the author had "ineptly expressed" was not worth the trouble to investigate (R. Venuti, *Numismata romanorum pontificum praestantiora a Martin V ad Benedictum XIV*, Rome 1744).

M.W.

Gian Lorenzo Bernini (NAPLES 1598–1680 ROME);
Giovanni Battista Bonacina (active ROME 1650–1670)

*Plan and Elevation of Piazza
S. Pietro* 1659

Engraving, 54.3 × 85 cm
Biblioteca Apostolica Vaticana
(Inv. no. Barberini Stamp.
X.I.31, 6);
Copper plate (not illus.),
54.3 × 85 cm
Biblioteca Apostolica Vaticana,
Archivio Chigi (Inv. no. 25274)

The inscriptions held by the trumpeting Fames proclaim Alexander VII's intentions in commissioning the Piazza S. Pietro to facilitate access to the Basilica by providing shelter from the heat of the sun in summer and from the rains of winter, and to increase the magnificence of St Peter's. Since so many people from distant lands were desirous of seeing this famous work, it was thought fit to put out a print.

The presentation of the inscription on an illusionistic scroll of paper that seems to curl up off the page on which it is printed, and creates the impression of a vast expanse of sky above the colonnade, is typical of Bernini, and the inscription at the bottom left must refer to his authorship of the engraving-design as well as of the architecture. The Fames in the original drawing in the British Museum (H. Brauer, R. Wittkower, *Die Zeichnungen des Gianlorenzo Bernini*, Berlin 1933, pl.162a) appear to be autograph, whereas the architectural elements would have been drawn by an assistant such as Mattia de' Rossi, or by the engraver himself from drawings with which he would have been provided, as was the case with the engravings of Bernini's design for the Louvre, for which he himself drew two figures of Hercules (*cf.* M. Worsdale, *Revue de l'Art,* Vol. 61, 1983, p. 71, n.93). The contrast between the advancing and receding figures, one in shadow, the other in the light, is a typically Berninesque compositional motif (*cf.* the catafalque of the Duc de Beaufort in V. Martinelli, *Bernini. Disegni,* Florence 1981, pl. XLIII). The surviving original copper plate in the Chigi Archives is mentioned in the first inventory of Cardinal Flavio Chigi's possessions (*cf.* CAT. NO. 17). The indebtedness of the paper image to the metal plate that imprints it further enhances the paradoxical conceit that paper is more longlasting than bronze, here subtly referred to by the final statement of the inscription in relation to the graphic representation of the paperiness of the image's material support (*cf.* INTRODUCTION, P. 29f.).

The implication that Alexander VII was responsible for the conception of the Piazza is probably more accurate than is generally supposed. The attribution is more extensively stated in a report (*cf.* T. Kitao,

Circle and Oval in the Square of St Peter's: Bernini's art of planning, New York 1974, p. 89, n.40) presented to the Pope, written in fact by Monsignor Filippo Bernini, one of the artist's sons. Many of the rough sketches for the Piazza and other projects hitherto thought to be by Bernini are by Alexander VII, being on the back of letters addressed to him and notes written by him. Amongst these drawings are some of higher quality that appear to be by Bernini, drawn on the same page, probably on those occasions when Bernini discussed projects with the Pope and demonstrated his ideas, using the pencil and paper handed to him by Alexander.

M.W.

PORTICI DELLA PIAZZA DI S·PIETRO DI ROMA

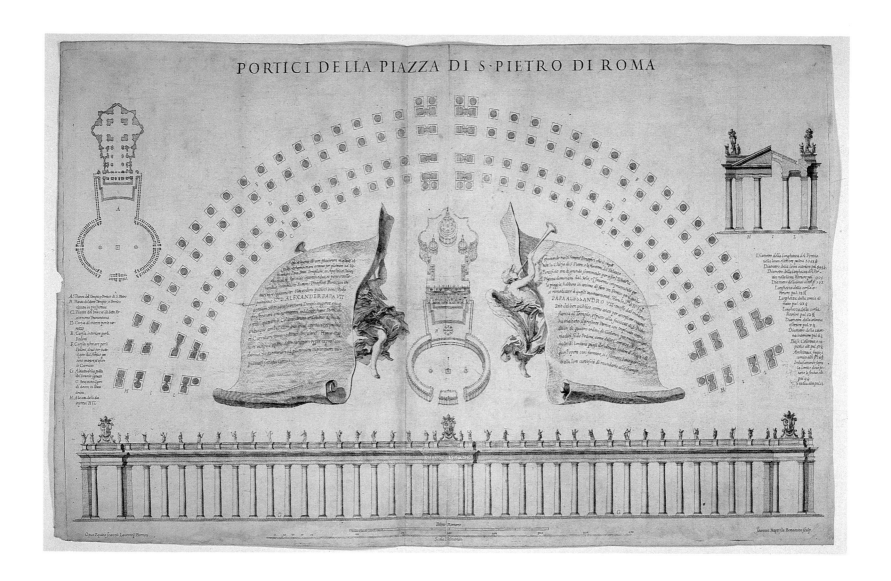

Faldstool and Cover with the Arms of Paul V

Stool, iron and gilt bronze, 83 × 74 × 50 cm; Cover, gold-and silver-thread on white silk, 158 × 139 cm
Sacristy of Sta Maria Maggiore, Rome

The coat-of-arms and inscription on the faldstool indicate that it dates from the twelfth year of Paul V's reign, between 29 May 1617 and 28 May 1618. Although the cover is not necessarily exactly contemporary, it is indubitably not an adaptation of a separate donation. For the crossed-keys and triple-crown motifs are reversed where they would otherwise have shown upside down on the flap that folds over the back. The embroidery is therefore designed specifically for this faldstool, and the surprising, unusual asymmetry in the overall layout of the pattern that results from the choice of placing the more prominent panel-motifs enclosing the crossed-keys to either side of the coat-of-arms must have been intentional. This achieves an effect of ever-shifting movement by the alternation, both vertically as well as horizontally, of the triple-crown motif with that of entwined lilies and palms. The latter is itself also asymmetrical on any axis, but conveys a predominantly diagonal sense of direction. The three crowns exemplify the incipient tendency that was to develop in the course of the 17th century to free armorial figures from their strictly heraldic confines. In this instance more emphasis is thereby given to the components of the papal tiara, thus drawing attention to its symbolic significance rather than applying it only as a distinction of the supreme hierarchical dignity. The standard explanation of the three crowns was that they signified the imperial, regal, and priestly authority of the pope, who has the faculty to teach, punish, and dispense throughout the Church Militant on Earth, the Church Suffering in Purgatory, and the Church Triumphant in Heaven. The two crossed-keys are distinguished in the traditional manner, one in gold-thread, the other in silver, signifying the pope's right (*giurisdizione*) and might (*potestà*) to open and close, to bind and to loose on Earth and in Heaven (*cf.* G. Moroni, *Dizionario di erudizione storico-ecclesiastica*, Venice 1861, Vol. 81, p. 29; Vol. 11, p. 174).

The origins of the faldstool are variously explained (*cf. ibid.* Vol. 23, pp. 11–16). Its function at the time of the present example was to serve as a portable throne for those occasions when the pope had to sit in front of the altar, as at ordinations, confirmations, etc., and to provide a support for his arms when he had to kneel (*cf.* FIG. 14 and CAT. NO. 42). The faldstool was more frequently used by prelates celebrating in a church under the jurisdiction of another bishop; and since the pope is bishop of Rome, this was the case in many an instance. The present faldstool would have been used by Paul V's nephew Cardinal Scipione Borghese (see FIG. 4) when celebrating in the Pauline Chapel at Sta Maria Maggiore, and such may have been the principal purpose of the donation. It was suggested by M. Andaloro (in exh. cat., *Tesori d'Arte Sacra di Roma e del Lazio dal Medioevo all'Ottocento*, Rome 1975, no. 192) that the cover could be identified with a *"pallium sericum argento intexto aureis taeniis"* with the insignia of Paul V at its centre (mentioned in P. De Angelis, *Basilicae S. Mariae Maioris de Urbe A Liberio Papa I Vsque ad Paulum V Pont. Max. Descriptio et Delineatio...*, Rome 1621, p. 152). In any event, the design of the embroidery is stylistically far more advanced than that of the orphrey on the purple chasuble of Paul V (CAT. NO. 39). The motifs distributed with such liberality are evenly balanced, and though they may outweigh the white background, indicative of liturgically festive character, what is lost in clarity of pattern is more than made up for by abundance of splendour and wealth of vigorous form.

M.W.

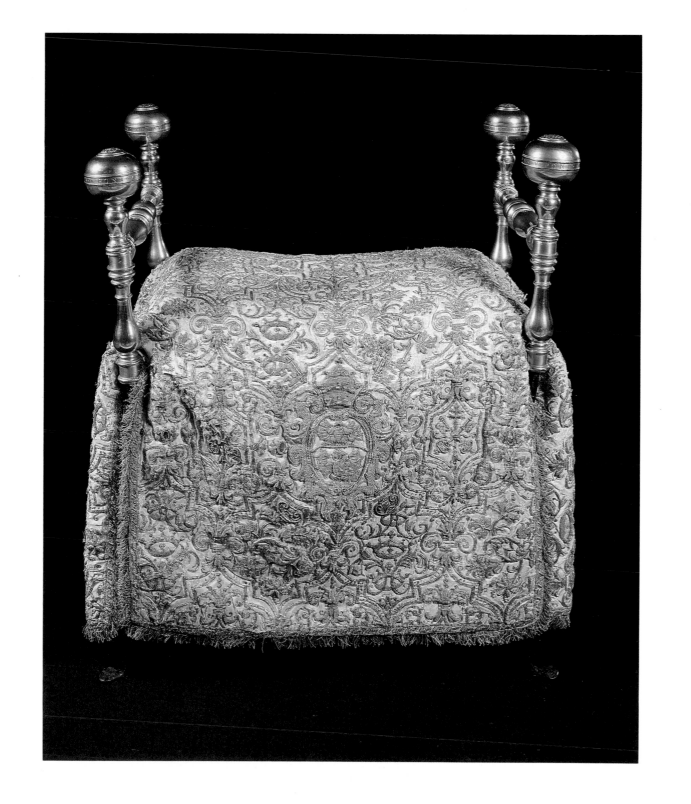

Vestments with the Arms of Paul v

Damask of purple silk and gold-thread with embroidery in gold-thread on purple silk. Chasuble 112 × 72 cm, stole and maniple

Biblioteca Apostolica Vaticana, Museo Sacro (Inv. nos. 2708, 2691, 2690)

The steady, compact rhythm and frequent repetition of the strictly circular curves, disposed symmetrically on both the vertical and horizontal axes, give the embroidered orphrey or "column" of the chasuble an archaic appearance when compared to the graceful fluency of the embroidery on the chasuble from the red vestment set with the arms of Urban VIII Barberini (CAT. NO. 40). The damask shows more originality in the freeing of the heraldic beasts of the Borghese from the confines of their coat-of-arms. Only the dragon is fully visible, for the damask has been cut in such a way that the eagle has been divided and appears as if partly obscured by the orphrey. It would therefore seem that the damask was here adapted for another purpose than that for which it may originally have been conceived. However, a clearer display of the even rhythm of the full pattern may have been ensured by other accompanying vestments such as a dalmatic and tunicle, though even the examples of these among the Barberini vestments are also cut somewhat irregularly. A complete set of pontifical Mass vestments would also have included a cope. Its ample folds provided sufficiently wide surfaces for the pattern to appear in its entirety.

The chasuble is a vestment worn by the celebrant for the Mass. Beneath it he wears the stole, placed over his shoulders like a yoke that is easy and a burden that is light. If he is not a prelate, he folds the right band over the left in the form of a cross signifying his submission to the authority of the bishop, who wears the bands of the stole hanging straight down. The stole is held in position by the girdle, a long cord usually made of plaited silk-thread. The maniple, which is similar in form to the stole but much shorter, is descended from the handkerchief and is worn over the left forearm. When laid out for the celebrant to vest, it forms the letter 'I', which together with the stole folded in the form of an 'H' and the girdle as an 'S' composes the monogram of Christ.

The liturgical colour purple is used during Lent and Advent as a sign of penance. It would not have been worn by the pope in the solemn Masses for which there existed a specific papal rite that retained the more ancient usage of red, where the development of the Roman rite had introduced purple, and, for mourning, black vestments.

M. W.

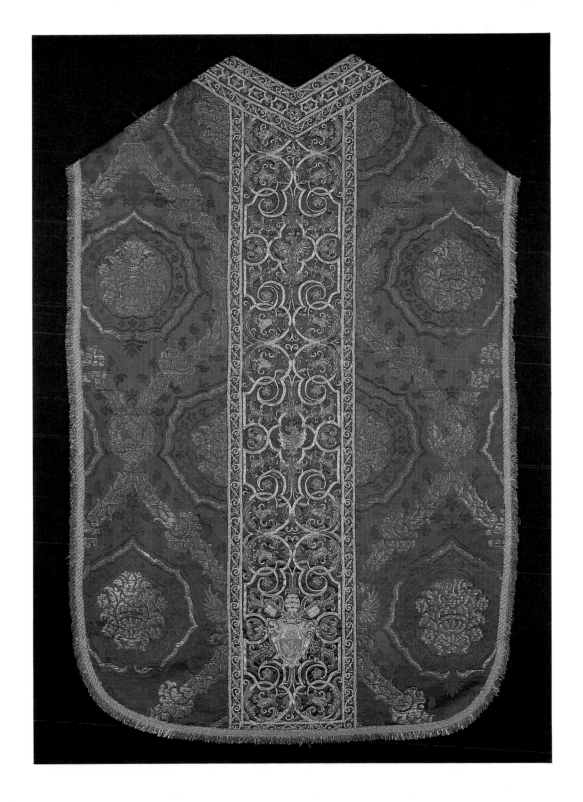

Vestment Set with the Arms of Urban VIII 1625–27

Damask of red silk and gold-thread with embroidery in gold-thread and coloured silk on red silk. Chasuble 118 × 76 cm, stole and maniple. Dalmatic 140 × 110 cm, stole and maniple. Tunicle 140 × 110 cm and maniple
Sacristy of Sta Maria Maggiore, Rome

a. Chasuble
b. Dalmatic
c. Stole
d. Maniple

The damask from which these vestments are cut clearly recalls that used for the purple chasuble with the arms of Paul V (CAT. NO. 39). However, the design fills the field with a well-balanced abundance of foliate forms in gold-thread leaving almost no voids of plain colour, thus endowing the whole with an overall honeyed tone. The heraldic elements are transferred back into the "cells" whose chequered backgrounds may be reminiscent of the honeycomb. The embroidered orphrey of the chasuble is teeming with an almost buzzing swarm of Barberini bees gathering nectar from the flowers and laurels, which in turn convey a sense of vigorous growth by the upward flow of movement achieved by dispensing with symmetry on the horizontal axis of the pattern.

Partly obscured by the orphrey of the chasuble, slightly clearer in the dalmatic and tunicle, and fully legible in the purple cope of the same weave (*cf.* exh. cat. *L'Arte degli Anni Santi*, Milan 1984, p. 150, III.3.12), there appears the motif representing three bees homing in on a laurel. This is taken from the *Impresa* (FIG. 22) with the motto HIC DOMUS; see INTRODUCTION, P. 39, N.22 for an explanation of the rich significance of this motif as given by Giovanni Ferro.

The set was probably complemented by an altar frontal, since a payment dating from October 1627 to Cinzio and Vincenzo Sabasio, a father and son who were laymen and embroiderers to the Reverenda Camera Apostolica, mentions that their work was destined for the Church of Sta Bibiana, with which the vestments are associated in the inventories of Sta Maria Maggiore, whose Chapter ensured its service (*cf.* exh. cat. *Bernini in Vaticano*, Rome 1981, no. 237). The inventories state that the chasuble was donated by Urban VIII in the Holy Year 1625 (*cf.* L. Cardilli Alloisi in *L'Arte degli Anni Santi*, p. 162, III.6.1), and that the Chapter commissioned the dalmatic and tunicle in 1627. The latter are of standard form and the distinction between them is therefore nominal, the dalmatic being worn by the deacon over the alb, a long white linen shirt, with a stole placed over the left shoulder and tied at the waist on the right. The tunicle, originally longer and narrower than the dalmatic, is worn by the subdeacon, without a stole but with the maniple which is the characteristic vestment of his order, worn by the others as a sign of

compunction. A general impression of the vestments in use can be gathered from Andrea Sacchi's *St Gregory and the Miracle of the Corporal* (CAT. NO. 6), which shows a type of damask not dissimilar to that of the Barberini vestments.

The liturgical colour red, other than serving as a substitute for purple and black in the papal rite (*cf.* CAT. NO. 39), is used for the commemoration of martyrs as well as for Palm Sunday and Pentecost. The choice of red vestments for this donation was appropriate therefore to St Bibiana (*cf.* CAT. NO. 16), a saint to whom Urban VIII showed particular devotion, and for whose office he composed the hymn.

A drawing (FIG. 21) representing the same pattern as that of the orphrey of the chasuble survives among a set of embroidery designs, architectural projects, and academic nudes, some of which can be associated with Bernini's studio. These were collected in an album that belonged to Francesco Maria Febei, appointed master of ceremonies and Commendatore of the Ospedale di Santo Spirito, by Alexander VII. In view of Febei's connection with Bernini in relation to the commission of pilaster drapes for St Peter's, inaugurated on the occasion of the canonization of St Francis de Sales (*cf.* CAT. NO. 31), the presence of this drawing in his collection together with that for a chasuble most probably produced under Bernini's supervision (*cf.* CAT. NO. 44) suggests that the outstanding quality and striking originality of the embroidered orphrey of the Barberini chasuble may indeed derive from Bernini's involvement.

M.W.

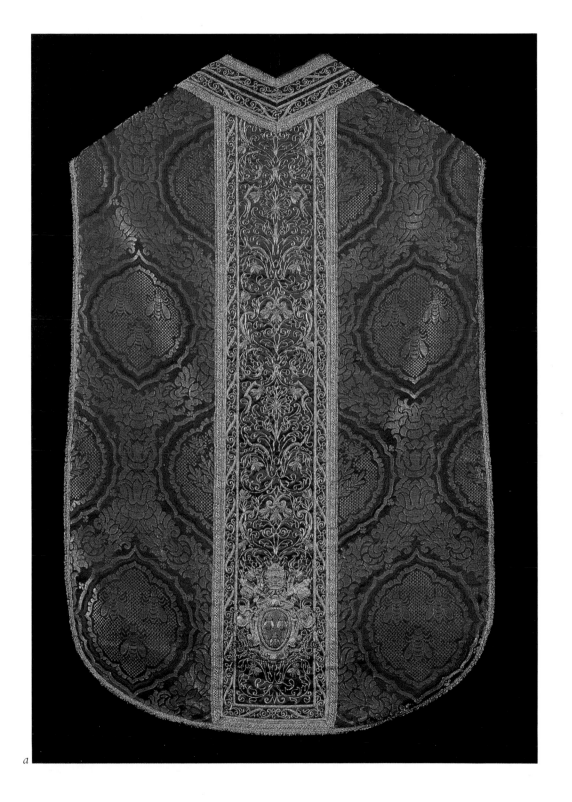

a

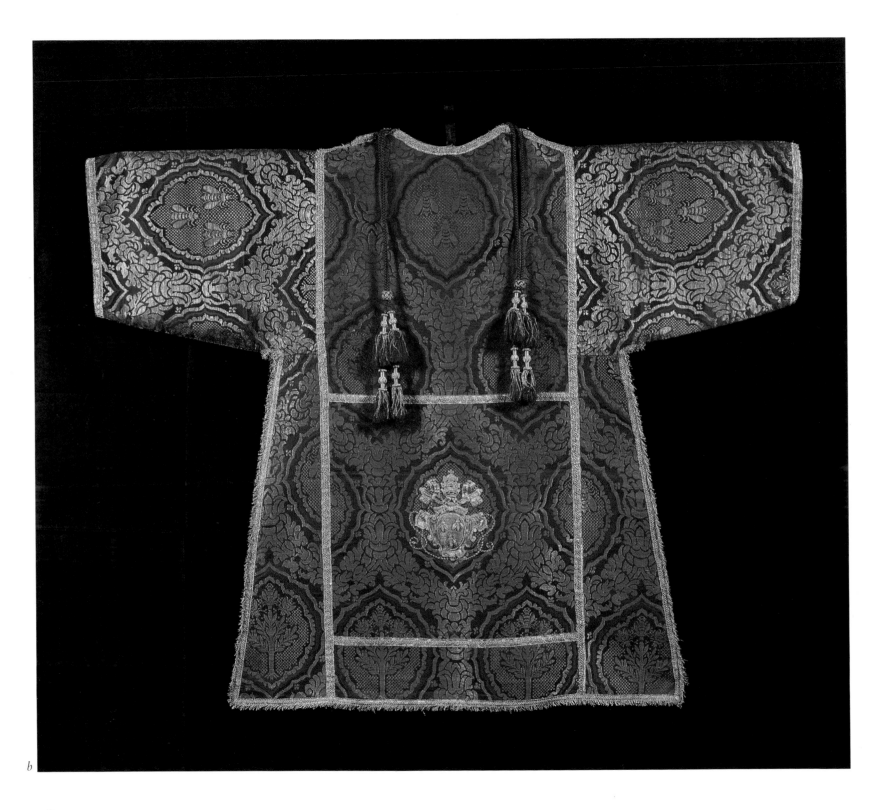

b

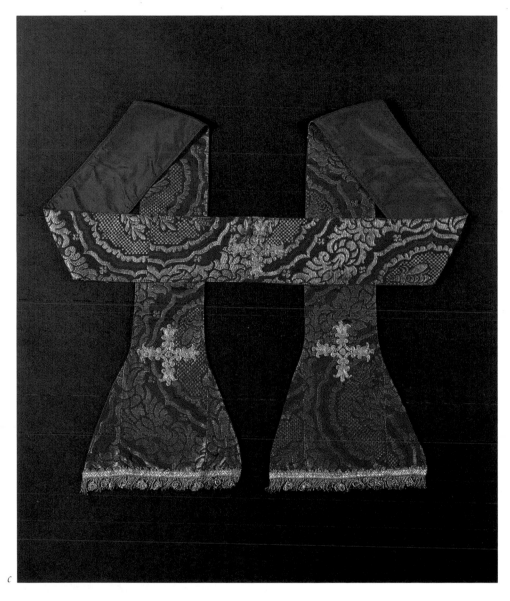

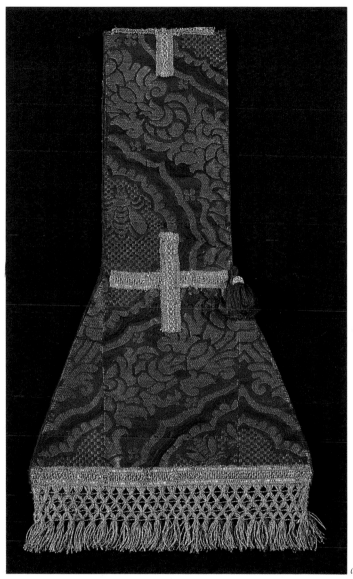

Vestment Set with the Arms of Clement IX and Renato Borromeo, Count of Arona

Embroidery in coloured silks, gold-thread and braid, on white silk. Chasuble 121 × 85 cm. Stole, maniple, chalice veil, and burse Biblioteca Apostolica Vaticana, Museo Sacro (Inv. nos. 2705, 2744, 2743, 2704, 2735)

a. Maniple
b. Stole
c. Chasuble
d. Chalice veil
e. Burse

This vestment set is particularly remarkable for its different conception in comparison with the other vestments so far considered. The arabesque motifs now unfurl in a single broad sweep without any repetition. The composition, together with the delicate colours of the flowers, achieves the effect of a picture worthy of a still-life painting by Mario dei Fiori. The coat-of-arms shows the lozenges of Clement IX, "dexter," in the position of honour, the right from the point of view of the shield. The other components are from the Borromeo coat-of-arms whose combination with the pavilion of the church and a crown suggests that the vestments may have been offered by Renato Borromeo, Count of Arona, who assiduously pursued for awards of Cameral titles (*cf. Dizionario Biografico degli Italiani*, Rome 1971, Vol. 13, p. 66), of which the pavilion is an emblem. The chalice veil and burse, or corporal-case, are other liturgical fittings that are usually of the same material as the vestments, which can also include a missal cover, one for the Gospels and another for the Epistles, a humeral veil for the subdeacon, and a gremial with which a bishop covered his knees when sitting at the throne.

M.W.

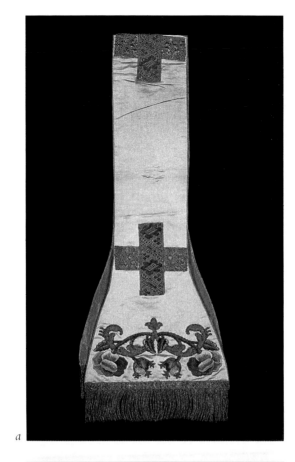

a

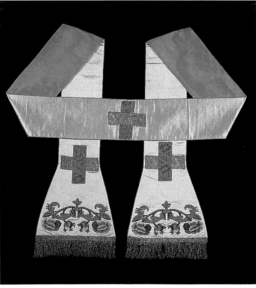

b

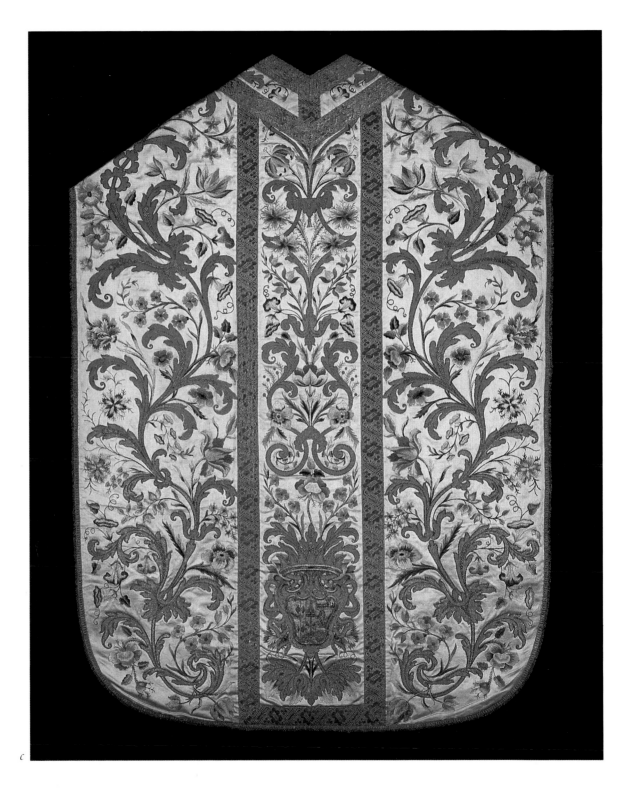

C

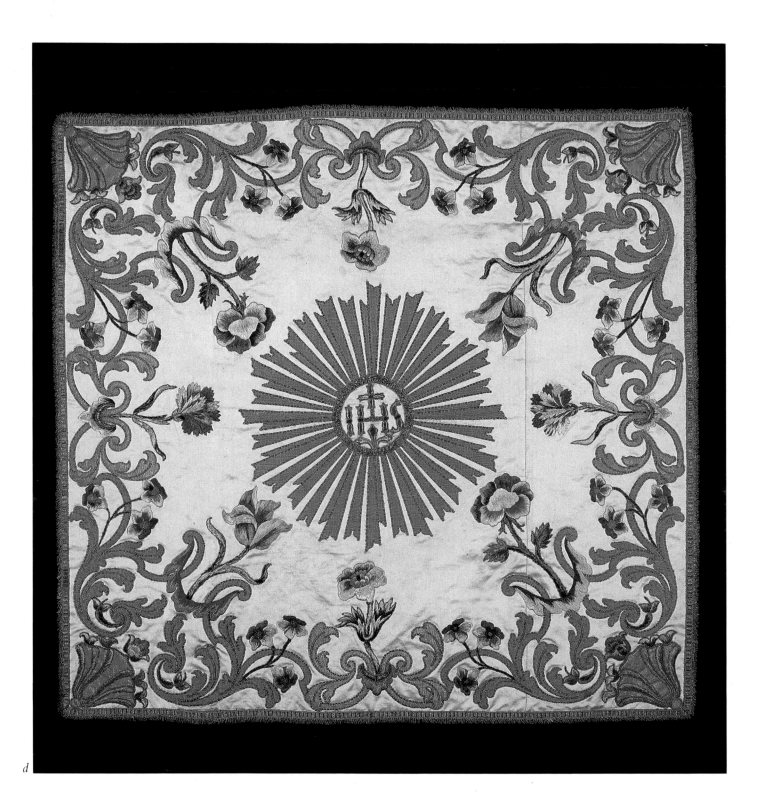

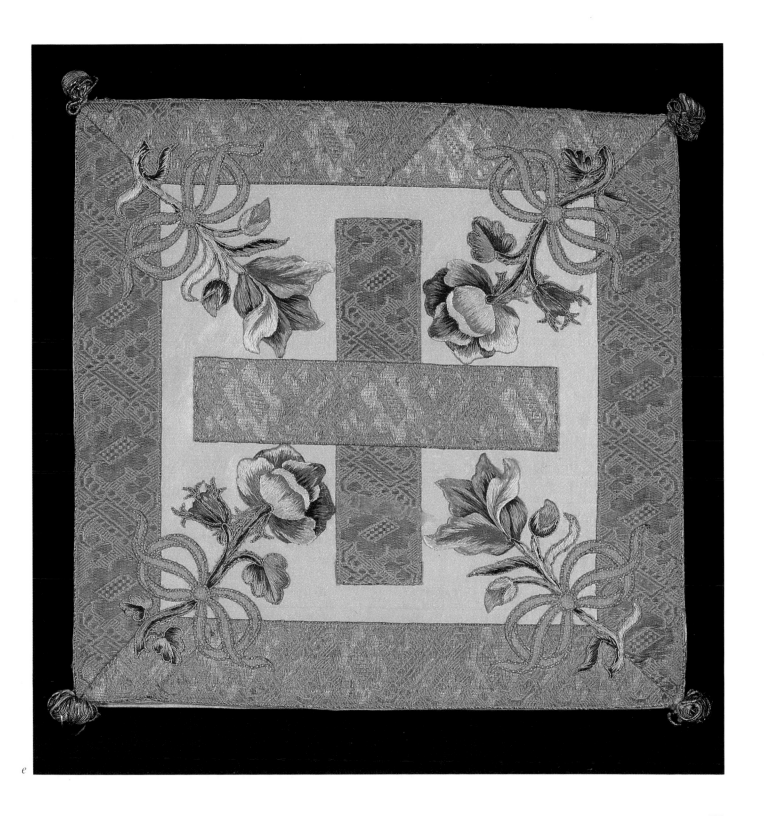

e

Papal Mantle of Clement IX

Embroidery in silvered ribbon
and coloured silk, on red silk,
284 × 368 cm
Biblioteca Apostolica Vaticana,
Museo Sacro (Inv. no. 2688)

The vast dimensions of the mantle, a larger version of the cope or pluvial, are said to signify the extension of the pope's sacred character into eternity (*cf.* G. Moroni, *Dizionario di erudizione storico-ecclesiastica*, XLII, Venice 1847, p. 162). When the pope walked while wearing the mantle, its front extremities were held by the cardinal proto-deacon and cardinal deacon. Other bearers were required for the train, and this rôle was granted as a privilege to attendant sovereigns. The stateliness with which the mantle invested the act of taking a few paces must have been most impressive. When the pope was standing or seated at his throne, the front folds of the mantle covered the steps that lead to it in such a way that the figure of the pope stood out all the more from the surrounding attendants. One can recognize in this the practical advantage in making the pope more visible to the faithful who would not otherwise be able to distinguish him from a distance in a crowded church or piazza of such proportions as those of St Peter's. Without some external extension the majesty of office would not be perceptible. Thus the cardinals and bishops also wore long trains in the scarlet or purple distinctive of their dignity (*cf.* CAT. NO. 10). However, they would not unfurl their train in a church not under their jurisdiction, and in Rome, therefore, the train was held bunched up over the left arm except on certain prescribed occasions (*cf.* CAT. NOS. 46 and 47).

The decoration of the present mantle alludes discreetly to the coat-of-arms of Clement IX Rospigliosi which consists of four lozenges, here disposed in regular intervals between the arabesque volutes. The accumulation of circumstantial evidence (*cf.* exh. cat. *Bernini in Vaticano*, nos. 240–248) suggests the authorship of G. P. Schor for the design (*cf.* CAT. NO. 45). The harmonious development of delicate tendrils, rhythmically curling and crossing, balances with extreme elegance the embroidery in silvered ribbon against the expanse of red silk (for the significance of the colour, *cf.* CAT. NO. 40). The tempo quickens and the "orchestration" becomes fuller in the orphrey and hood; multicoloured vignettes, whose freshness is enhanced by the contrast with the relative plainness of the rest of the mantle, represent the Immaculate Conception on the hood, below

God the Father, flanked by SS. Peter and Paul, on a different axis so that they appear upright when the mantle is worn. Beneath these are the four evangelists, and two sainted popes, one of whom may be St Clement. A mantle can be seen in use in Algardi's relief of *St Leo the Great and Attila* (*cf.* J. Montagu, *Alessandro Algardi*, Vol. 2, pls. 132–135) and in a painting once attributed to Andrea Sacchi (rejected by A. Sutherland Harris, *Andrea Sacchi*, Oxford 1977, p. 109, R. 14) possibly the work of Giovanni Maria Morandi, representing Alexander VII carried by the *Sediari* as he kneels in adoration before the Blessed Sacrament on the feast of Corpus Christi (FIG. 14). The representation of the *Talamo* – whose name has the connotation of a mystical nuptial bed – or prie-Dieu – is probably a faithful representation of Bernini's design (*cf. Bernini in Vaticano*, no. 306), for there still survives in the Floreria Apostolica a similar, though slightly simplified, version with the arms of Pius IX, which may have been necessary to replace the original, possibly damaged from frequent use over two centuries.

The exceptional survival of the mantle of Clement IX, together with a pair of sandals and buskins or liturgical stockings (*cf. Bernini in Vaticano*, no. 247) as well as his cassock also preserved in the Museo Sacro of the Vatican Library, may be due to their being regarded as relics, since Clement IX had died with the reputation of sanctity. Evidence of this can be found in the unpublished diary of Cartari, Dean of the Consistorial Advocates, who relates how, shortly after Clement's death, a beggar claimed to have received from an unknown priest a ring which his benefactor instructed him to sell to a particular jeweller. The jeweller then recognized it as the one he had supplied to the Pope, who had been buried wearing it. The mysterious priest was never identified, and the body of the Pope had to be removed to prevent further attempts by the crowds to hack away at the masonry for relics.

M. W.

43

Altar Frontal with the Barberini Insignia and the Arms of Innocent X

Embroidery in gold-thread over cord, silvered ribbon and coloured silk, gold- and silver-braid, on red silk, 98 × 184 cm
Sacristy of the Sistine Chapel

The coats-of-arms of Innocent X Pamphilj (reigned 1644–55) are applied over the field of the frontal strewn with Barberini emblems. The way in which the laurels are cut by the top and lower edges of the frontal suggests that the embroidery was originally destined for another purpose. For the sake of symmetry, the even intervals between the laurels and the alternating bees and suns are not maintained where they become more closely paired on either side of the vertical bands masking the seams. The "perpetual motion" of the arabesques is thus interrupted. The motif is very similar to that on the faldstool cover with the arms of Paul V (CAT. NO. 38), but much clearer in its linear quality, which effectively heightens the relief of the bees, giving the impression that they have just alighted. The lozenge-shaped panel with lobes that appears on either side of the suns in the frontal is almost identical with that framing the crossed-keys and triple-crown motifs in the faldstool cover. The latter were very closely repeated by Bernini in the stole on the bronze bust of Urban VIII now in the Louvre, of which a marble variant is in Palazzo Barberini (*cf.* R. Wittkower, *Gian Lorenzo Bernini,* London 1966, nos. 19 (3) and 19 (4), proposing a date around 1630 for the model from which these busts were derived). In 1631 a white papal mantle, the description of whose decoration corresponds to the present frontal, was paid by the Reverenda Camera Apostolica to the embroiderer Cinzio Sabasio (*cf.* F. Mancinelli, in *Bernini in Vaticano,* no. 238). The frontal may also have previously been a mantle that would no longer have served its purpose for Urban's successor Innocent X, on whose accession the Barberini fled into exile. It may therefore have been thought of by those who saw the bees out of their heraldic formation on the tomb of Urban VIII as a sign of the dispersal of the Barberini – which Bernini certainly did not intend (*cf.* F. Baldinucci, *Vita del cavaliere Gio. Lorenzo Bernini,* Florence 1682, p. 18); the arms of Innocent X are applied in a way that evokes his domination over the memorials of Barberini rule. However, the primary reason behind such an adaptation of what may have been a redundant vestment would probably have been its suitability for the adornment of the altar in the chapel commissioned by Urban VIII in the Vatican Palaces, to which it seems to belong on account of the correspondence of its proportions.

M.W.

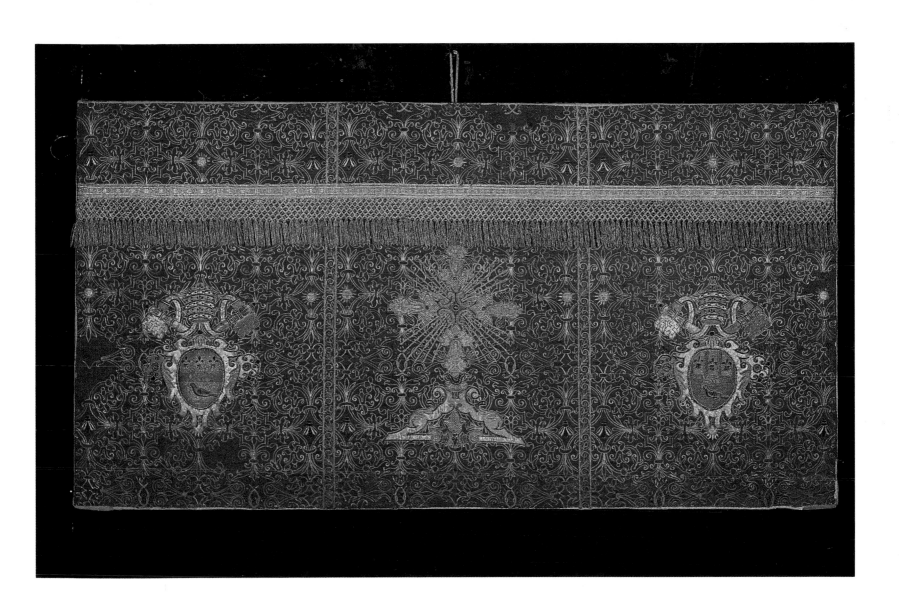

Altar Frontal with the Arms of Alexander VII

Embroidery in silvered ribbon, gold- and silver-thread and braid, and coloured silk on red silk, 102 × 375 cm
Sacristy of the Sistine Chapel

The way in which the Chigi emblems of oaks and of mountains and star are disposed, and the perfect symmetry between the individual vertical panels of which the frontal is composed, indicate that it was designed all-of-a-piece. Its size indicates that it was intended for the altar of the Sistine Chapel. The linear quality of the design was more suitable than high-relief (such as can be seen in the frontal from the Lateran, CAT. NO. 45) for the Sistine Chapel, which was considered domestic rather than monumental. The palm-frond motif in the embroidery suggests that it was intended for the feasts of martyrs, principal among whom, of course, were SS. Peter and Paul, and the Proto-martyr St Stephen. The affinity of the design and embroidery style with the mantle of Clement IX (CAT. NO. 42) suggests that they are both by the same designer and embroiderer. The design and embroidery technique are very close to those of a purple chasuble with the Chigi arms (*cf. Bernini in Vaticano*, no. 244), in turn very similar to the vestments for the Chigi Chapel in Siena. The latter are mentioned in Alexander VII's diary where he implies that Bernini was involved with them (R. Krautheimer and R. Jones, *op. cit.* p. 215, no. 491). A drawing for the chasuble features among the embroidery designs in the Febei Album in Orvieto (*cf.* CAT. NO. 40). It is very similar to the drawing from the Farnesina (*cf. Bernini in Vaticano*, no. 242) showing the same motifs that appear in the present frontal.

M.W.

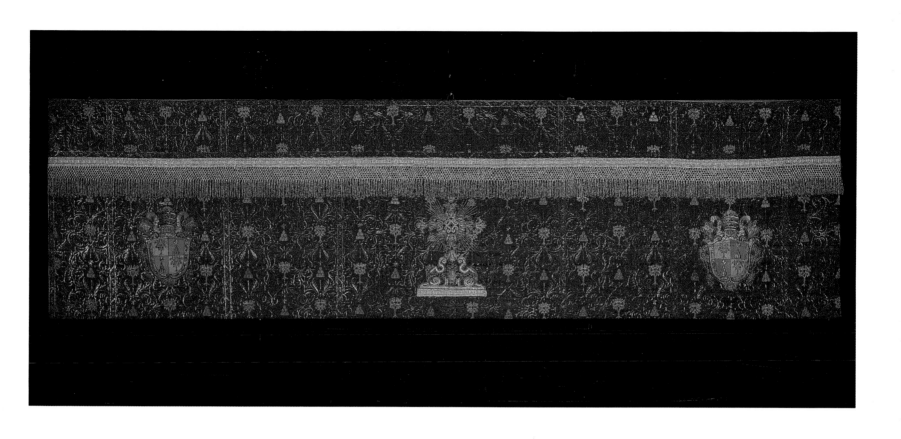

Altar Frontal with the Arms of
Alexander VII

Red velvet of silk with embroidery
in gold- and silver-braid,
106 × 260 cm
Basilica of St John Lateran

The high relief of the embroidery and the bold strength of the ponderous volutes, curling in slow circular movements, give this design a monumental quality, which reflects a response to the scale of its intended surroundings. Whereas the other frontals (CAT. NOS. 43 and 44) were destined for spaces that were either smaller or where the decoration was two-dimensional, this frontal with the arms of Alexander VII adorned the high altar of St John Lateran, which is crowned by a free-standing canopy requiring a design of sculptural character for the frontal to figure adequately. The clarity and vigour of the design is similar to that of the frontal in the medals of the *Cathedra Petri* (CAT. NO. 29) and of the canonization of St Francis de Sales (CAT. NO. 31), although it lacks the effective simplicity of their two great sweeping volutes. Closer to these were to be the mosaic translations of embroidered frontals of a standard pattern adorning all the side-altars of St Peter's, commissioned under Pius VI, but possibly based on an earlier design originally painted on canvas such as the similar frontals that adorn some of the altars in the Chiesa Nuova. According to G. Moroni (*Dizionario di erudizione storico-ecclesiatica*, Vol. I, Venice 1840, p. 275, under the heading "*Altare*") these designs could be used all-year-round because they contained the colours of every liturgical season.

In the present altar-frontal the cross is represented as if it stood on a stand, although its three-dimensional appearance is much attenuated compared to that of the cross in the frontal from the Chapel of Urban VIII (CAT. NO. 43). However, the sense of recession and projection in space is effectively conveyed by the perspective angle of the keys. The traditional acanthus scrolls here change into oak-leaves and acorns from the della Rovere quartering on the Chigi coat-of-arms. In the centre of the cross is an eight-pointed star also contained in the Chigi coat-of-arms. Its relation to the rays of light emanating from the cross seems to indicate that the Pope was providentially destined to transmit the celestial fire in whose nature his armorial star participates. Such would seem to be the conceit underlying the alternation with the six-pointed star associated with divine wisdom on the antique bronze doors of the Lateran, restored to a design by Borromini, who also used the

motif with more explicit clarity in the ribs of the vault in S. Ivo alla Sapienza.

The decoration of altar frontals with scroll motifs may derive from the associations of the vine with the Eucharist celebrated at the altar, and with Christ as the vine of which the disciples are the branches. Nor should the permutation into oak necessarily exclude the possibility that the motif was intended to allude to these familiar notions. For in a design by Bernini (FIG. 16) for a golden rose, traditionally sent by the pope as a gift to a deserving Catholic sovereign, the flowers blossom somewhat unexpectedly from an oak tree growing at the summit of the Chigi mountains suggesting that it is deeply rooted in virtue. Similarly, in a golden rose with the arms of Paul V in the Schatzkammer in Vienna (FIG. 15) the fragrant perfume of the rose is evoked by the relics in phials "which are the prayers of the saints" (Apoc. 5:9).

The slightly archaic quality of the present design, well-suited to the Gothic altar of the Lateran, is reminiscent of the dossal or backdrop from the throne of the Emperor Maximilian, which was reverently preserved and still survives at Innsbruck, native city of Johannes Paulus Schor or as he was known in Rome, Giovanni Paolo Tedesco. He may have been responsible for the mantle of Clement IX (CAT. NO. 42) and for the red altar frontal from the Sistine Chapel with the arms of Alexander VII (CAT. NO. 44), as he indubitably must have been for another superb red altar frontal from the Lateran with the arms of Cardinal Flavio Chigi. The latter is extremely close to the decoration beneath the throne of the *Cathedra Petri* (see CAT. NO. 29), documented as the work of Schor, who was Bernini's trusted assistant for the elaboration of his ideas in such matters as embroidery, costumes, stage scenery, and fireworks displays (*cf. Bernini in Vaticano*, p. 234, n. 19). A drawing attributed to Schor representing a livery (Rome, Gabinetto Nazionale dei Disegni e delle Stampe, F.C. 127540) is very close to the present frontal in the slow rhythm of its evenly distributed volutes.

M. W.

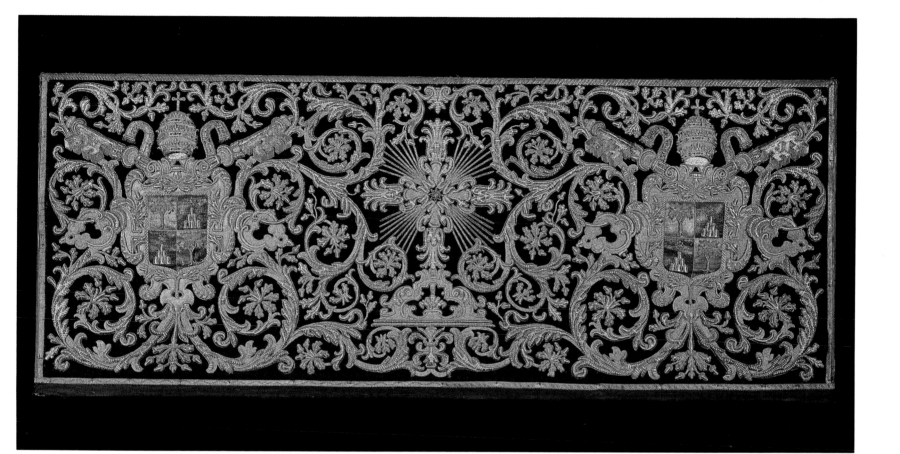

*Monsignor Maffeo Barberini
Created Cardinal* 1666–67

Tapestry, in silk and wool,
396 × 501 cm
Musei Vaticani (Inv. no. 3920)

In 1625 on a mission to Paris in the company of, among others, the Cavaliere Cassiano dal Pozzo, Cardinal Francesco Barberini greatly admired the tapestries at the Château of Fontainebleau. In honour of this visit, Louis XIII made him a gift of seven tapestries of the series designed by Rubens on the Life of Constantine. Cardinal Barberini resolved to open a tapestry atelier in Rome such as there had been mid-15th century under Pope Nicholas V.

By 1627 the tapestry workshop was already functioning, under the direction of the Fleming Jacob van den Vliete. The first work to be produced was a series of *Castelli* in imitation of the Gobelins *Maisons royales*. Thereafter followed between 1630 and 1641 the production of tapestries made on the designs of Pietro da Cortona, completing the Life of Constantine with richly conceived borders containing emblems of the Barberini family to match those by Rubens, which included allusions to the French Royal House. This set is today in Philadelphia (see David DuBon, *Tapestries from the Samuel H. Kress Collection at the Philadelphia Museum of Art – The History of Constantine the Great designed by Peter Paul Rubens and Pietro da Cortona*, Aylesbury 1964; and Prince Urbano Barberini "Pietro da Cortona e L'Arazzeria Barberini," *Bollettino d'Arte*, XXXV, 1950, pp. 43–51 and 145–52).

The series on the *Life of Urban VIII* was produced late in the history of the manufacture, from 1663 on, but they take up a subject previously suggested for frescoes on the walls of the great hall of the Barberini Palace (see Walter Vitzthum, review of DuBon in *The Burlington Magazine*, CVII, May 1965, p. 262, for a discussion of the proposed iconography of this room). Commissions for their designs were awarded to various artists in the circle of Pietro da Cortona, among them Ciro Ferri, Romanelli, Lazzaro Baldi, and Camassei. Aside from their own narrow borders decorated with vine leaves and bees at the corners, there were separate, quite elaborate borders above and below and at the sides. These borders are now generally dispersed. Payments to various artists for the cartoons for the major scenes and for the borders have been identified in the Barberini Archives by Jennifer Montagu and Marilyn Aronberg Lavin, as well as to Maria Maddalena della Riviera (d.1678),

who seems to have been head of the workshop where they were woven (see Prince Urbano Barberini, "Gli Arazzi e i Cartoni della Serie 'Vita di Urbano VIII' della Arazzeria Barberini", *Bollettino d'Arte*, LIII, 1968, pp. 92–100). The tapestries were for the most part acquired by the Vatican in 1937 from the Barberini family. The cartoons, with the exception of three ceded to the Corsini family in 1934, are exhibited in Palazzo Barberini (see I. Faldi, *I cartoni per gli Arazzi Barberini della serie di Urbano VIII*, Rome 1967).

Among the earlier scenes from the life of Maffeo Barberini comprising the tapestry series were those of his receiving his doctorate in law at the University of Pisa, and his successful efforts in dealing with the floods of Lake Trasimene under Pope Clement VIII. The present scene shows the Cardinal's hat being bestowed on him by Pope Paul V after his return from Paris where he had held the position of nuncio, and where in September 1606 he received news of his nomination as cardinal. It is based on the cartoon of A. Gherardi, which is in the collection of the Galleria Nazionale d'Arte Antica in Palazzo Barberini. Assisting at the investiture are various cardinals, among them Cardinals Farnese, Borghese, Belarmino, Serafino Olivario, and Arigoni; behind the balustrade on the right are foreign ambassadors, while on the left are members of the Swiss Guard. The angel above, with a lily signifying purity, also holds the *pallium* with which Maffeo was invested as Archbishop of Spoleto. The mitre held by the soldier foreground right may refer to this same tenure, though John Beldon Scott has suggested this could be Nazareth, of which Maffeo was titular Archbishop.

C.J.

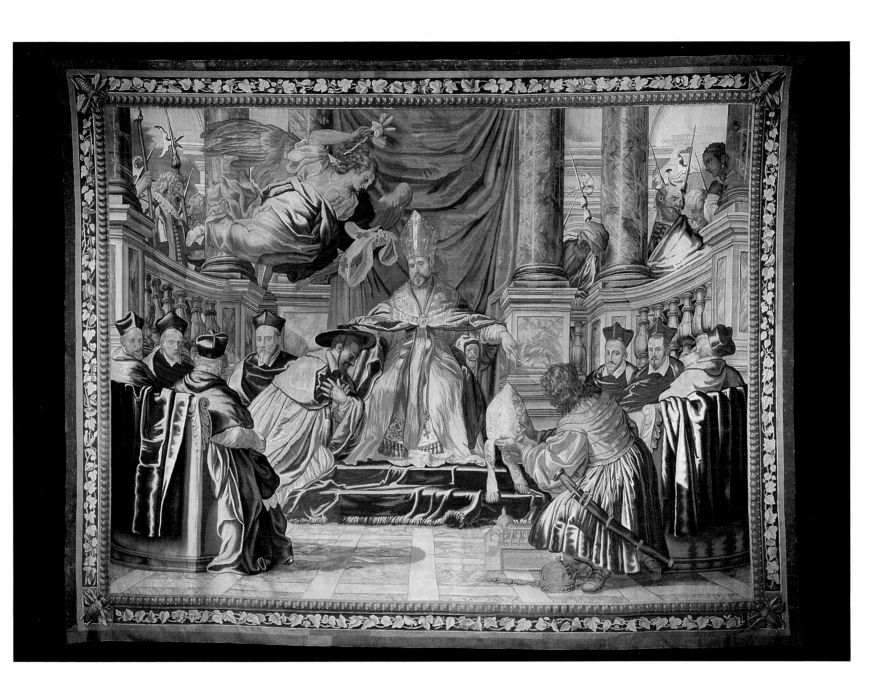

Cardinal Maffeo Barberini Elected Pope after 1667–68

Tapestry, in silk and wool, 403 × 525 cm
Musei Vaticani (Inv. no. 3921)

The conclave following the death of Pope Gregory XV on 8 July 1623 was long and arduous and, as was typical of the Roman summer in that period, an epidemic of malaria broke out to which the low-lying Vatican territory was particularly subject. Eight of the fifty-four participating Cardinals fatally succumbed to the disease, and Maffeo himself was to fall sick at the close of the conclave. The consideration of his name as one of the *papabili* occurred only towards the end of the session, when a swift rallying of supporters brought a favourable vote on 6 August. As there was some question about the number of votes, Cardinal Barberini quickly called a recount before accepting the outcome, which pronounced him Pope by a nearly unanimous vote.

The story of the repeated scrutiny is what is represented in this scene. It was recounted in a poem celebrating the election of Urban VIII by Francesco Bracciolini, who was also responsible for the iconography of Pietro da Cortona's famous frescoes on the ceiling of the Barberini Palace; and this was one of the scenes originally suggested as wall frescoes lower down in the same room (see von Pastor, XXIX, p. 502). Based on the cartoon by Fabio Cristofani, we see the Cardinals gathered in the Sistine Chapel, with the papal tiara already being proffered to Cardinal Barberini, who gestures, however, to Cardinal Boncompagni (recognizable from Van Dyck's portrait of him in the Pitti Palace) to make a recount of the papers spread out on the table being examined by the other scrutineers. Overhead are allegories of Modesty and Magnanimity (see C. Ripa, *Iconologia*, 1970 ed., 300f.) wearing a crown and a lion's skin, and holding a cornucopia with two crowns, one of them the Crown of Tuscany.

It has been suggested that a drawing by Lazzaro Baldi in the National Gallery of Canada (FIG. 8) represents a scene proposed for this series. Of a squarish shape similar to CAT. NO. 49, it shows the Pope, seated and flanked by cardinals, being presented with a tablet by a kneeling female figure. Other similar tablets are appended to the walls in the background. Such a scene did not form part of the series as finally executed. Lazzaro Baldi is, however, clearly indicated in payments involving other scenes, and in a letter of 1663 he is singled out as Cardinal Francesco's choice for the tapestry designs. (See Adolf Cavallo, "Notes on the Barberini Tapestry Manufacture at Rome," *Bulletin of the Museum of Fine Arts*, Boston, LV, no. 299, spring 1957, p. 22).

C.J.

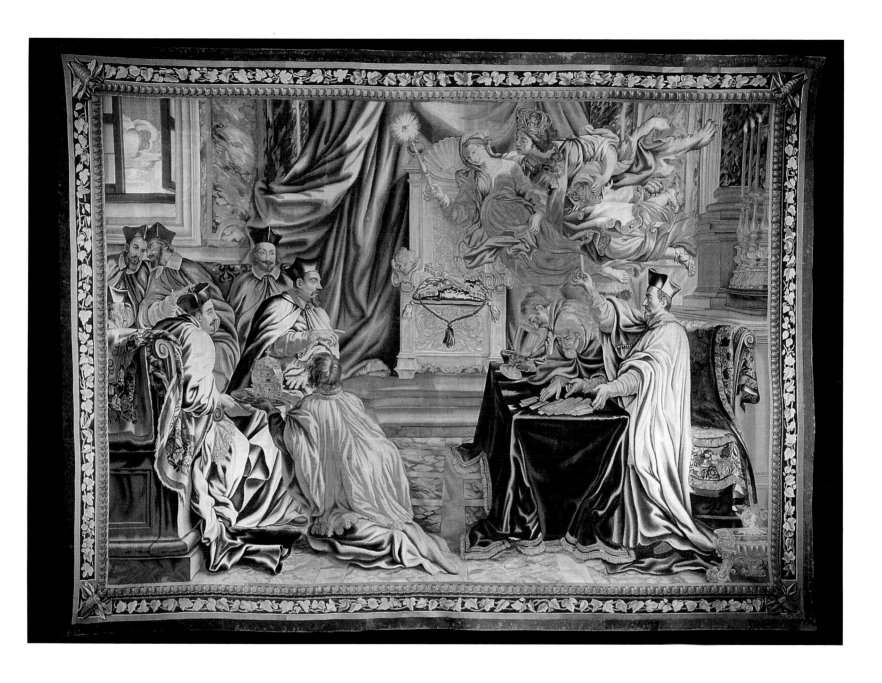

Pope Urban VIII Consecrates the Basilica of St Peter 1671–73

Tapestry, in silk and wool,
400 × 519 cm
Musei Vaticani (Inv. no. 3923)

Since his election, the Pope had been actively involved in the completion of the new Basilica of St Peter, which was begun during the Early Renaissance by Bramante, continuing in the 16th century with the addition of Michelangelo's dome. In 1605 what was left of the original Constantinian basilica, erected on the site of Peter's martyrdom and tomb, was razed to permit the construction of Carlo Maderno's nave (completed 1615). Paul V had consigned to Giovanni Lanfranco the important commission to decorate the Benediction Loggia over the entrance, but under Gregory XV there was the suggestion that this might be placed in the hands of Guercino. Urban VIII initially considered Bernini for this commission (which was not to be executed, however, before the next century). He immediately named Bernini head of the Vatican foundry, and the sculptor began the task of designing the enormous bronze columns that support the *Baldacchino* (FIG. 5) over the tomb of St Peter. Begun in 1624, the *Baldacchino* was completed with the collaboration of Francesco Borromini only in 1633. The columns had been cast and were erected by 18 November 1626, when Urban VIII officially consecrated the Basilica.

The *Baldacchino* is represented in the background at the right of the tapestry, although the top with large palm fronds and four angels at the corners could not yet have been executed as we see them here. In the act of consecrating the space, the Pope had first to bless the twelve mosaic crosses which were then affixed to the walls of the Basilica, some of which we see at the left. Conforming with early church tradition he also traced the letters of the Greek and Latin alphabet on the floor. The tapestry, based on the cartoon by Fabio Cristofani, includes a number of portraits. The Pope is portrayed as the Bishop of Rome and thus wears a mitre and holds a crozier with which he writes the letters in ashes. His richly embroidered cope is held by his two nephews, Cardinals Francesco and Antonio, while their brother Taddeo (FIG. 6), who became Prefect of Rome on his father's death in 1630, stands at the extreme left. Behind him is the brother of the Pope, Cardinal Antonio senior, a member of the Capuchin order. At the right are Taddeo Barberini's young sons Maffeo and Carlo, and behind them Gian Lorenzo Bernini,

who stands before his *Baldacchino*. The female personifications of Faith and Religion (see C. Ripa, *Iconologia*, 1970 ed., 149ff. and 430ff.) survey the scene from above. Payments to Giacinto Camassei for cartoons for the borders to this subject are recorded, but the borders themselves have disappeared (see Urbano Barberini, *loc. cit.*, p. 97).

C.J.

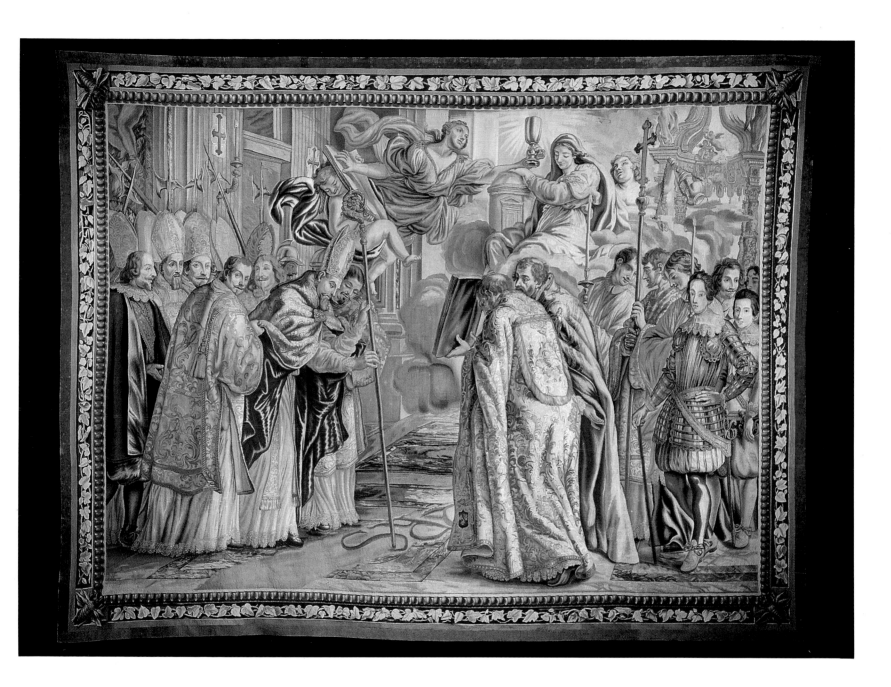

Pope Urban VIII Receives the Homage of the Nations 1678

Tapestry, in silk and wool, 427 × 407 cm
Musei Vaticani (Inv. no. 3948)

The cartoon for this tapestry was commissioned from Pietro Lucatelli in 1667, although the tapestry itself was only delivered late in 1678, payments also having been made to Giuseppe Passeri for cartoons for the side panels in 1677. Preparatory drawings for the cardinals on either side of the Pope are in the Uffizi and have been reattributed to Lucatelli by Prince Urbano Barberini, who has also identified a further drawing in the Teylers Foundation in Haarlem as connected with this subject (cf. *Bollettino d'Arte*, LIII, 1968, p. 99). Drawings for the Cardinal to the right of the Pope and for the drapery on the stairs are in Berlin (see Peter Dreyer, "Pietro Lucatelli," Jahrbuch der Berliner Museen, 1967, pp. 256–257, figs. 39 and 40). Containing many figures, the composition is one of the most complicated of the series, both structurally and in its iconography. The Pope, portrayed very much as in Bernini's tomb figure (see FIG. 13), is seated on a throne at the right beneath a baldachin from which hangs a voluptuous curtain embroidered with the Barberini emblems: the sun, bees, and laurel. He is flanked by his nephew, Cardinal Francesco at the right, who commissioned the series, and further back his nephew, Cardinal Antonio, although Prince Urbano has suggested that this figure is Urban's brother Antonio. Venice and France are in the foreground right. Kneeling before the Pontiff is the personification of the Papal States, wearing a laurel crown and carrying a sceptre with orb and cross (this interpretation was kindly provided by John Beldon Scott; the figure has also been called the Roman State by M. Calberg in "Homage au Pape Urbain VIII," Bulletin des Musées Royaux d'Art et d'Histoire, 1959, p. 104). Immediately behind her is Malta, bearing a shield on which is visible part of what would appear to be a Maltese cross (but could also be that of the Knights of St Stephen, in which case the figure represented would be Pisa). Between this last and the figure of Tuscany (cf. Ripa, p. 252) wearing an ermine cape and the Tuscan imperial crown is another female figure in armour, with plumes in her helmet and with a palm frond in her hand, who can be identified with Liguria (cf. Ripa, p. 252). Immediately behind is an unidentified figure, and further to the left another crowned head. At the extreme left is a bare-breasted female figure with a bow in her hand, who might represent America, for in the cartoon her skin is definitely dark. The seven female figures in the far background bear no distinguishing attributes. In the foreground left is a river god, resting on a lion and holding a cornucopia out of which spill gold coins. This is the Arno (Ripa, pp. 158 and 252), with the Florentine lion *il marzocco* as an indication of the Barberini's origin in Tuscany.

In the identification of this scene as an allegory of Catholic nations paying homage to the Pontiff, the absence of Spain is noteworthy. Payments to Lucatelli cited by Prince Urbano (*loc. cit.*, p. 98) quote the scene as "l'historia della Santa Memoria di Papa Urbano VIII quando l'ambasciatori le rendono obedienza," without identifying which ambassadors were meant; the tapestry is referred to simply as "L'Obedienza dell'Ambasciatore" in the inventory drawn up on Cardinal Francesco's death in 1679 (see M. Lavin, *Seventeenth-Century Barberini Documents and Inventories of Art*, New York 1975, p. 358). The lower border, the location of which is presently unknown, bore a scene of the reception of the Ethiopian emperor in Rome.

With the Barberini succession in the 19th century, this tapestry and two others with some border pieces had passed to Prince Maffeo Sciara di Colonna and were sold in 1892 to a Belgian collector. Two of these were subsequently bought in 1947 on the Paris art market by the then nuncio, Cardinal Roncalli, later Pope John XXIII, who donated them to the Vatican Museums. This subject had meanwhile entered the Musées Royaux in Brussels (see Calberg, *loc. cit.*, pp. 99–110). In 1966 an arrangement was made by which it was reunited with the other subjects from the series, which had become part of the collection of the Musei Vaticani in 1937.

C.J.

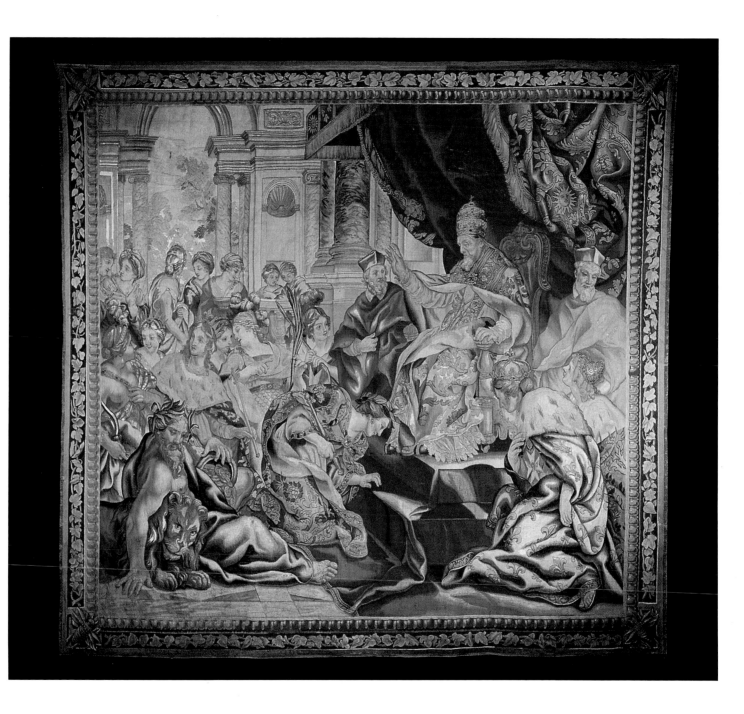

Select Bibliography

I. Contemporary sources: biographies of the artists, guides, documents

Baglione, G. *Le vite de' pittori, scultori, architetti, ed intagliatori, dal pontificato di Gregorio XIII del 1572, fino a' tempi di Papa Urbano VIII nel 1642*. Rome 1642. Facsimile edition with marginal notes by Bellori (ed. V. Mariani). Rome 1935.

Baldinucci, F. *Notizie de' professori del disegno da Cimabue in qua*. Florence 1681–1728.

Bellori, G.P. *Le vite de' pittori, scultori ed architetti moderni*. Edition revised and annotated by Evelina Borea, Turin 1976, incorporating original edition of 1672 and the lives of Guido Reni, Andrea Sacchi, and Carlo Maratti only added in 1942.

Malvasia, C.C. *Felsina Pittrice. Vite de pittori bolognesi*. Bologna 1678.

Mancini, G. *Considerazioni sulla pittura*. (Eds. A. Marucchi and L. Salerno). Rome 1956–57.

Noehles, K. *Roma l'anno 1663 di Giov. Batt. Mola*. Berlin 1966.

Passeri, G.B. *Vite de' pittori, scultori ed architetti che hanno lavorato in Roma, morti dal 1641 fino al 1673*. Rome 1772. Re-issued with notes by J. Hess. Vienna 1934.

Pastor, L. Von. *Geschichte der Päpste*. Freiburg im Breisgau 1901ff. English translation, *The History of the Popes*. London 1957. Vols. XXIII–XXXII.

Pollak, O. *Die Kunsttätigkeit unter Urban VIII*. Vienna 1927 and 1931.

Ripa, C. *Iconologia overo descrittione di diverse imagini cavate dall'antichità, e di propria inventione*. Rome 1603. Modern reprint Hildesheim and New York 1970; French edition, Paris 1677. The edition published in Padua 1611 is more fully illustrated than that of 1603.

Titi, F. *Descrizione delle pitture, sculture e architetture esposte al pubblico in Roma*. Rome 1763.

II. For modern literature, the reader is referred to the very extensive bibliography with critical notes given in Rudolph Wittkower's *Art and Architecture in Italy 1600–1750*, Penguin Books Ltd, Harmondsworth, Middlesex, 1958 (1982 revised paperback edition). Specific references are made in the footnotes to the introduction and within the individual catalogue entries. The following works are singled out for their particular relevance to the topic.

Blunt, A.F. *Guide to Baroque Rome*. London 1982.

———. *The Paintings of Nicolas Poussin, A Critical Catalogue*. London 1966.

———. "Roman Baroque Architecture: The Other Side of the Medal," *Art History,* III, 1980, pp. 61–80, figs. 23–40.

Boorsch, S. "The Building of the Vatican: The Papacy and Architecture," *The Metropolitan Museum of Art Bulletin,* Winter 1982/83.

Borsi, F. *Bernini*. New York 1984.

Boschloo, A.W.A. *Annibale Carracci in Bologna: Visible Reality in the Art After the Council of Trent*. The Hague 1974.

Brejon de Lavergnée, A. and Cuzin, J.P. *Valentin et les Caravagesques*. (Exhibition: Paris, Grand Palais) 1974.

Briganti, G. *Il Palazzo del Quirinale*. Rome 1962.

———. *Pietro da Cortona e della pitture barocca*. Florence 1962.

Faldi, I. *La scultura barocca in Italia*. Milan 1958.

Harris, A.S. *Andrea Sacchi*. Oxford 1977.

Haskell, F. *Patrons and Painters: A Study in the Relations between Italian Art and Society in the Age of the Baroque*. London 1963.

Hempel, E. *Francesco Borromini*. Vienna 1924.

Hibbard, H. *Bernini*. Harmondsworth 1965.

Lavagnino, E., Ansaldi, G.R. and Salerno, L. *Altari barocchi in Roma*. Rome 1959.

Lavin, I. *Bernini and the Crossing of Saint Peter's*. New York 1968.

Lavin, M.A. *Seventeenth-Century Barberini Documents and Inventories of Art*. New York 1975.

Magnanimi, G. *Palazzo Barberini*. Rome 1983.

Magnusson, T. *Rome in the Age of Bernini*. Stockholm 1985.

Mahon, D. *Studies in Seicento Art and Theory*. London 1947.

Mâle, E. *L'art religieux de la fin du XVIe siècle du XVIIe siècle et du XVIIIe siècle*. Paris 1951.

Mancinelli, F. *Vatican Museums: Pinacoteca*. Vatican 1981.

Martinelli, F., Fagiolo, M., Worsdale, M., Tocci, L.M. and Morello, G. in *Bernini in Vaticano*. (Exhibition: Vatican, Braccio di Carlo Magno) 1981.

Montagu, J. *Alessandro Algardi*. New Haven and London 1985.

Parks, N.R. "On Caravaggio's 'Dormition of the Virgin' and its Setting," *The Burlington Magazine,* CXXVII, 1985, pp. 438–448.

Pergola, P. della. *Galleria Borghese: i dipinti*. Rome 1955–59. 2 volumes.

———. *The Borghese Gallery in Rome*. A guide to the collection, first published by the Ministero della Pubblica Istruzione in 1951, frequently reprinted.

Pietrangeli, C., Raggio, O., Mancinelli, F. and Morello, G. in *The Vatican Collections, The Papacy and Art*. (Exhibition: New York, The Metropolitan Museum of Art) 1982.

Posner, D. "Domenichino and Lanfranco: the Early Development of Baroque Painting in Rome," *Essays in Honour of Walter Friedlaender*. New York 1965, pp. 135–146.

Raggio, O. "Bernini and the Collection of Cardinal Flavio Chigi," *Apollo,* CXVII, 1983, pp. 368–379.

Redig de Campos, D. *I Palazzi Vaticani*. Bologna 1967.

Safarik, A. and Torselli, G. *La Galleria Doria Pamphilj a Roma.* Rome 1982.

Spear, R. *Domenichino.* New Haven and London 1982.

Spike, J. *Portraiture in Italy: Work from North American Collections.* (Exhibition: Sarasota, Ringling Museum) 1984.

Strinati, C. "L'Arte a Roma nel Seicento e gli Anni Santi," in *L'Arte degli Anni Santi: Roma 1300–1875.* (Exhibition: Rome, Palazzo Venezia) 1984.

Varriano, J. and Whitman, N. *Roma Resurgens: Papal Medals from the Age of the Baroque.* (Exhibition: Ann Arbor, University of Michigan) 1983.

Voss, H. *Die Malerei des Barock in Rom.* Berlin 1924.

Waterhouse, E.K. *Italian Baroque Painting.* London 1962.

———. *Baroque Painting in Rome: The Seventeenth Century.* London 1937 (reprint).

Wittkower, R. *Gian Lorenzo Bernini, the Sculptor of the Roman Baroque.* Oxford 1981 (3rd edition).

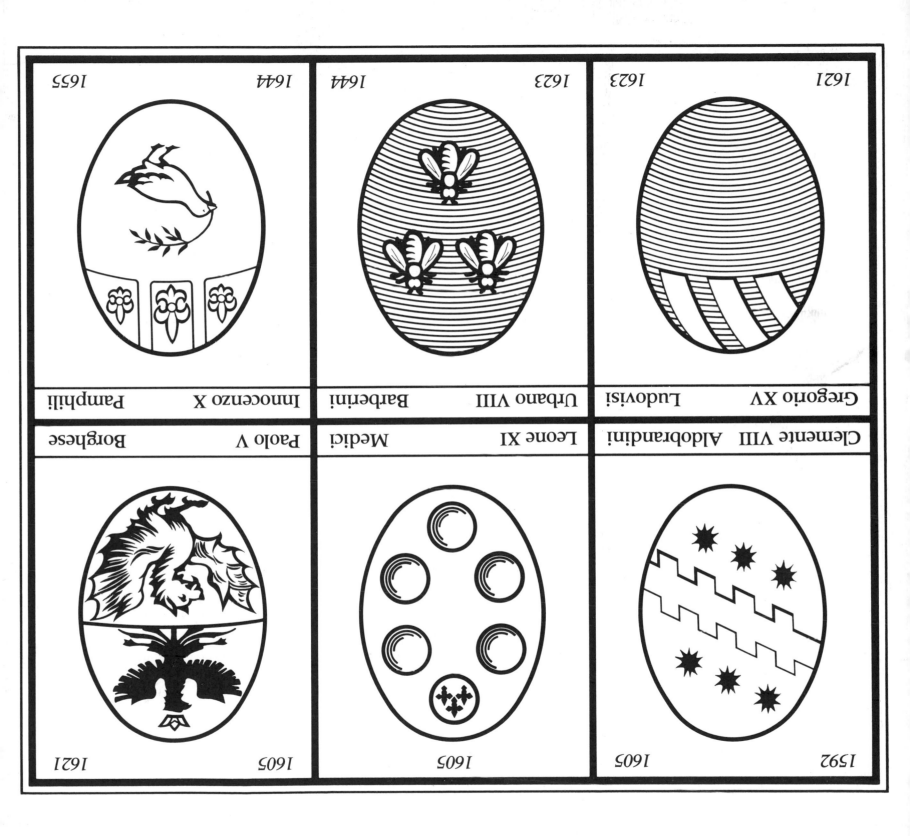